YOKO ONO HALF-A-WIND SHOW A RETROSPECTIVE

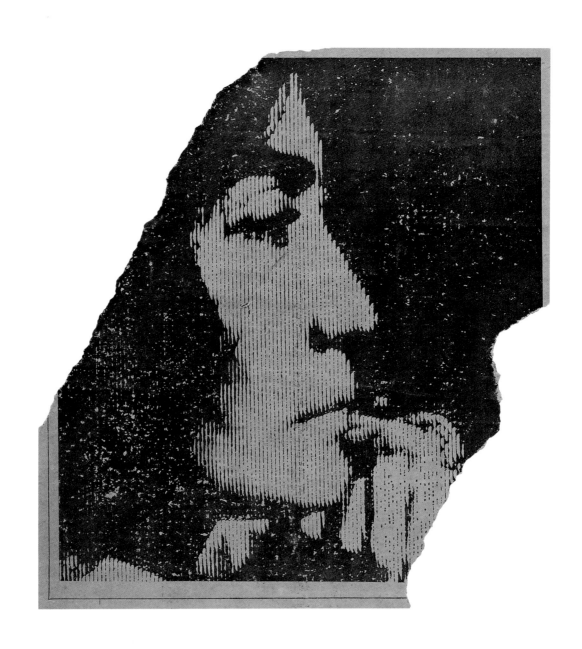

ADD COLOR PAINTING, 1960/1966
(detail, complete image, p. 97)

YOKO ONO

HALF-A-WIND SHOW

A RETROSPECTIVE

Editors: Ingrid Pfeiffer and Max Hollein
in cooperation with Jon Hendricks

Curator: Ingrid Pfeiffer

Schirn Kunsthalle Frankfurt
February 15 – May 12, 2013

Louisiana Museum of Modern Art, Humlebæk
June 1 – September 15, 2013

Kunsthalle Krems
October 20, 2013 – February 23, 2014

Guggenheim Museum Bilbao
March 18 – September 7, 2014

SCHIRN KUNSTHALLE FRANKFURT **PRESTEL** MUNICH · LONDON · NEW YORK

Sponsored by

Dr. Marschner Stiftung

Media partners

Frankfurter Allgemeine
ZEITUNG FÜR DEUTSCHLAND

RollingStone

SCHOLZ & VOLKMER

VG F

Mobility partner

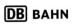 **BAHN**

Foreword

What a life and what an oeuvre we are privileged to gaze upon here! The Yoko Ono retrospective presented by the Schirn Kunsthalle Frankfurt in 2013 is devoted to one of the most fascinating women of our time. At home in two worlds—Japan and the United States—since early childhood; a dedicated pioneer of the avant-garde as an artist, a musician, and a political activist; and not least of all a living symbol of emancipation. What a life it has been, and what outstanding works of art it has produced!

In Germany, Yoko Ono has provided multiple impulses to Modernism and has marked out significant artistic positions—in Kassel at documenta 5 and 8 in 1972 and 1987, for example. We recognize a relationship with her life's work that began more than fifty years ago. For she was a source of inspiration and a protagonist in the Fluxus movement associated with her patron and admirer George Maciunas, which made a name for itself with the magnificently shocking performance concert *Fluxus. Internationale Festspiele Neuester Musik* (Fluxus. International Festival of Very New Music) presented in Wiesbaden in 1962.

Art and culture are windows to the world. They create the foundation for the identity and vitality of a community. In order to promote this process sustainably in and for the Frankfurt Rhine-Main metropolitan region, the cities of Frankfurt, Darmstadt, Wiesbaden, and Hanau, along with the Main-Taunus and Hochtaunus counties and the State of Hessen have formed an alliance for art and culture chaired by Hochtaunus County Commissioner Ulrich Krebs. The curatorium of internationally renowned experts is headed by Minister of State (ret.) Ruth Wagner of Darmstadt.

The Kulturfonds is pleased to contribute to the success of the exhibition devoted to Yoko Ono at the Schirn within the context of its thematic focus on "Frankfurt Rhine-Main as a Transformer of Modernism." Such a thoughtfully conceived retrospective devoted to the life and work of this bold pioneer of Conceptual and Performance Art seems long overdue. The artist's eightieth birthday in 2013 provides the perfect occasion, with the City of Frankfurt, a hub of Modernism, offering the perfect setting. On behalf of the Kulturfonds, I am pleased and honored to express the hope that the exhibition will enjoy the reception and success it truly deserves. I wish both experienced and younger visitors an inspiring (re)encounter with the work of a pioneer for art and society.

Albrecht Graf v. Kalnein, Kulturfonds Frankfurt RheinMain

Foreword

On behalf of the Dr. Marschner Stiftung, I wish to emphasize how pleased we are to be able to support the first major Yoko Ono retrospective in Europe. With this survey exhibition, the Schirn Kunsthalle brings to Frankfurt an artist who has attained the status of a contemporary historical figure through her art and her life with John Lennon.

Her oeuvre is as multifaceted as Yoko Ono herself—as a filmmaker, a composer, and singer, and more recently as a fashion designer, but above all as one of the best-known representatives of the Fluxus movement.

Yoko Ono's art, which originated in the 1960s and is still progressing today, is composed of an impressive mix of poetry, humor, and fantasy, and is particularly fascinating by virtue of its incredible media diversity. It is the mirror image of her own personality, calling upon us to cast off everyday concerns, free our minds, and think outside the box, beyond the sphere of familiar paths and thought patterns.

In that spirit, I wish this exhibition every success and trust that it will provide its visitors with many inspiring moments.

Peter Gatzemeier, Chairman of the Board, Dr. Marschner Stiftung

Preface

Yoko Ono is a unique, indeed perhaps even a mythical figure, not only in the art world, but in the field of music and the peace and feminist movements as well. She is familiar to practically everyone, yet only very few people are fully aware of the outstanding artistic oeuvre she has created or of the important pioneering role her early performances and conceptual works of the 1960s played and continue to play in the development of contemporary art today.

In the year of her eightieth birthday, the Schirn Kunsthalle is presenting the most extensive overview possible of the diverse oeuvre of this extraordinary artist in an exhibition featuring some 200 objects, films, installations, photographs, drawings, and textual pieces, as well as a special room devoted to her music. This is the most comprehensive show there has ever been in Europe of Yoko Ono's work.

In close collaboration with the artist and curator Jon Hendricks, her long-time curator and friend, we have attempted, in the exhibition and the catalog, to do justice to Yoko Ono's unique conceptual approach. I wish to thank both of them sincerely for their extraordinarily helpful and intensive support.

I extend my particular thanks at this point to Jon Hendricks and his assistant Susie Lim—the exhibition and catalog could never have reached their present quality without his guidance and extensive knowledge of the context of the works involved and all their relevant details. This project would also not have been possible without the commitment and active support of Studio One, especially on the part of Karla Merrifield, Connor Monahan, Colby Bird, Andrew Kachel, Eva Bracke, and Ellen Goldin. For their help on many issues, we also thank Jonas Herbsman and Joanne Hendricks.

It is not easy to present an oeuvre that often tends toward the immaterial, the substance of which consists less of objects and installations than of ideas and texts. Much of Ono's art resists classification according to conventional categories, yet we have identified and highlighted a number of characteristic themes and leitmotifs that appear throughout her entire oeuvre. Ono has developed a new work—the installation and performance entitled *Moving Mountains*—specifically for the exhibition at the Schirn Kunsthalle. It is based in essence on her *Bag Piece* from the 1960s, just as many other recent works take up fundamental ideas and often relate to the *Instructions* published by Ono in her pathbreaking book *Grapefruit* in 1964.

We are very pleased to have recruited a number of partners for our exhibition tour, which will be traveling on to other venues after its presentation in Frankfurt. Thanks are due in particular to Director Poul Erik Tøjner and Curator Kirsten Degel at the Louisiana Museum of Modern Art in Humlebæk for their cooperation and commitment. The Kunsthalle Krems will be the third stop on the exhibition tour, and I wish to express special thanks to its Director, Hans-Peter Wipplinger. The fourth and last exhibition venue is the Guggenheim Museum in Bilbao. My heartfelt thanks go to its Director, Juan Ignacio Vidarte, and Petra Joos for their congenial support.

We are grateful for generous loans of specific works to the Museum of Modern Art in New York, the Walker Art Center in Minneapolis, Northwestern University in Illinois, the ZKM, Center for Art and Media Karlsruhe, the Gilbert and Lila Silverman Collection, Detroit, the Collection of Barbara Goldfarb, to Chimera Music, and to numerous private lenders who have asked to remain anonymous.

A great deal of committed support is always needed in order to realize such an ambitious project, and our sponsors and partners contributed substantially to the achievement of that goal. A special word of thanks therefore goes to the Kulturfonds Frankfurt RheinMain

for its exemplary support of this exhibition. My personal thanks go to the fund's Managing Director, Dr. Albrecht von Kalnein, for the tremendous enthusiasm with which he accompanied the project from the outset. Furthermore, I would like to express my gratitude to the Dr. Marschner Stiftung, whose support also played a crucial role in the realization of this exhibition. Thanks go in particular to the foundation's Board of Directors, represented by Peter Gatzemeier, who from an early stage followed our project with great interest. I also thank the Hasenkamp company for its assistance in the transportation of the various artworks. Thanks are due as well to our culture partner, hr2, and our media partners, the *Frankfurter Allgemeine Zeitung*, the *Rolling Stone Magazine*, Scholz & Volkmer and VGF.

I wish as always to express special thanks to the City of Frankfurt and to Lord Mayor Peter Feldmann and Cultural Affairs Director Felix Semmelroth as representatives of everyone involved in the decision-making process. The work of the Schirn would not be possible without their support.

Thanks go as well to Karsten Weber for the excellent exhibition architecture and to Manu Lange and Elisabeth Durach for the outstanding exhibition graphics. I also wish to thank the catalog authors, Kathleen Bühler, Jörg Heiser, Jon Hendricks, Alexandra Munroe, Ingrid Pfeiffer, and Kerstin Skrobanek, for their inspiring scholarly articles, as well as Lisa Beißwanger for compiling a chronology of the artist's life. I thank Harold Vits for his impressive catalog design. We also owe a word of thanks to the Prestel Verlag and in particular to Program Director Katharina Haderer and Project Manager Gabriele Ebbecke. Thanks also go to Barbara Delius and Danko Szabó for their excellent work in editing the German and English texts and to John Southard and Bernd Weiß for their fine translations. Katharina Siegmann deserves a word of thanks for the catalog management.

As always, I wish to express my personal thanks to the dedicated and highly motivated team at the Schirn Kunsthalle. I am grateful first and foremost to Curator Ingrid Pfeiffer, who developed the exhibition concept and realized it with considerable élan, expertise, and imagination. She was assisted by Academic Assistant Lisa Beißwanger, who provided invaluable support for the project and the catalog. I thank Ronald Kammer and Christian Teltz along with Stefan Schäfer and Stephan Zimmermann for their expert handling of all technical matters, as well as Andreas Gundermann and the members of the hanging team. I wish to thank Esther Schlicht for her management of the exhibition, Karin Grüning, Elke Walter, and Jessica Keilholz for the organization of loans, as well as our conservators Stefanie Gundermann and Stephanie Wagner. My thanks go to Inka Drögemüller for her supervision of the exhibition tour and as Head of Marketing, and to her team members Luise Bachmann, Laura Salice, and intern Darja Zub. I also thank Heike Stumpf, Scholz & Volkmer, and Owig DasGupta for the design and realization of the advertising campaign. Julia Lange and Elisabeth Häring handled sponsoring matters and also organized all of the exhibition events, for which I wish to thank them as well. Thanks are also due to Axel Braun, Carolyn Meyding, Markus Farr, and Simone Krämer for their handling of press relations and to Fabian Famulok for editing the Schirn Magazine. The diverse educational program accompanying the exhibition was developed by the team of Chantal Eschenfelder, including Simone Boscheinen, Irmi Rauber, Laura Heeg, and Antje Lindner. I also wish to thank my personal assistant Katharina Kanold and our team assistant Daniela Schmidt. We are grateful as well for the support provided by Klaus Burgold, Katja Weber, and Tanja Stahl of our administrative staff. Thanks also to our courier Ralf Stoßmeister and to Josef Härig, Vilizara Antalavicheva, and their colleagues on the reception team and to Michael Henke and his Building Supervision and Security staff. Finally, I wish to thank everyone who was involved in this project for their commitment and hard work.

Max Hollein, Director, Schirn Kunsthalle Frankfurt

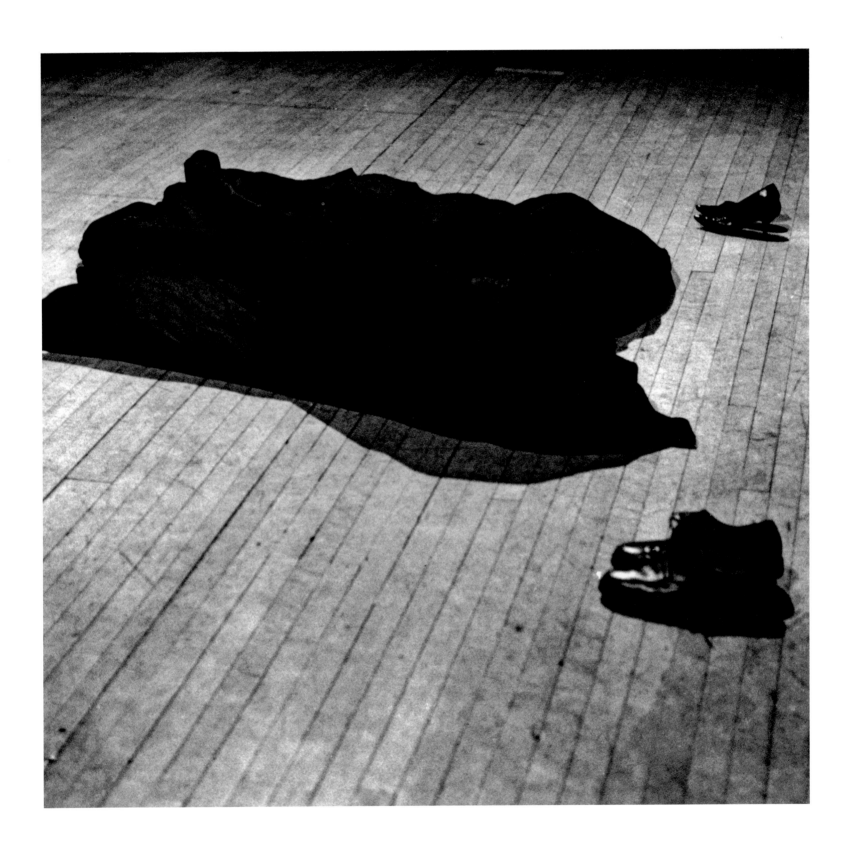

BAG PIECE, 1964
Performed by Yoko Ono and Anthony Cox,
Carnegie Recital Hall, New York, March 21, 1965

Ingrid Pfeiffer

Bringing the World into Balance —————————————— 23
Yoko Ono's Contribution to an Art of Self-reflection
from 1955 to the Present

Jon Hendricks

Yoko Ono and Fluxus ——————————————————— 53

Alexandra Munroe

Yoko Ono's Bashō ————————————————————— 87
A Conversation

Kerstin Skrobanek

Yoko Ono beyond Categories ———————————————— 123

Kathleen Bühler

Yoko Ono's Films ————————————————————— 149

Jörg Heiser

Against the Wind, against the Wall ————————————— 165
Yoko Ono's Music

Texts by Yoko Ono —————————————————————— 179
Biography / Statement ———————————————— 179
To the Wesleyan People ——————————————— 180
On Film No. 4 ——————————————————— 183
Water Talk / Air Talk / On Rape ———————————— 184
The Feminization of Society —————————————— 185
What is the Relationship between the World and the Artist? — 186

Chronology *compiled by Lisa Beißwanger* ————————————— 188

Selected Bibliography —————————————————————— 199

The Authors ———————————————————————————— 201

List of Exhibited Works ————————————————————— 203

Imprint, Image Credits ————————————————————— 206

NUMBER PIECE I

Count all the words in the book
instead of reading them.

NUMBER PIECE II

Replace nouns in the book with numbers
and read.
Replace adjectives in the book with
numbers and read.
Replace all the words in the book with
numbers and read.

1961 winter

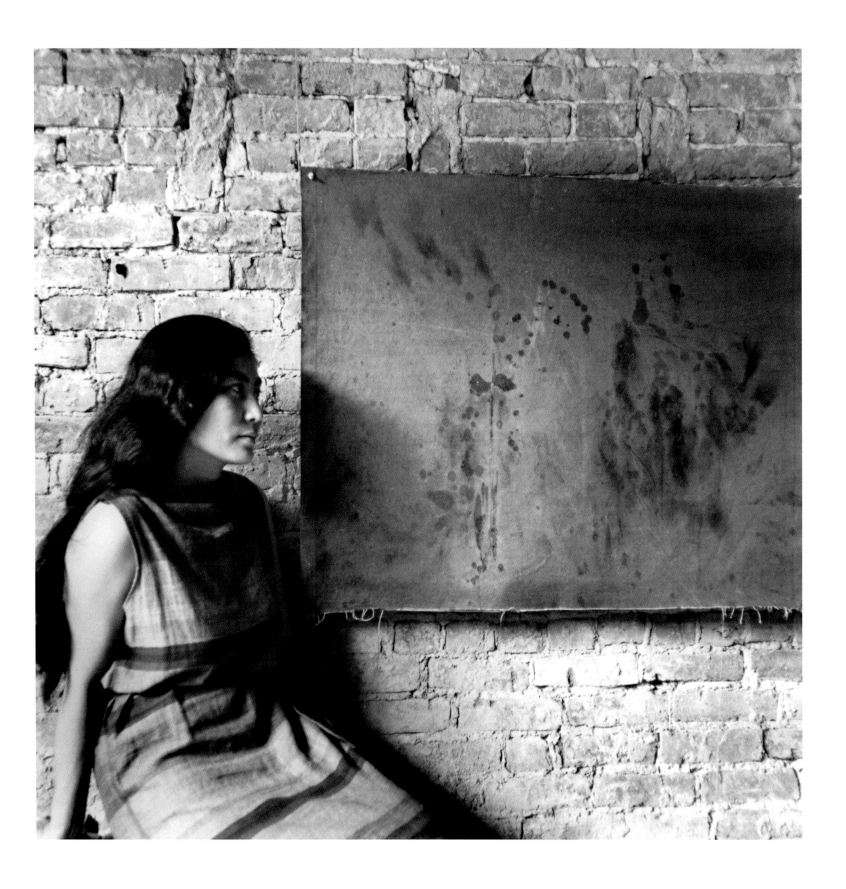

PAINTING TO SEE IN THE DARK (Version 1)
Installation view with the artist
at the AG Gallery, New York, July 1961
Photograph by George Maciunas

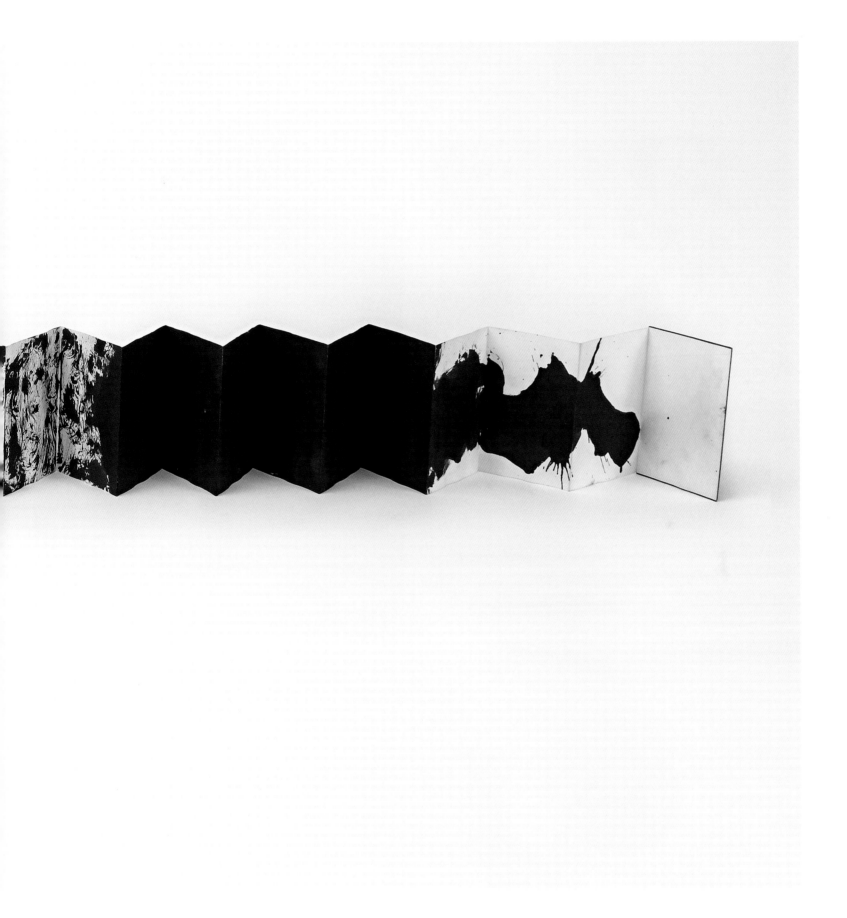

PART PAINTING / PAINTING UNTIL IT BECOMES MARBLE, 1961
Ink on paper
Folded: 6.25 × 5 cm, unfolded c. 6.25 × 120 cm

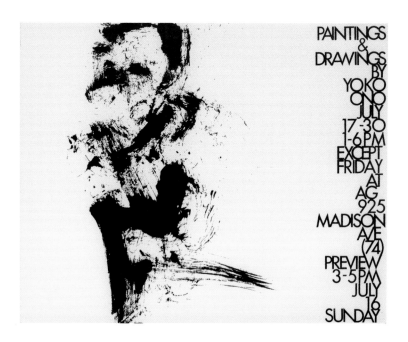

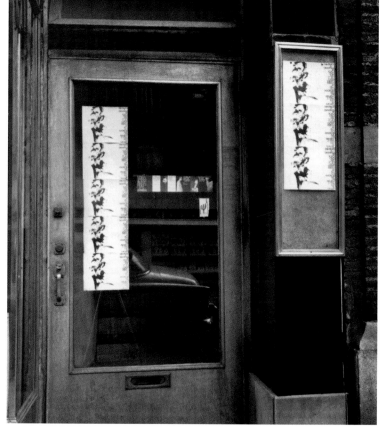

PAINTINGS & DRAWINGS BY YOKO ONO,
AG Gallery, New York, July 16–30, 1961
Poster
Offset on paper
20.3 × 26 cm

Entrance to
PAINTINGS & DRAWINGS BY YOKO ONO,
AG Gallery, New York, July 16–30, 1961
Photograph by George Maciunas

The First Solo Exhibition—at the AG Gallery in New York, 1961

Instruction Painting separates painting in two different functions: the instructions and the realizations. The work becomes a reality only when others realize the work. Instructions can be realized by different people in many different ways. This allows infinite transformation of the work that the artist himself cannot foresee, and brings the concept of 'time' into painting. It immediately eliminates the usual emphasis put on the original painting, and art comes down from the pedestal …

Instruction Painting makes it possible to explore the invisible, the world beyond the existing concept of time and space. And then, sometimes later, the instructions themselves disappear and are properly forgotten.

From *Yoko at Indica*, Indica Gallery, London, 1966

The exhibition entitled *Paintings & Drawings by Yoko Ono* opened in New York on July 16, 1961 at the AG Gallery, which George Maciunas and Almus Salcius had established on Madison Avenue. The expectations awakened by the conventional title were not fulfilled, as visitors saw neither paintings nor drawings, but rather a small number of calligraphic pieces (which Maciunas hoped to sell) along with a larger group of works bearing rather puzzling titles, such as *Painting to See in the Dark* and *Painting to Be Stepped On*. These works consisted of pieces of cloth dyed with Japanese ink and spread out on the floor or hung over windows and in corners, and thus bore no resemblance to conventional paintings, except perhaps in terms of format. In addition to the titles, Ono issued verbal statements indicating how viewers should approach the "paintings." The works would not be realized without the contributions of the viewers themselves, which involved either the performance of real acts—such as dripping water onto the painting in the case of *Waterdrop Painting*—or the exercise of imagination, as in the case of *Painting for the Wind*. The original works perhaps no longer exist; only the photographs taken by George Maciunas have survived as documentary records of this important exhibition.

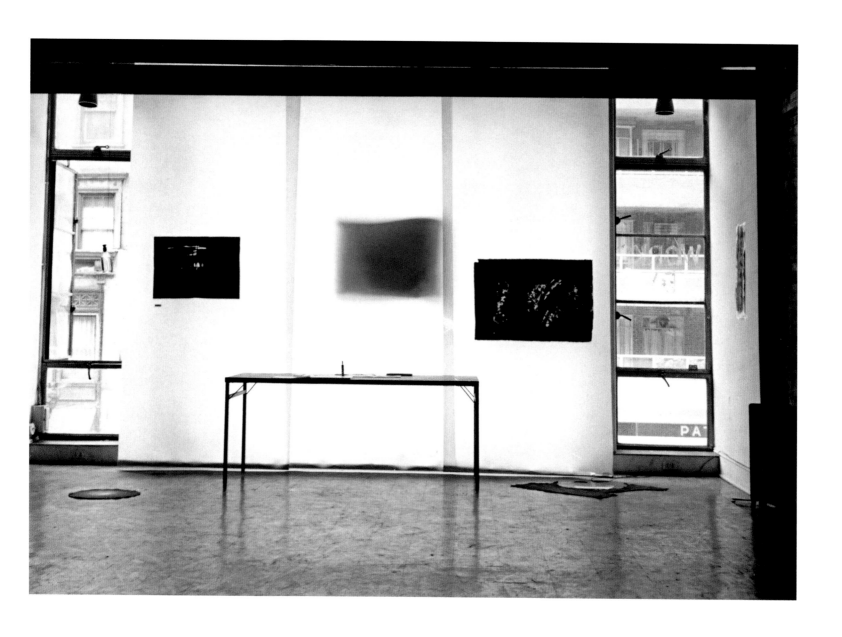

PAINTINGS & DRAWINGS BY YOKO ONO,
AG Gallery, New York, July 16–30, 1961,
Installation view with **WATERDROP PAINTING** (Version 1),
PAINTING TO BE STEPPED ON, and
PAINTING UNTIL IT BECOMES MARBLE on the table
Photograph by George Maciunas

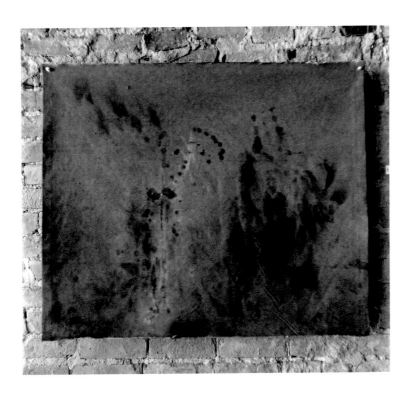

PAINTING TO SEE IN THE DARK
(Version 1), 1961
Installation photograph at the AG Gallery,
New York, July 1961
Photograph by George Maciunas

PAINTING TO SEE IN THE DARK
(Version 2), 1961
Installation photograph at the AG Gallery,
New York, July 1961
Photograph by George Maciunas

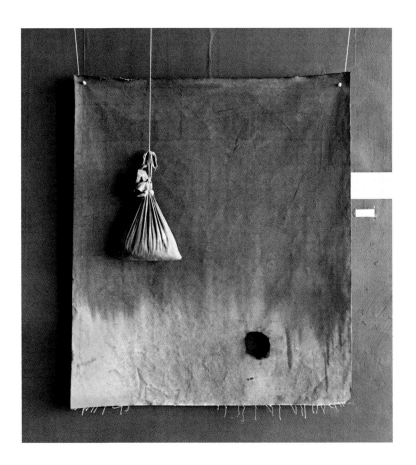

PAINTING FOR THE WIND, 1961
Installation photograph at the AG Gallery,
New York, July 1961
Photograph by George Maciunas

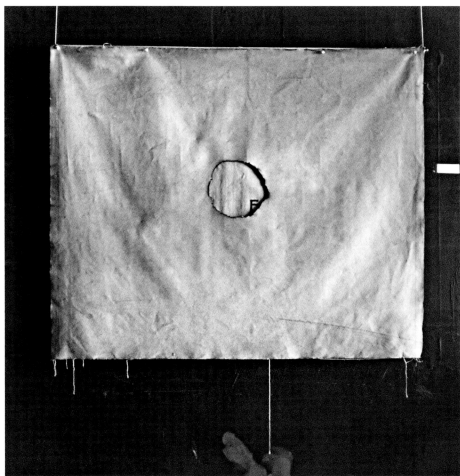

A PLUS B PAINTING, 1961
Installation photograph at the AG Gallery,
New York, July 1961
Photograph by George Maciunas

PAINTING TO BE STEPPED ON, 1961
Installation photograph at the AG Gallery,
New York, July 1961
Photograph by George Maciunas

WATERDROP PAINTING (Versions 1 and 2), 1961
Installation photograph at the AG Gallery,
New York, July 1961
Photograph by George Maciunas

WATERDROP PAINTING (Version 1), 1961
Installation photograph at the AG Gallery,
New York, July 1961
Photograph by George Maciunas

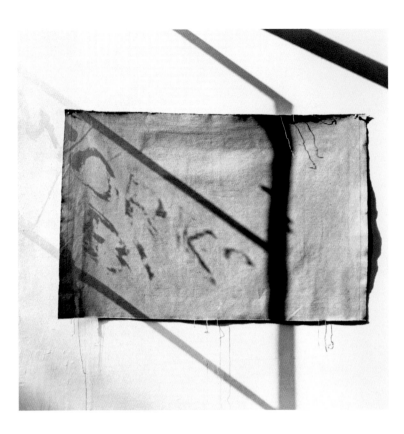

SHADOW PAINTING, 1961
Installation photograph at the AG Gallery,
New York, July 1961
Photograph by George Maciunas

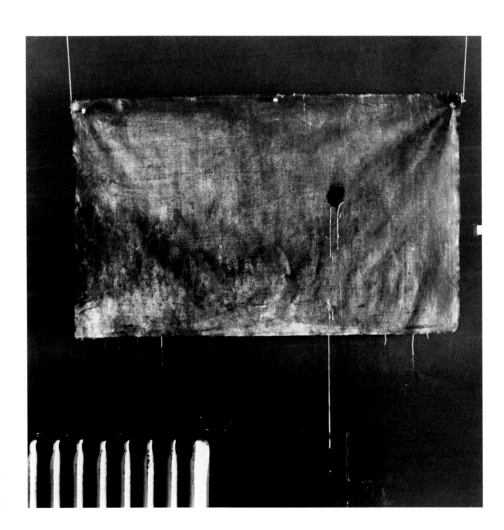

SMOKE PAINTING, 1961
Installation photograph at the AG Gallery,
New York, July 1961
Photograph by George Maciunas

TIME PAINTING, 1961
Installation photograph at the AG Gallery,
New York, July 1961
Photograph by George Maciunas

PAINTING TO LET THE EVENING LIGHT GO THROUGH, 1961
Installation photograph at the AG Gallery, New York, July 1961
Photograph by George Maciunas

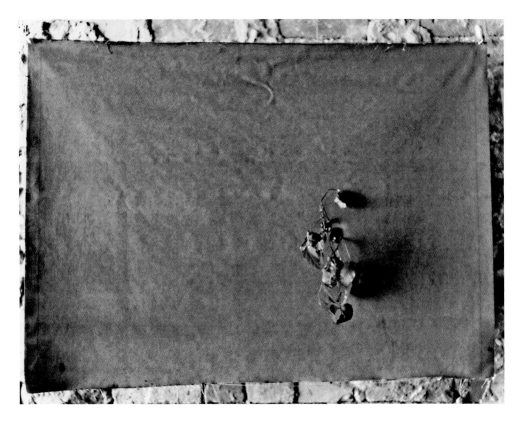

PAINTING IN THREE STANZAS, 1961
Installation photograph at the AG Gallery,
New York, July 1961
Photograph by George Maciunas

It ends when its covered with leaves,
It ends when the leaves wither,
It ends when it turns to ashes,
And a new vine will grow, —————————

PAINTING IN THREE STANZAS, 1961
Instruction
Ink on the back of an AG Gallery program
announcement card, installed next to the painting
at the AG Gallery, New York, July 1961
8.5 × 27 cm

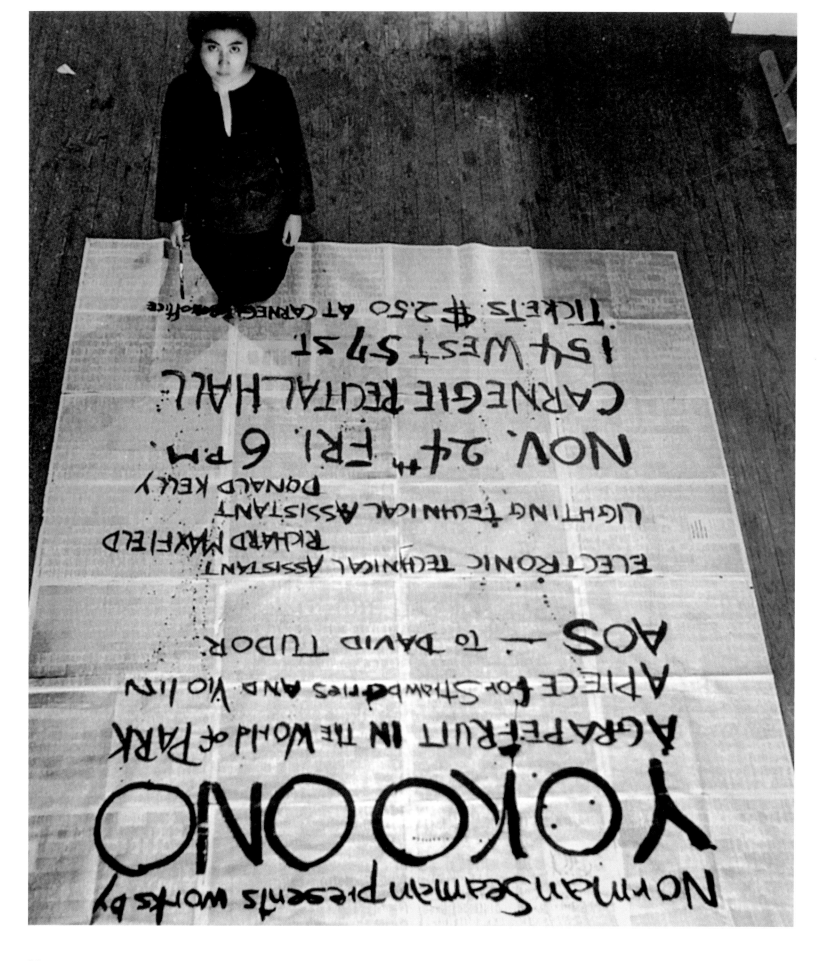

Bringing the World into Balance

Yoko Ono's Contribution to an Art of Self-reflection from 1955 to the Present

Ingrid Pfeiffer

EARTH PIECE

Listen to the sound of the earth turning.

1963 spring

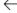

←

WORKS BY YOKO ONO
The artist with her poster for the concert,
Carnegie Recital Hall, 1961
Photograph by George Maciunas

The art of Yoko Ono is based above all on ideas and on verbal instructions for actions that are either utopian or actually performable. Occasionally, an idea is manifested in a two- or three-dimensional object, although much remains in a state of "almost" or "perhaps." These are poetic ideas, clever ideas, crazy ideas. Some betray a subtle sense of humor, while others are expressions of harsh social criticism motivated by political, feminist, and in most cases profoundly human concerns.

One of the difficulties involved in the attempt to do justice to Yoko Ono in an exhibition is that she is already a historical figure, a leading exponent of the socially critical art of the 1960s, and an artist who played an instrumental role in the origin and formal development of Performance and Conceptual Art. Yet Ono is also an artist of today and is therefore quite naturally discussed within the context of contemporary art as well. But without a look back, without an attempt to identify her position in the early years, it would not be clear just how early on and to what extent Ono's approach helped pave the way for later developments. Most of her recent works are also based on earlier concepts, and the artist is more than willing to produce new or updated versions of certain works again and again. That can be confusing at times and makes critical reception difficult.

This stance reflects a fundamental departure from the convention of the "work of art" created by the artist at a fixed point in time, with the object character of works, with their function as tradeable, saleable goods, and with their material value. Yoko Ono developed her concept of art during the era of the "dematerialization of the work of art,"[2] and it was part of the movement known as Fluxus. George Maciunas founded Fluxus in order to "... Purge the world of bourgeois sickness, "intellectual", professional & commercialized culture ... dead art, imitation, artificial art, abstract art, illusionistic art, mathematical art Promote a revolutionary flood and tide in art ... promote living art, anti-art, promote non art reality ..."[3]

Although Yoko Ono avoided an overly close affiliation with the group, she participated in many of the actions organized by George Maciunas, and her ideas exerted a significant influence on the basic working approach of this artist and those associated with him early on.[4] Even before Fluxus had articulated its own objectives, Ono was producing works that called for viewer participation and assigned viewers a role of unaccustomed importance. To that end, the artist employed all of the media at her disposal: paintings and objects with poetic and utopian instructions for completion, text, film, performance, conceptual photography, Mail Art, installations, works in public space, sound pieces, and multimedia actions involving combinations of several different media. This diversity of external form did not detract from the stringency of the dominant themes, which run like continuous threads through Ono's oeuvre. Her art is shaped by basic elements and fundamental issues of human existence.

___1 Unless otherwise stated, all of the instructions by Yoko Ono cited in this catalog are quoted from Yoko Ono, *Grapefruit* (Tokyo, 1964), n.p.
___2 Lucy Lippard, *Six Years: The Dematerialzation of the Art Object* (Berkeley, 1973).
___3 George Maciunas, "Fluxus Manifesto 1963," in: Tracy Warr (ed.), *The Artist's Body* (London, 2000), 201f.
___4 See the article by Jon Hendricks in this catalog.

Light and Shadow

One of Yoko Ono's earliest works is *Lighting Piece* (1955) (ills. pp. 36, 37), which she performed several times before it was photographed in Tokyo in 1962 and later produced as a film entitled *Film No. 1 (Match Piece)* (1966) (ill. p. 153). The simple sequence of events—the striking of a match, a sudden burst of flame, and its rapid burnout—contains all the elements of her art: simple actions that nevertheless convey a meditative aura. This work can also be interpreted in a figurative sense: the brevity of human existence that bursts forth, burns briefly, and is finally extinguished. References to both vanity symbolism in Western art and Asian sources are recognizable.

One of the earliest of Yoko Ono's works dealing with light and shadow is *Shadow Painting* (ill. p. 19), which she presented at her first solo exhibition, at George Maciunas's AG Gallery in New York in 1961. The painting is not complete without the effect of incoming light and the shadow pattern. In the later version of *Painting to Let the Evening Light Go Through* (ills. pp. 20, 74), a Plexiglas painting done in 1966, the image-bearing surface is rendered literally transparent as an opaque material vehicle of illusion or the vision of an illusionistic landscape—bringing the real landscape into the center of focus. In this case, Ono abandoned illusion in favor of contemplation and imagination. Both works are based on "instructions" and required the viewer to perform more or less concrete acts in order to make them complete.

Many of Ono's instructions are equally poetic and utopian:

LIGHT PIECE

Carry an empty bag.
Go to the top of the hill.
Pour all the light you can in it.
Go home when it is dark.
Hang the bag in the middle of your
room in place of a light bulb.

SUN PIECE

Watch the sun until it becomes square.

1963 autumn

1962 winter

The recurring theme of light is present even in Yoko Ono's more recent installations. Thus, for example, the ropes stretched from a considerable height in *Morning Beams / Riverbed* (1996) (ill. p. 145) symbolize rays of sunlight.

In *Shadow Piece,* a performance from 1963 (ill. p. 44), one person must bend over another in such a way that their two shadows become one. Yoko Ono realized an impressive performance of this work outdoors in London with twenty participants. In Kristine Stiles's description of it, the figures lying along the edge of the path called to mind the shadows of victims of Hiroshima.[5]

[5] Kristine Stiles, "Destruction in Art Symposium" (DIAS) 1966, in: Alexandra Munroe and Jon Hendricks (eds.), *Yes: Yoko Ono*, exh. cat. (New York, 2000), 168.
[6] Julia Peyton-Jones and Hans Ulrich Obrist, "Interview with Yoko Ono," in: *Yoko Ono. To the Light*, exh. cat. (London, 2012), 34.
[7] Ibid., 35.

water talk

you are water
I'm water
we're all water in different containers
that's why it's so easy to meet
someday we'll evaporate together

but even after the water's gone
we'll probably point out to the containers
and say, "that's me there, that one."
we're container minders

For Half-A-Wind Show, Lisson Gallery, London, 1967

AIR TALK

It's sad that the air is the only
thing we share.
No matter how close we get to each other,
there is always air between us.

It's also nice that we share the air.
No matter how far apart we are,
the air links us.

From Lisson Gallery brochure '67

Yoko Ono, *Grapefruit. A Book of Instructions
and Drawings,* New York, 1970, n.p.

___8 Yoko Ono, "Yoko Ono at Indica," quoted from Barbara Haskell and
John G. Hanhardt (eds.), *Yoko Ono. Arias and Objects,* exh. cat. London, 1996
(Salt Lake City, 1991), 14.
___9 For the full text, see p. 181 in this catalog.
___10 Quoted from Alexandra Munroe, "Spirit of YES. The Art and Life of
Yoko Ono," in: Munroe and Hendricks (eds.), 2000 (see footnote 5), p. 13.
___11 For the full text, see p. 179 in this catalog.
___12 Chrissie Iles, "Sky TV 1966," in Munroe/Hendricks (eds.), 2000
(see footnote 5), p. 226.
___13 Cf. Geoffrey Hendricks (ed.), *Critical Mass. Happenings, Fluxus,
Performance, Intermedia and Rutgers University 1958–1972,* exh. cat.,
Amherst, MA, pp. 64 ff.

Water and Fire

"Water is one of the most important constants in our lives. We are also carriers of water. 90% of us is water. In pagan terms, water is emotion, love."[6] And as Yoko Ono noted on a different occasion, "Water thinks, feels, and heals."[7]

The element of water is the essential component of *Waterdrop Painting* (1961) (ill. p. 18) and *Painting to Be Watered* (1962) (ill. p. 75), and it plays the leading role in *We Are All Water*, 2006 (ill. p. 80). The same is true of *Water Talk* (1967) (ill. left) and *Water Event*, which numerous friends and acquaintances of the artist were invited to participate in—in a joint artwork at her first museum exhibition at the Everson Museum in 1971 (ills. pp. 128, 129). Yoko Ono asked them to provide containers for water, into which she added water, at least conceptual water.

In these works, Yoko Ono describes water as an element of communication and unity shared by all individuals, and she is willing to accept unexpected outcomes. On that matter she writes: "[The instruction] allows infinite transformations of the work that the artist cannot foresee, and brings the concept of 'time' into painting."[8]

Fire appears in *Smoke Painting* (1961) (ill. p. 19). In this case, it not only alters and deforms the painting, but actually causes it to disappear while at the same time creating the work.

Air and Sky

Collecting air, capturing it as a precious commodity, and even offering it for sale are the themes of such poetic objects as the *Air Dispenser* group (1967) (ills. pp. 110, 111). On the subject of the sky, Yoko Ono wrote in 1971 that she "would like to see sky machines on every corner of the street instead of the coke machine. We need more skies than coke."[9]

The theme calls to mind Yves Klein. Lying on the beach at Nice at the age of eighteen in 1946, he signed the blue Mediterranean sky and declared it his first and greatest *Monochrome*. Yoko Ono describes a similar, albeit somewhat less carefree experience: During the war, after children in Tokyo had been evacuated to the countryside to escape bombing raids on the city, she gazed up at the sky with her younger brother through an opening in the roof and imagined that it contained food and other things that were lacking—an attempt on her part to survive a difficult period in her life.[10] In a biographical statement written in 1966, she notes: "early childhood: collected skies."[11] Scarcely any other word appears so often in her art—from *Painting to See the Skies* (1961), to *Glass Keys to Open the Skies* (1967) (ill. p. 131) and *Sky Machine* (1961) (ills. pp. 112, 113), to *Sky TV* (1966) (ills. pp. 126, 127), one of the very first video works ever produced. Ono did not focus the camera on people and their activities, as was ordinarily the case, but instead made the sky her leading performer. She enjoyed a close friendship with her Fluxus colleague and video artist Nam June Paik and also took part in performance festivals organized by Charlotte Moorman, who worked closely with Paik on numerous projects.[12] Besides Ono, other Fluxus artists, including Geoffrey Hendricks in particular, chose the sky as the central theme of their works in a literal or figurative sense.[13]

In Yoko Ono's *Sky Piece to Jesus Christ,* a performance realized in 1965 (ills. pp. 56, 191), members of an orchestra were wrapped in gauze bandages during a concert and thus forced to stop playing their instruments. The title is not a reference to Christian subjects but to John Cage, who had earned such a cult status in avant-garde music circles that he was celebrated "like Jesus." In Ono's eyes, the sky represents the epitome of freedom in contrast to the inner and outer bonds visualized in the performance.

Material and Immaterial

The art of Yoko Ono is founded not on principles of traditional visual art, but rather on those of music, language, and philosophy. That is surely one of the reasons why her works tend toward the ephemeral. Many of her early works from the 1960s in particular consist of industrial and found materials that had never been used in the production of works of art to any appreciable extent before, materials that were light and transparent, such as Plexiglas. Several objects, including *Pointedness* (1964–66) (ill. p. 78) and *Forget It* (1966) (ill. p. 72), seem almost completely immaterial. They are not objects or sculptures in the traditional sense, nor was the artist concerned with their physical properties per se—new, industrially manufactured, or transparent—but rather with the poetic, ambiguous, and even absurd interplay of print/instruction and object character. Only when the viewer carries out the mental process and accepts the meaning of the whole is the work as such complete.

In 1971, Yoko Ono wrote that "Artists must not create more objects, the world is full of everything it needs. I'm bored with artists who make big lumps of sculpture and occupy a big space with them and think they have done something *creative*"[14]

Destruction and Healing

The Destruction in Art Symposium (DIAS) organized by Gustav Metzger and others was held in London from August 21 to September 30, 1966. Yoko Ono was invited and presented several performances. At first glance, there appeared to be nothing destructive about them. Yet her *Whisper Piece*, based on an instruction written in 1961 and published in her seminal book *Grapefruit*, actually did relate to the theme of the symposium. The listeners in the audience were asked to whisper a certain word to the person sitting next to them, one after the other. As Ono pointed out, this ultimately led to the destruction of the original word and its meaning.[15] Later, Ono described the vehemence with which some of the other artists, all of whom were men whose all-too-obvious actions consisted of bashing pianos and automobiles, had appealed to the organizer to retract her invitation before the symposium began. Gustav Metzger refused to accede to their demand, however, and she remained on the program with her much quieter conceptual works.[16]

One author describes Yoko Ono's performance of *Kitchen Piece* (ill. right) in front of an audience in her loft on Chambers Street. She threw leftover food at a canvas attached to the wall, acting in an almost aggressive manner. Then she covered her hands with ink and rubbed everything away. Finally, the work evolved into another version of *Smoke Painting*, as the artist set it on fire. Some observers suggested that this impassioned action represented a reaction to the overpowering tradition of painting and the Action Painting of Jackson Pollock.[17]

The artist's objective is not to destroy, Yoko Ono contends, but to change the value of things.[18] *Mend Piece, 1966* (ill. p. 27) exhibits this dualism of destruction and healing. Viewers are instructed to mend a broken cup to convey the experience of mental healing.

Wall Piece for Orchestra (1962) contains the following instruction: "Hit a wall with your head." The most extreme instruction Yoko Ono ever formulated is surely *Blood Piece*: (ill. p. 27)

This act of artistic self-destruction "for the sake of the work" has numerous precedents and parallels, but is actually quite uncharacteristic for Yoko Ono.

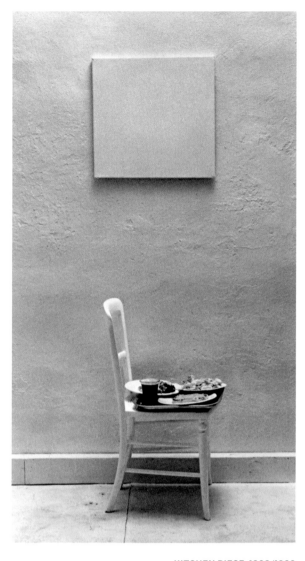

KITCHEN PIECE, 1960/1966
Installation view at Indica Gallery, London, 1966

___14 For the full text, see p. 187 in this catalog.
___15 Chrissie Iles, "Yoko Ono," in: *Have You Seen the Horizon Lately?*, exh. cat. (Oxford, 1997/98), 17.
___16 Hans Ulrich Obrist, "Early Morning. A conversation with Gustav Metzger. London, June 2009," in: Obrist (ed.), *Yoko Ono* (Cologne, 2009), 78 f.
___17 Joan Rothfuss, "Somewhere for the Dust to Cling. Yoko Ono's Paintings and Early Objects," in: Munroe and Hendricks (eds.), 2000 (see footnote 5), p. 94.
___18 For the full text, see p. 187 in this catalog.
___19 In her show at Indica Gallery in London in 1966, Yoko Ono presented an object with the instruction "Leave your fingernails to balance these scales." *Yoko at Indica*, exh. cat. (London 1966), n. p.
___20 *Have You Seen the Horizon Lately?* (see footnote 15), p. 1.

MEND PIECE, 1966/1968
Broken cup, tube of glue, ink on paper, ink on collaged box
Installations dimensions variable

BLOOD PIECE

Use your blood to paint.
Keep painting until you faint. (a)
Keep painting until you die. (b)

1960 spring

___21 Cf. Munroe 2000 (see footnote 10), pp. 87–91.
___22 Ulrich Bischoff (ed.), *John Cage* (Düsseldorf, 1992), 18.
___23 Ibid., 16.
___24 Ibid., 19.
___25 Munroe 2000 (see footnote 10), p. 54.
___26 See the article by Kerstin Skrobanek in this catalog.
___27 Ibid.
___28 Cf. Bruce Altshuler, "Instructions for a World of Stickiness: The Early Conceptual Work of Yoko Ono," in: Munroe and Hendricks 2000 (see footnote 5), p. 65.
___29 Roland Barthes, "Der Tod des Autors," in: Fotis Jannidis (ed.), *Texte zur Theorie der Autorschaft* (Stuttgart, 2000).

Balance

As early as 1958, Yoko Ono emphasized the goal of achieving a "balance of the mind" in her instruction for *Balance Piece* (ills. pp. 138, 139), which was realized as an installation in 1997, but also has forerunners in other versions.[19]

As Chrissie Iles has noted,[20] this quest for a balancing of oppositions and the attempt to bring them into equilibrium, this quest for unity, and the expression of the absence of that ideal state are elements shared by many of Yoko Ono's works. In pursuing that objective, she follows a basic principle of Zen Buddhism.[21] Her art is frequently described as more inner-directed than extroverted. Tranquillity and self-awareness, the process of coming to terms with one's own desires and actions are important aspects of most of her objects and instructions.

John Cage himself described silence as a "change of consciousness" and a process of "transformation," and his art as a process of "exploring the non-intentional." Thus he saw it as a progressively less goal-oriented activity, in which the "doing" is more important than the outcome. He described his use of the "random operations of the "I Ching" for his compositions. His discovery of the "non-intentional" gave his work a new direction.[22] Another source of inspiration for Cage was Marcel Duchamp, whom he had met in New York in 1942. While Duchamp may be regarded as a mediator between Europe and America, John Cage can be described as a mediator between East and West.[23] He was particularly fascinated by the writings of the Japanese Zen master Daisetz T. Suzuki, who introduced East-Asian philosophy to a circle composed primarily of New York intellectuals.[24] In contrast to Suzuki, Yoko Ono has drawn from a variety of philosophical approaches from her own cultural background and religion from early childhood on, while integrating such Western influences as the ideas of French Existentialism, which were widely disseminated in Japan during the postwar period.[25]

Language

Yoko Ono's instructions employ a broad range of linguistic resources—all of which tend toward Minimalist form, with emphasis on the sounds of words as well as their form and length. This clearly reveals her familiarity with Japanese *haiku*.[26] In terms of content, the artist frequently works with contradictions, secrecy, and ambiguity. In some cases, she alienates conventions of meaning. Thus her *Paintings*, for example, which she first exhibited in her studio as part of the Chambers Loft Series and later at the AG Gallery, have nothing to do with traditional concepts of painting. They are material offers by the artist, meant to be completed by viewers with the aid of the corresponding instructions. Ono's art has often been described as the art of communication. But some are just "mind pieces"—things to be completed in your mind.

It is interesting to note in this context that at her first exhibition at George Maciunas's AG Gallery in 1961, she issued oral instructions (beside some written instructions on the wall) about how her "paintings" (ills. pp. 16–21) were to be altered and completed. It was not until later that she published them as a collection in *Grapefruit*[27] (ill. p. 52). Such *Instructions* or *Scores* were also written in 1960 by the composer La Monte Young and later by the Fluxus artists George Brecht and Dick Higgins. Much like those of Yoko Ono, the performances of works by these artists leave considerable room for interpretation and are characterized by an "openness"[28] through which the artist's gesture is emphasized and the work becomes increasingly independent of the artist. The "death of the author" in literature diagnosed by Roland Barthes in 1968[29] came much earlier in the visual arts—and in the oeuvre of Yoko Ono.

For the most part, her instructions employ a very soft and poetic language. On the whole, her texts are linguistically more sophisticated and considerably more literary in form than most of the succinct descriptive instructions for everyday activities of her fellow artists, among them George Brecht, who writes "Exit" (*Word Event*, 1961), and Alison Knowles, who instructs viewers to "Make a salad" (*Proposition*, 1962). La Monte Young and Ono shared a fondness for the absurd and an occasionally reduced language. All things considered, however, the differences between his *Scores* and hers were greater than the features they had in common: coming in part from the world of jazz, La Monte Young was always happy to improvise and he cultivated a matter-of-fact language, whereas Ono—strongly influenced by her studies in philosophy—frequently used metaphors. Stylistically, her *Instructions* are more like poems and equal in their number and diversity any of those written by the other artists mentioned.

Music

Yoko Ono's parents were both talented musicians. Her father, Yeisuke Ono, originally wanted to become a classical pianist, but then opted for a career in banking for pragmatic reasons. Her mother, Isoko, played a number of traditional Japanese instruments and was familiar with numerous historical singing styles.[30] Ono recalls that she experienced an unusually demanding early musical education, as she not only took piano lessons, learned the principles of harmony, and performed simple exercises in composition and in singing German *lieder*, but was also, as a young child, encouraged to listen carefully to everyday sounds and transpose them into musical notation. According to her own statements, this training provided the foundation for her extraordinary attentiveness and sensitivity to sounds and anticipated in essence something of the musical theory and practice of a John Cage.[31]

Cage taught at Black Mountain College in the 1950s and processed various art forms in his pieces, including dance, moving images, and poetry and prose readings, as well as recorded music. Every kind of material, every musical and non-musical element was treated as sound. Traditional harmonies and compositions were abandoned in favor of open structures united not by the element of intrinsic logic but merely by their duration.[32]

Yoko Ono defined music in a more general way and expressed the goal of helping viewers/listeners or participants in her performances achieve a higher level of attention much more clearly. "I think of my music more as a (Zen) practice (*gyo*) than as music. The only sound that exists to me is the sound of my mind. My works are only to induce music of the mind in people.[33]

In her earliest performances in the New York avant-garde scene, Yoko Ono practiced a kind of talking chant and accompanied poetic texts she recited either alone or with others with sounds that exhibited her extraordinary vocal range. She developed some of these features from her early performances into her own inimitable vocal style as a professional musician with her own band in concert settings.[34] John Lennon referred to her "revolutionary ... sixteen-track voice."[35]

Performance

Several different terms were used to describe public appearances by artists in the years around 1960—"happening," "event," and "performance." The word "happening" originated with *18 Happenings in 6 Parts* (1959) by Allan Kaprow, who studied with John Cage. Yet a multimedia event that took place at Black Mountain College is regarded today as one of the forerunners of happenings.[36] In those early years, many artists initially referred to their public appearances with the traditional term "theater" (Claes Oldenburg: *Ray Gun Theater*;

Norman J. Seaman presents

Works by YOKO ONO

Program

A Grapefruit in the world of Park
A Piece for Strawberries and Violin
AOS - to David Tudor

Electronic Technical Assistant - Richard Maxfield

Voice and Instruments	Movements
Ayo	Patricia Brown
Edward Boagni	Richard Levine
George Brecht	Jerome Martin
Joseph Byrd	Yvonne Rainer
Philip Corner	and others
Terry Jennings	
Joe Kotzin	
Jackson Mac Low	
Jonas Mekas	
Yoko Ono	
Yvonne Rainer	
La Monte Young	

CARNEGIE RECITAL HALL
FRIDAY, NOVEMBER 24, 1961, at 6:00 O'clock

All seats $2.50 tax included available at Main Carnegie Hall box office. Mail orders to N. Seaman, 119 W. 57 St., N.Y.C.

Works by Yoko Ono, 1961
Program flyer
Carnegie Recital Hall, New York
Announcement for performance
November 24, 1961

___30 Robert Palmer, "On Thin Ice. The Music of Yoko Ono," in: *Onobox* (New York, 1992), n.p.
___31 Peyton-Jones/Obrist 2012 (see footnote 8), pp. 7 ff.
___32 Mariellen R. Sandford (ed.), *Happenings and Other Acts* (London, 1995), 33.
___33 Quoted from Haskell and Hanhardt 1991 (see footnote 8), p. 5.
___34 See the article by Jörg Heiser in this catalog.
___35 Quoted from Munroe 2000 (see footnote 10), p. 14.
___36 Wulf Herzogenrath, "John Cage: Musik – Kunst – Leben. Gedanken zu John Cage als bildender Künstler," in Herzogenrath/Barbara Nierhoff-Wielk. (eds.), *„John Cage und ...“ Bildender Künstler – Einflüsse, Anregungen* (Berlin, 2012), p. 37.

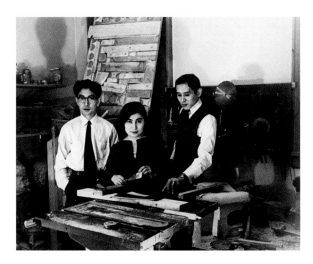

Toshi Ichiyanagi, Yoko Ono, and Toshirō Mayuzumi in Ono's loft, 112 Chambers Street, New York, 1961

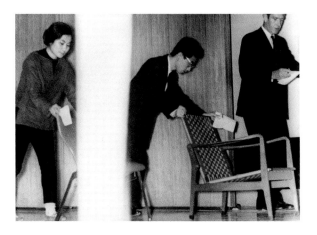

Yoko Ono performing at Sōgetsu Art Center with John Cage, David Tudor, and Toshirō Mayuzumi Tokyo, October 9, 1962

Yoko Ono performing in John Cage's *Music Walk*, Sōgetsu Art Center, Tokyo, October 9, 1962

Carolee Schneemann: *Kinetic Theater*).[37] George Maciunas defined the happening as "polymorphous … many things happen at the same time."[38] Happenings were often organized at specially selected sites, but rarely in traditional theaters or on other stages. Many people participated in these events, and there was a great deal of coming and going. Yoko Ono usually spoke of "events," a term that was roughly as general as "performance," but the latter word eventually won out.

Performative action, the corresponding directions, and performance-oriented thinking per se played equally important roles in Yoko Ono's works in the 1960s. Yet unlike many artists whose life's work is focused on the medium of performance, these presentations represented just one of many means of expression, albeit an important one, for Ono, and were never an end in themselves. Many artists of this period regarded the development of a radical new form for their art and the meaning that emerged from it as their most important contributions. But Ono was not one of them. She was not content with merely simulating aspects of everyday life, which was so important for Allan Kaprow, George Brecht, and others, for "Art is not merely a duplication of life. To assimilate art in life, is different from art duplicating life," as she pointed out in her important text entitled *To the Wesleyan People* in 1966.[39] Brecht's and Kaprow's happenings and events were rather more outer-directed and based upon Western art tradition,[40] whereas Ono was more concerned during this period with what she called "dealing with oneself."[41]

In one of her first public performances at the Village Gate Theater in New York in 1961, Yoko Ono combined visual images with sound and text. Her work entitled *A Grapefruit in the World of Park* contained a recording of mumbled words, raucous laughter, and atonal music.

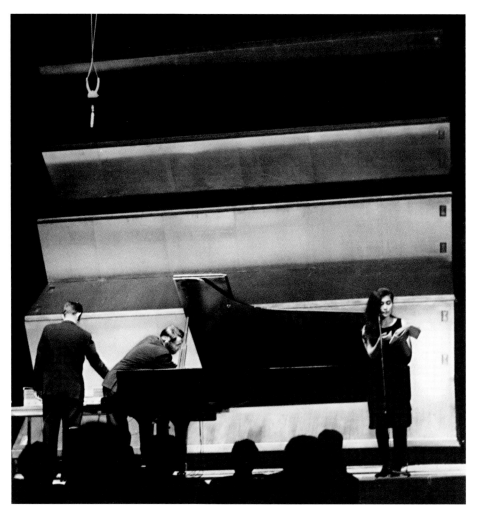

___37 Sandford 1995 (see footnote 32), p. 34.
___38 "Interview with George Maciunas by Larry Miller," March 24, 1978, quoted from Herzogenrath/Nierhoff-Wielk 2012 (see footnote 36), p. 110.
___39 For the full text, see p. 182 in this catalog.
___40 Have you see the horizon lately (see footnote 15), p. 12
___41 For the full text, see p. 181 in this catalog.

A performer spoke without emotion about peeling a grapefruit, squeezing lemons, and counting the hairs on the head of a dead child.[42] Strongly reminiscent of Dadaist and Surrealist presentations, this event used many mediums and was performed in a larger setting at Carnegie Recital Hall in 1961 along with *AOS— to David Tudor* by dancers and performers in the dark,[43] and *A Piece for Strawberries and Violin*. Ono recalled that these performances enabled her to begin "… to see things beyond the shapes … [to] hear the kind of sounds that you hear in silence … to feel the environment and tension and people's vibrations … the sound of fear and darkness … [and] of togetherness based on alienation."[44]

Even in her earliest performances, Yoko Ono was concerned above all with complex psychological interaction involving actors and spectators, with a process of heightened self-perception, and the development of an awareness of one's thoughts and feelings. These objectives can still be considered fundamental aspects of her working approach today.

Scholars have often referred to the 1970s as the "golden age" of performance art,[45] with such artists as Vito Acconci, Marina Abramović, and Hermann Nitsch. Yet although the period brought forth numerous performances that attracted unprecedented public attention, the pioneer phase of this art form must be dated to the early 1960s. Given how early and how frequently Yoko Ono presented performances and how intensely and formatively they influenced the eventual growth of performance art, it is all the more astonishing that her contributions to the development of performance art are completely neglected or mentioned only in passing in some surveys devoted to the history of this art form. A change in the critical reception of her art has been observable in recent years, however. While her performances were rarely cited or not mentioned at all during the 1980s and 1990s, none of the more recent publications fails to mention *Cut Piece* (ills. pp. 31, 38, 39, 191), for example. This reassessment is a by-product of the general recognition of the significance of this artist.

Yoko Ono performed *Cut Piece* herself at least six times, first in Kyoto in July 1964 and then in Tokyo the following August (ill. p. 38). The next performance took place at Carnegie Recital Hall in March 1965, and a film was made on that occasion. The fourth and fifth presentations of the performance were part of the above-mentioned Destruction in Art Symposium (DIAS) in London at the Africa Center in September 1966, and again in Paris in 2003.

Cut Piece has been interpreted in a number of ways since it was first performed. The artist commented on this herself in a 1974 interview:

> "Traditionally, the artist's ego is in the artist's work. In other words, the artist must give the artist's ego to the audience. I had always wanted to produce work without ego in it. I was thinking of this motif more and more and the result was *Cut Piece*. Instead of giving the audience what the artist chooses to give, the artist gives what the audience chooses to take. That is to say, you cut and take whatever part you want; that was my feeling about its purpose. I went onto the stage wearing the best suit I had. To think that it would be OK to use the cheapest clothes because it was going to be cut up anyway would be wrong; it's against my intentions. I was poor at that time, and it was hard. This event I repeated in several different places, and my wardrobe got smaller and smaller. However, when I sat on stage in front of the audience, I felt that this was my genuine contribution. This is how I really felt. The audience was quiet and still, and I felt that everyone was holding their breath. While I was doing it, I was staring into the room. I felt kind of like I was praying. I also felt that I was willingly sacrificing myself."[46]

Interestingly enough, the performance was conceived for both male and female artists from the outset, and was later performed by men several times.

BAG PIECE

After the curtain has gone up (or if there is no curtain, at a designated time after the announcer announced the piece) two performers walk onto the stage.

Performers may be two males, two females, or a mixed couple.

Performers carry a bag large enough for both to get inside of.

Bag made of non-transparent material.
Both performers get inside of bag.

Both remove all clothing while inside of bag.

Both put all clothing back on.

They come out of bag.

They exit with bag from stage.

Yoko Ono, BAG PIECE from STRIPTEASE SHOW (1966) [47]

___42 Quoted from Haskell and Hanhardt 1991 (see footnote 8), p. 4.
___43 A detailed description of the different scenes can be found in Munroe and Hendricks 2000 (see footnote 5), p. 274.
___44 Quoted from Kristine Stiles, "Unbosoming Lennon: The Politics of Yoko Ono's Experience," in: *Art Criticism*, vol. 7, no. 2 (1992): 27.
___45 RoseLee Goldberg, "Performance. The Golden Years," in: Gregory Battcock (ed.), *The Art of Performance. A Critical Anthology* (New York, 1984), 71 ff.
___46 First published in *Gazin Bungei Shunju* 1974, quoted from Kevin Concannon, "Yoko Ono's CUT PIECE: From Text to Performance and Back Again," July 22, 2010, http://imaginepeace.com/archives/2680 (retrieved September 25, 2012).
___47 Yoko Ono: Strip Tease Show, early spring New York 1966, self-published.

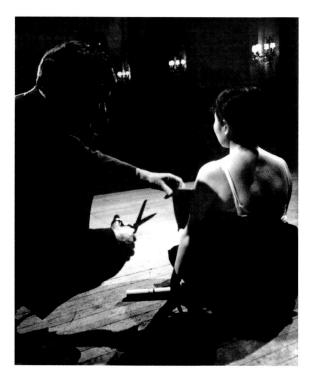

CUT PIECE, 1964
Performed by Yoko Ono,
Carnegie Recital Hall, New York, March 21, 1965

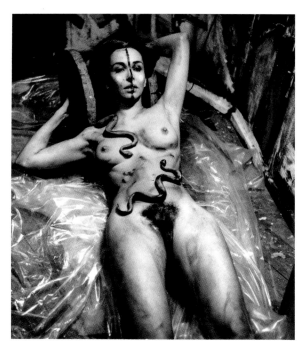

Carolee Schneemann performing her work
Eye Body: 36 Transformative Actions for camera, 1963

—48 Quoted from Haskell and Hanhardt (see footnote 8) 1991, p. 91.
—49 Cf. Warr 2000 (see footnote 3).
—50 RoseLee Goldberg, *Performance. Live Art since the 60s* (New York, 1998), 17.
—51 Ibid., 16.
—52 Some, like *Eye Body*, have been performed in private for the camera.

Like *Cut Piece*, *Bag Piece* (ills. pp. 8, 40–43, 54) is also a particularly complex performance by Yoko Ono, which she has presented many times, either alone or with others. In most cases, two people perform together in a kind of dark fabric bag—an action that leaves a great deal of room for the audience's imagination and which revolves above all around the external gestalt that gives form to the moving "thing" inside. Here, the artist addresses the theme of the hidden self that is scarcely recognizable from the outside. In the ways in which the external form changes, she merely suggests what things might look like on the inside.

Another remark made by Yoko Ono calls attention to the latent violence to which she was exposed in her first presentation of *Cut Piece*: "One person came on the stage ... He took the pair of scissors and made a motion to stab me. He raised his hand, with the scissors in it, and I thought he was going to stab me. But the hand was just raised there and was totally still. He was standing still ... with the scissors ... threatening me."[48] The threat of violence Ono describes here can be experienced by men as performers as well. The complexity of this work leaves ample room for differing interpretations. *Cut Piece* is a milestone in the history of performance art. Certainly, female artists are known to have presented performances that rely to a much greater extent on the body and the use of spectacular effects. Yet one can hardly ignore the profound impression that *Cut Piece* leaves in the mind even after fifty years, especially in view of the historical and sociopolitical situation in which the work is embedded.

Feminism and the Body

In all of the photographs of performances from the early 1960s in which Yoko Ono was involved—either with her first husband, Toshi Ichiyanagi (ill. p. 29), with La Monte Young in her loft on Chambers Street, or at the Sōgetsu Art Center in Tokyo (ills. pp. 56, 190)—she is the only woman in a group of men. She once played a dramatic role at a piano in a performance by John Cage, and on another occasion recited texts (ills. pp. 29, 165, 200). In a photo from another appearance in traditional Japanese dress and with her hair in a bun, she seems to be assisting John Cage, but actually is not. Ono had gained considerable respect quite early on and was defining and directing her own programs and exhibitions as early as 1960/61.

Until well into the early 1960s, Body Art,[49] a form of art in which the artist's body becomes a tool, was dominated by male artists. In the 1950s, Jackson Pollock acted in a highly expressive manner in creating his *Action Paintings*. In France, Yves Klein employed women's bodies as "living brushes" in his public performances with the *Anthropometries*. He also produced prints of his own body in blue ink, but only in a private setting. In 1955, the Japanese "Gutai" group presented performances in which the (male) artists rolled around in mud and made paintings with their feet in public appearances.[50] The Japanese artist Sho Kazakura went even further and posed as a living art object, standing nude and motionless at a Tokyo gallery in 1962 in his performance entitled *The Real Thing*.[51]

Performance is an art form that is traditionally associated with provocation and often aims to bring about change by visualizing social taboos and heightening awareness of them. In the early 1960s, female artists in particular began exhibiting themselves in public and using their own bodies as arguments, forms of expression, and even weapons. Worthy of particular note, apart from Yoko Ono, is Carolee Schneemann, a New York artist who developed a new kind of Body Art and feminist statement with such works as *Eye Body* in 1963 and *Meat Joy* in 1964.[52] Even more extreme in effect is Shigeko Kubota's *Vagina Painting* of 1965 (ill. p. 32), which also offered an ironic commentary on Jackson Pollock's painting.

Yoko Ono first performed *Cut Piece* in 1964, at a time when neither male and female artists nor the general public had become aware of feminist issues and long before any funda-

mental theories on the subject had been articulated—that did not come until the late 1960s and then to a greater extent in the 1970s. Yet as an artist, Ono was already well aware of the political dimensions of feminist concerns. The idea of a young woman allowing herself to be "undressed" with scissors by members of a presumably predominantly male audience in Japan in 1964 remains profoundly disturbing even today and reflects the radical character of Ono's art.

In 1971, Yoko Ono published an essay entitled "The Feminization of Society"[53] containing arguments that still seem quite current today. In 1969, she collaborated with John Lennon in writing the song *Woman Is the Nigger of the World*, a joint statement that rubbed salt in the wound, so to speak, in equally playful and dramatic fashion.[54]

Absurdity and Humor

"Humor is probably something the male species discovered through their own anatomy," wrote Yoko Ono in an article on the film *Bottoms* (ills. pp. 148, 150, 151) in 1966. Showing little respect, she scoffed at the male anatomy and "the delicate long thing hanging outside their bodies." Yet her text is meant to be taken seriously when she asks why men are constantly starting wars and spreading so much aggression and destruction in the world—instead of laughing at themselves.

Yoko Ono does not enjoy a reputation as a woman with a particularly strong sense of humor in either the art world or the music scene. She is seen smiling in only very few photographs from the 1960s, and her themes—self-reflection, peace, and feminism—seem too serious to have a comical side. Yet a closer examination reveals that her subtle, incisive, and occasionally acerbic humor plays an important role in many of her works.

In 1961, she wrote the following instruction:

LAUGH PIECE

Keep laughing a week.

1961 winter

In Zen Buddhism, a person who laughs is regarded as closest to the divine. "The essence of Zen that was connected with Cage and all of us was a sense of laughter," says Yoko Ono. "Laughter is God's language."[55] It has been noted repeatedly that Ono's instructions exhibit the absurd humor of *Kōan,* a practice of Zen monks in which students are motivated to contemplate and meditate by contradictory, paradoxical, and illogical statements and thus led along the way to enlightenment.

A strategy often employed by Yoko Ono is that of systematically undermining the expectations of concert-goers and exhibition visitors. In *Striptease for Three*, which was performed in Kyoto and Tokyo in 1964 and at Carnegie Recital Hall (ill. p. 33) in 1965, the stage is empty except for three chairs. The curtain is raised, but no one appears. Ono repeats a conversation she had about this piece with a monk who had seen her performance:

"I went to your concert," he said.

"Thank you. Did you like it?"

"Well, why did you have those three chairs on the stage and call it a striptease by three?"

"If it is a chair or stone or woman, it is the same thing, my monk."[56]

Shigeko Kubota performing her work *Vagina Painting*, at the PERPETUAL FLUXFEST, Filmmaker's Cinematheque, New York, July 4, 1965

[53] For the full text, see p. 185 in this catalog.
[54] See the article by Jörg Heiser in this catalog.
[55] Quoted from Munroe 2000 (see footnote 10), p. 17.
[56] For the full text, see p. 182 in this catalog.

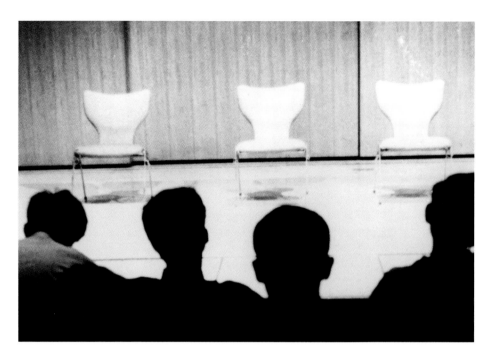

STRIPTEASE FOR THREE,
Performed during
Yoko Ono Farewell Concert: Striptease Show,
Sōgetsu Art Center, Tokyo, August 11, 1964

Chairs were also a favorite motif of James Lee Byars, an artist who was profoundly influenced by Japanese culture. In his actions performed in the later 1960s, they also serve as substitutes for human actors.[57]

A Contemporary Sexual Manual, an unrealized film script written in 1968,[58] is another typical Yoko Ono text. Here, too, she awakens certain expectations and disappoints them immediately. Instead of the "366 sexual positions" cited in the subtitle, the piece was to feature a couple with a four-year-old daughter sleeping peacefully and changing their positions 366 times during the night. "No critics, art dealers, or dogs allowed," writes Ono on one of the first pages of *Grapefruit*.[59] Her texts are full of such pointed, humorous jabs.

Works in Public Space and Mail Art

The works in which Yoko Ono made the most use of humor include her action entitled *Museum of Modern (F)art* of 1971 (ill. p. 34), in which she announced her solo exhibition at the MoMA in New York in an ad in *The Village Voice*. In the corresponding film, pedestrians are interviewed in the street and asked whether they have seen Ono's exhibition at the MoMA, to which most respond with something like "No, but I plan to." The subversive action continues: Ono describes the alleged opening of a container full of perfumed flies—with the same volume as her own body—in the middle of the MoMA garden. Photos in the corresponding book "document" all of the places in New York visited by the flies, including well-known art scene locations, such as Jasper Johns's studio on the Lower East Side. Here, Ono occupies, in a sense, the world's most famous museum—at which, until 1971, only very few solo exhibitions of the work of female artists, not to mention contemporary artists, had ever been presented—as well as "her" city of New York, making them both a backdrop for the presentation of her concepts.

The conceptual strategy of addressing a broad public through newspaper ads is evident in Yoko Ono's works as early as 1965. In the case of the "Draw Circle Event" and "Hole Events," she asked members of the audience to draw circles on paintings and to bore holes in various materials in the fictitious "IsReal Gallery." This use of ads for artistic purposes has been compared with actions by Dan Graham, although those did not take place until 1968.[60] Ono's idea of employing conventional advertising media, such as large billboards at Times Square,

___57 Klaus Ottmann and Max Hollein (eds.), *Leben, Liebe und Tod. Das Werk von James Lee Byars*, exh. cat. (Frankfurt/Ostfildern, 2004), 30.
___58 Munroe and Hendricks (eds.) 2000 (see footnote 5), p. 298.
___59 Yoko Ono 1964 (see footnote 1), n. p.
___60 Kevin Concannon, "Nothing IsReal: Yoko Ono's Advertising Art," in: Munroe and Hendricks 2000 (see footnote 5), pp. 177 ff.

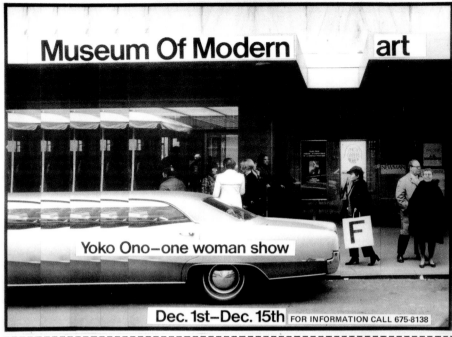

Museum Of Modern (F)art, 1971
Advertisement, published in *Village Voice*,
December 2, 1971
17 × 17.5 cm

as formats for artistic and publicity purposes, as in the case of *FLY* (ill. p. 35) and *War Is Over! If You Want It* (ills. pp. 194, 202), was widely echoed in works by Barbara Kruger and others.

The "Draw Circle Event" was also realized in a different form: as postcards sent to artists, composers, and other friends (ill. p. 102). The medium of Mail Art was used early by Ray Johnson and other artists as a means of disseminating their ideas.

The Exception

Yoko Ono had been accustomed to the role of an outsider since early childhood. Having lived in San Francisco as a child for several years, she was regarded as half-American in Japan, and in the US, where her family lived again after the war, children threw stones at her because of her Japanese origin. These early impressions, coupled with her linguistic, philosophical, and musical talents, imbued in her the fundamental feeling that she could never fit into conventional roles and would thus have to find her own way, far removed from the status of a Japanese woman from a family of high social standing to which she would have been entitled by birth. Her background in rebellion prepared Ono to assume a prominent role within a group of New York avant-garde artists and also to cope with the attacks of Beatles fans.

Yet Yoko Ono has not grown insensitive to the many attacks she has suffered. Even *Forget It,* a work realized in 1966 (ill. p. 72), refers to a needle that causes pain: "When someone says something hurtful, I always perceive it as a needle being stabbed into me."[61]

61 Quoted from Haskell and Hanhardt 1991 (see footnote 8), p. 55.

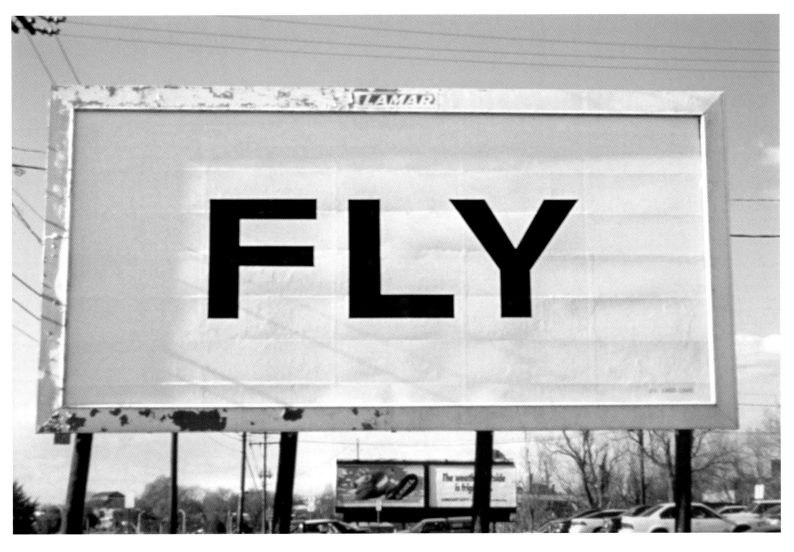

FLY, 1996
Billboard installed at one of five locations
in Richmond, Virginia,
in conjunction with an exhibition
at Anderson Gallery,
Virginia Commonwealth University,
Richmond, Virginia, 1996

A remark in reference to *Cut Piece* also points in the same direction: "People went on cutting the parts they do not like of me. Finally there was only the stone remained of me that was in me but they were still not satisfied and wanted to know what it's like in the stone."[62]

Yoko Ono has always been an exceptional individual—from her time as a female philosophy student at Gakushūin University in Tokyo in 1952 until today, with her actions in support of pacifism and environmental protection that go far beyond the context of art. During the past five decades, she has created an extraordinarily extensive body of work and given new meaning to the concept of avant-garde in music and art. Because she resists classification and definitive characterization, both as a person and an artist, critical reception is both difficult and mixed, yet that is precisely what sets her apart today and enables her to work as a "total artist" and serve as an inspiration for young artists. Ono fights for her ideals without a trace of cynicism and creates lasting symbols, as exemplified by the *Imagine Peace Tower* in Reykjavík (ill. p. 197), a column of light that is reignited every year.

Self-reflection remains her primary goal, and her works are meant to inspire us accordingly. She describes the process in the following words: "The natural state of life and mind is complexity. At this point, what art can offer (if it can at all—to me it seems) is an absence of complexity, a vacuum through which you are led to a state of complete relaxation of mind. After that you may return to complexity of life again, it may not be the same, or it may be, but that is your problem."[63]

___62 For the full text, see p. 179 in this catalog.
___63 For the full text, see p. 182 in this catalog.

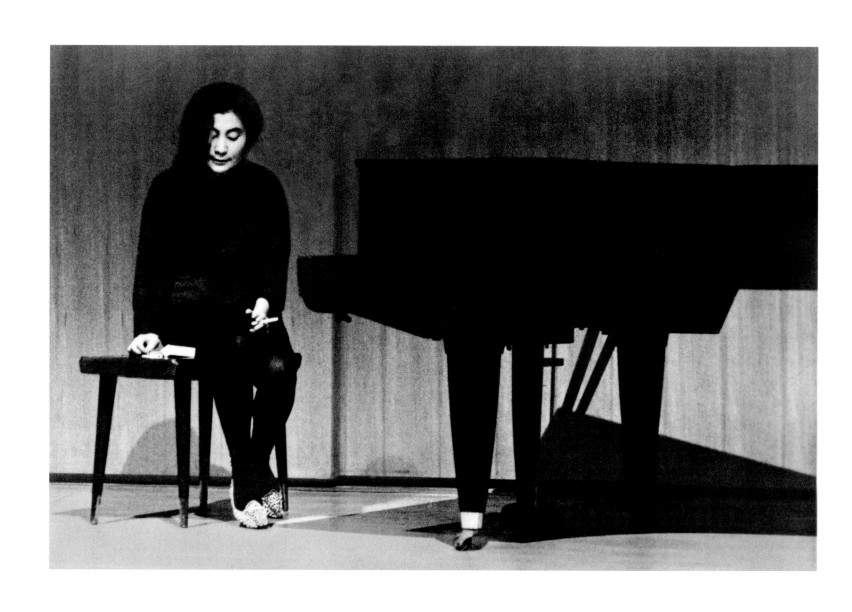

LIGHTING PIECE, 1955
Performed by Yoko Ono,
Sōgetsu Art Center, Tokyo, May 24, 1962

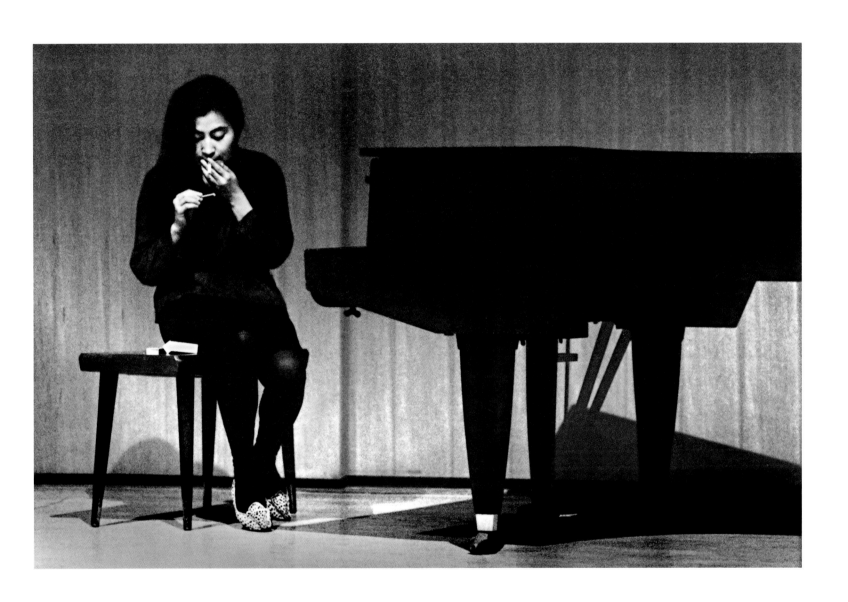

LIGHTING PIECE

Light a match and watch till it goes out.

1955 autumn

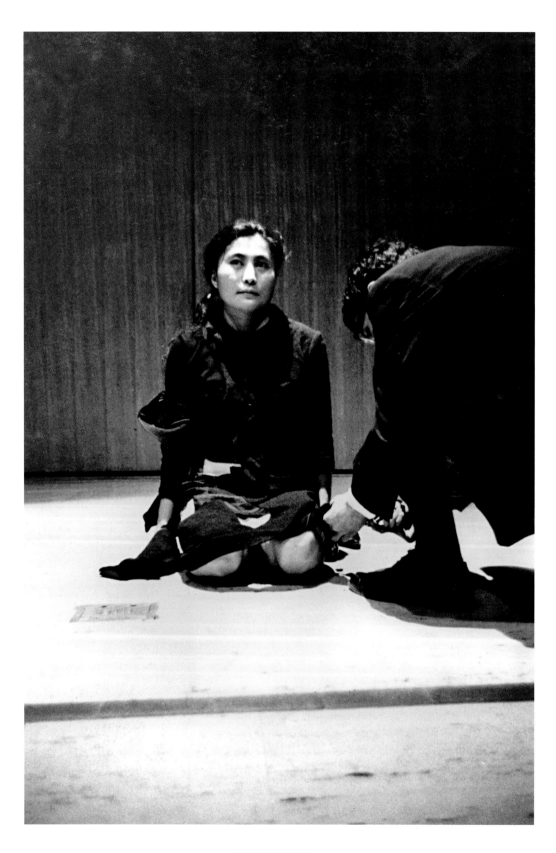

CUT PIECE, 1964
Performed by Yoko Ono,
Sōgetsu Art Center, Tokyo, August 11, 1964

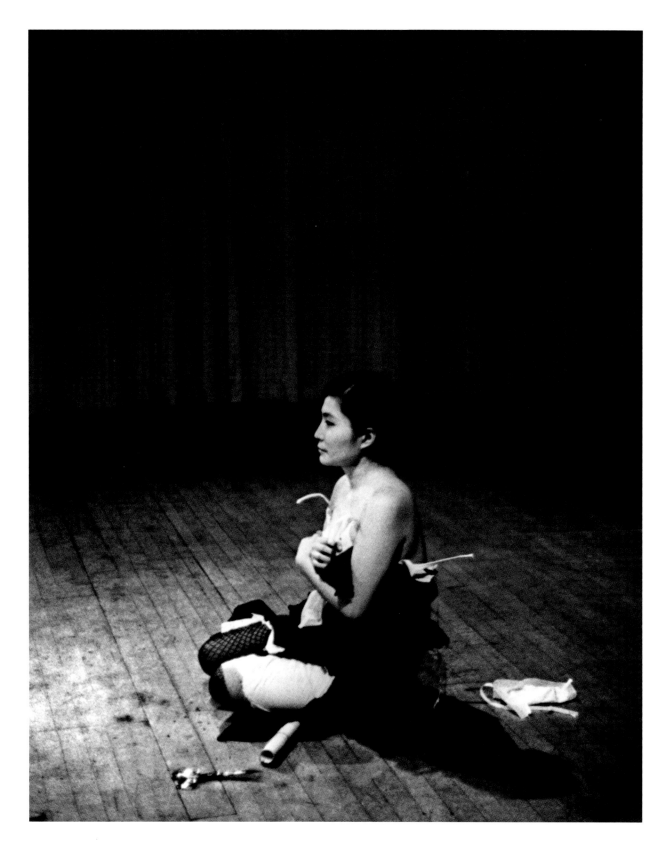

CUT PIECE, 1964
Performed by Yoko Ono,
Carnegie Recital Hall, New York, March 21, 1965

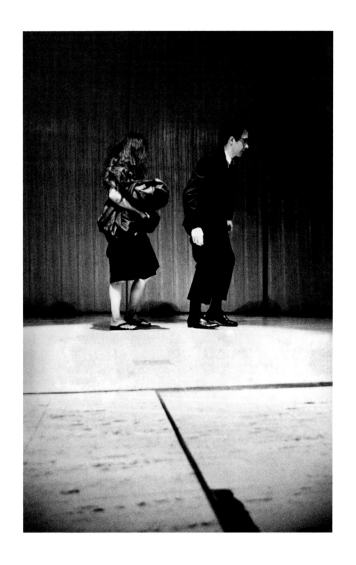
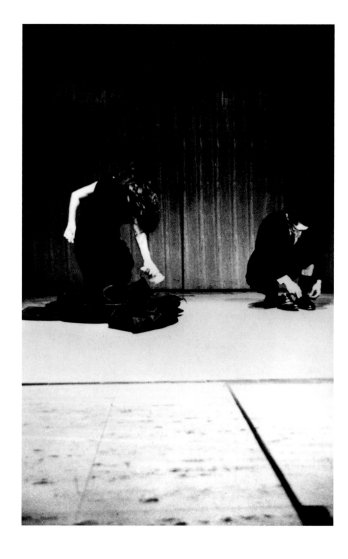

BAG PIECE, 1964
Performed by Yoko Ono and Anthony Cox,
Sōgetsu Art Center, Tokyo, August 11, 1964

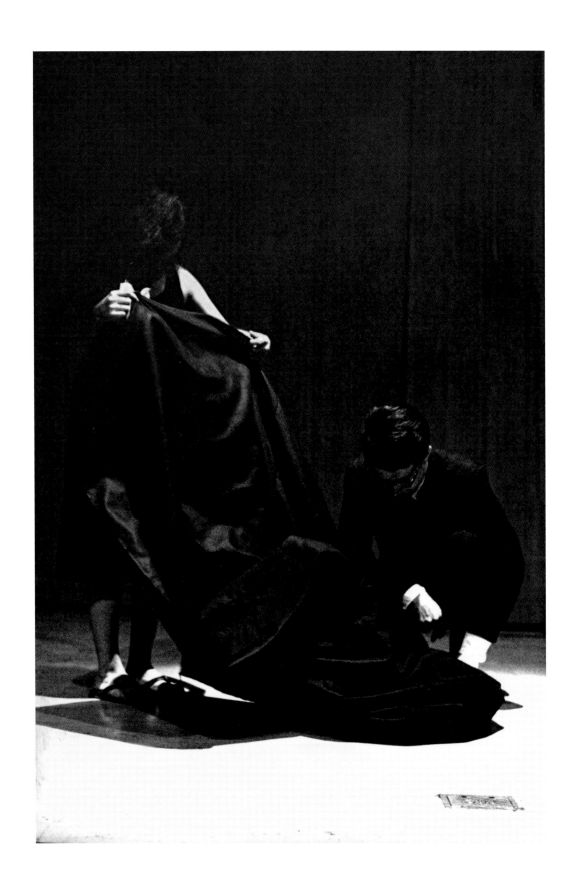

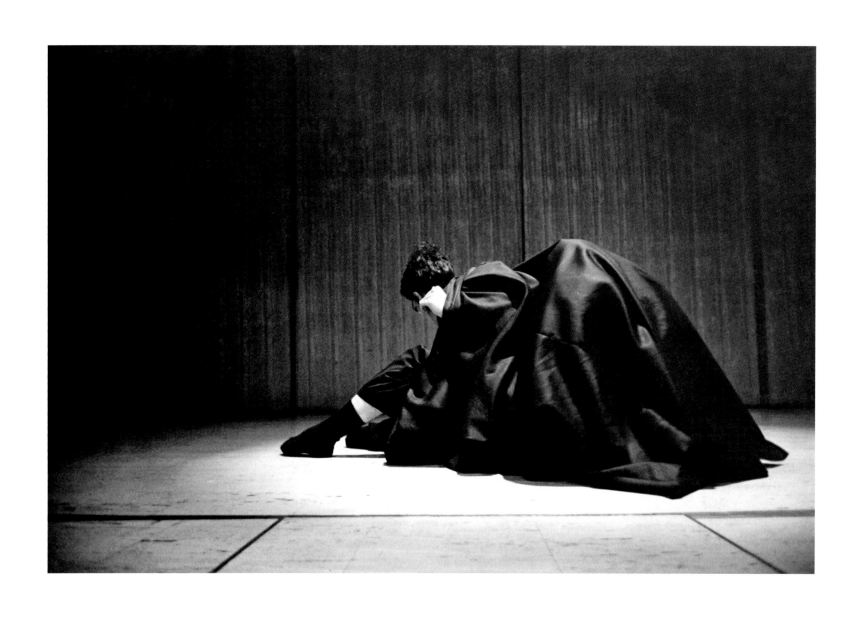

BAG PIECE, 1964
Performed by Yoko Ono and Anthony Cox,
Sōgetsu Art Center, Tokyo, August 11, 1964

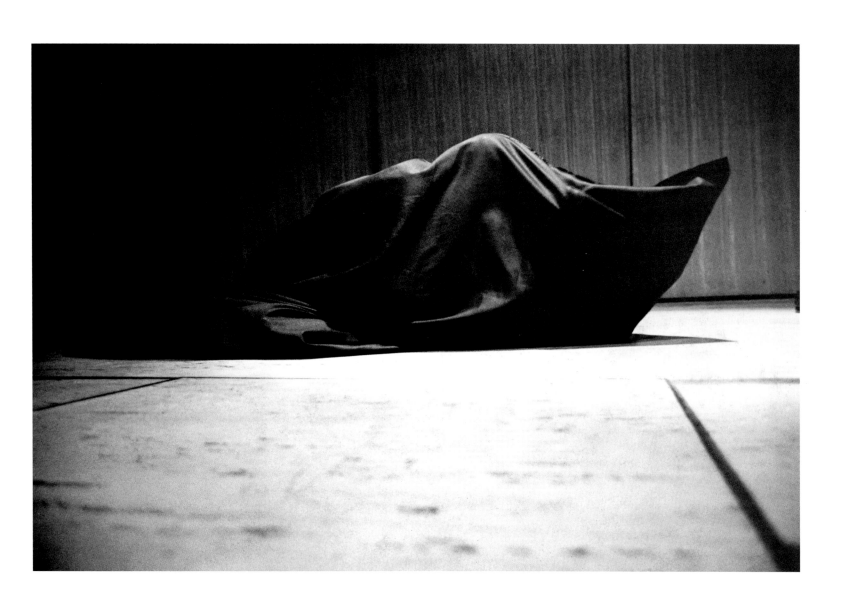

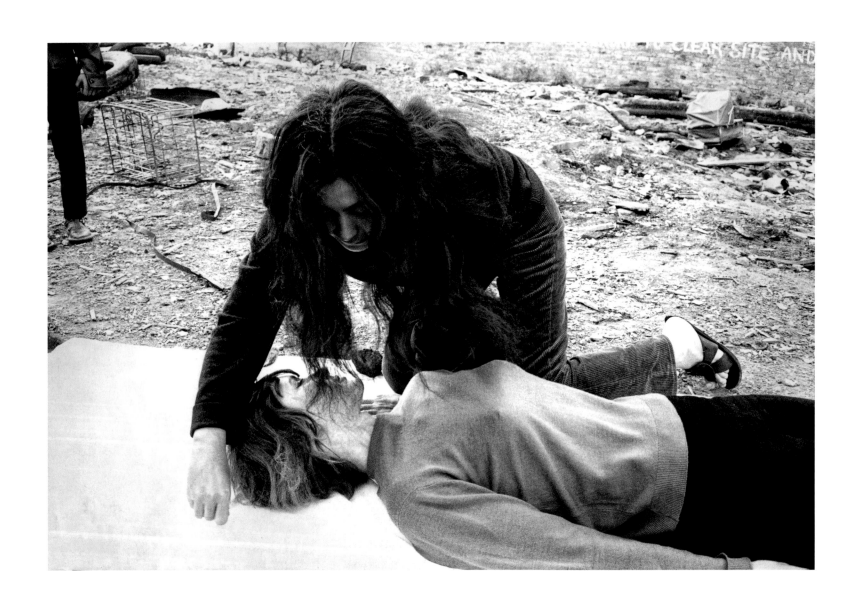

SHADOW PIECE, 1963
Performed by Yoko Ono and Barbara Steveni,
Destruction in Art Symposium (DIAS),
Notting Hill Gate, London, September 1966

SHADOW PIECE

Put your shadows together
until they become one.

1963

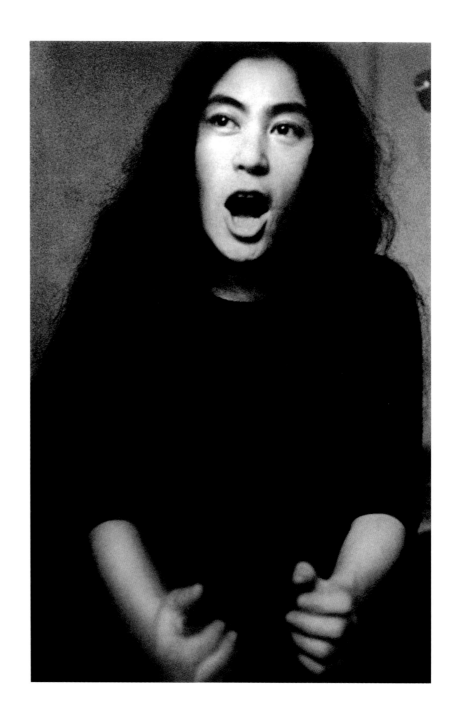

VOICE PIECE FOR SOPRANO
 to Simone Morris

Scream.
 1. against the wind
 2. against the wall
 3. against the sky

1961 autumn

VOICE PIECE FOR SOPRANO, 1961
Performed by Yoko Ono

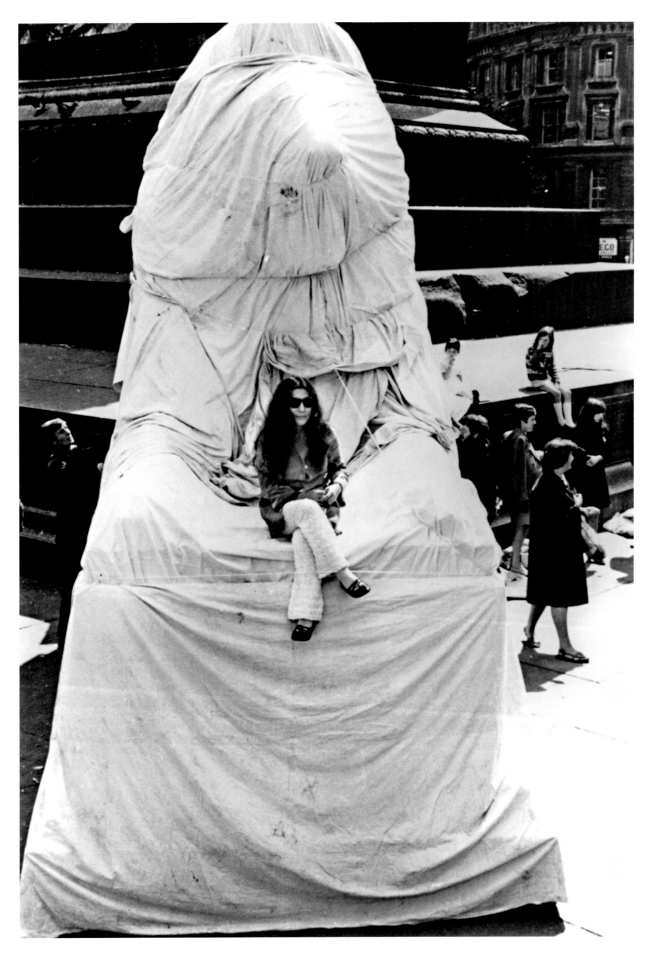

LION WRAPPING EVENT,
1967
Performed by Yoko Ono
and others,
Trafalgar Square, London,
August 3, 1967

LION WRAPPING EVENT,
Trafalgar Square, London, 1967

One of Yoko Ono's most spectacular actions took place at Trafalgar Square in London. A forerunner to the performance was her *Wrapped Chair*, an object she had exhibited at Indica Gallery in 1966. The first attempt, using paper, was stopped by the police. The second try, with cloth, was successful because the artist claimed that the wrapping of the lion would become part of a film. This performance was considered a political statement because she had covered up a typical symbol of the British Empire.

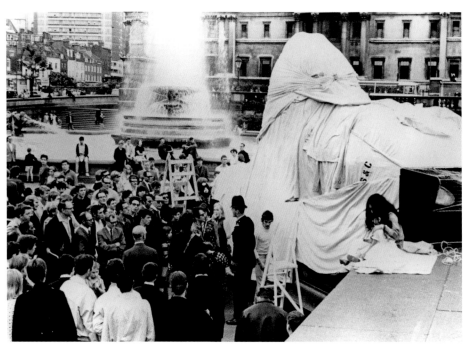

NOTICE

EVENT "9 a.m. to 11 a.m." took place on both May 24 and 31st, 1964.

(First day: NAIQUA GALLERY ROOF Second day: YOKO ONO ROOF) People were asked to wash their ears before they come.
Each person was asked to pay the price of "morning".

Also, other "mornigs" were on SALE, and they were sold as follows.

"morning" PRICE LIST

Jan. 1st, 1992	10 yen	✓✓
Feb. 3rd, 1987	15 yen	✓
Feb. 4th, 1991	25 yen	✓
Feb. 18th, 1991	50 25 yen	✓✓
March 3rd, 1991	50 yen	✓
May 24th 1992	50 yen	✓
June 11th, 1991	100 yen	✓✓✓ SOLD OUT
August 3rd, 1995	1000 yen	✓
September 8th, 1995	500 yen	✓✓
November 16th, 1996	500 yen	✓✓
December 27th, 1997	1000 yen	

"morning" byers

TAKEHISA KOSUGI
SHIGEKO KUBOTA
YASUNAO TONE
CHIEKO SHIOMI
GENPEI AKASEGAWA
SHO KAZAKURA
MASAO ADACHI
MIKIO DOI
MIYORI HAYASHI
SHOICHI TANIKAWA
TATSU IZUMI
NAM JUNE PAIK
DAN RICHTER
JED CURTIS
TONY COX

TYPES

A until sunrise
B after sunrise
C all morning

(THE PRICE does not change by the Type)

ONLY 33 "MORNINGS" WERE made.
SINCE 15 were sold as above,
I have 18 left.

When you order it by mail,
make clear what date and
type you want. Will send you
by mail. (include cash.)

you can see the sky through it.
Also, wear gloves when you handle
so you will not hurt your fingers.

Yoko Ono

Shibuya, Tokyo

cut
here

order sheet

name

address

Date of "MORNING"

TYPE of "MORNING"

OTHERS

MORNING PIECE (Notice), 1964
English version
Ink on paper
29.5 × 21 cm

MORNING PIECE, 1964 (performed in 1965)

Future beginnings are the theme of this performance, which Ono first staged in Japan in 1964. A list of participants (ill. left) shows how many of Japan's leading avant-garde artists performed in the piece. Ono sold future "mornings" in the form of labeled shards of glass, and varied the performance a year later in New York by also offering past mornings for sale. At this performance, dedicated to her friend George Maciunas, participants were invited to gather before sunrise on the roof of Ono's apartment at 87 Christopher Street. The words "Enter Sky" were posted on a door. Laid out on a table were pieces of glass rubbed smooth by sea waves, each one provided with a date in the past or the future.

→

MORNING PIECE (1964)
to George Maciunas, 1964/1965
Performed by Yoko Ono,
roof of 87 Christopher Street,
New York, September 1965
Photograph by Peter Moore

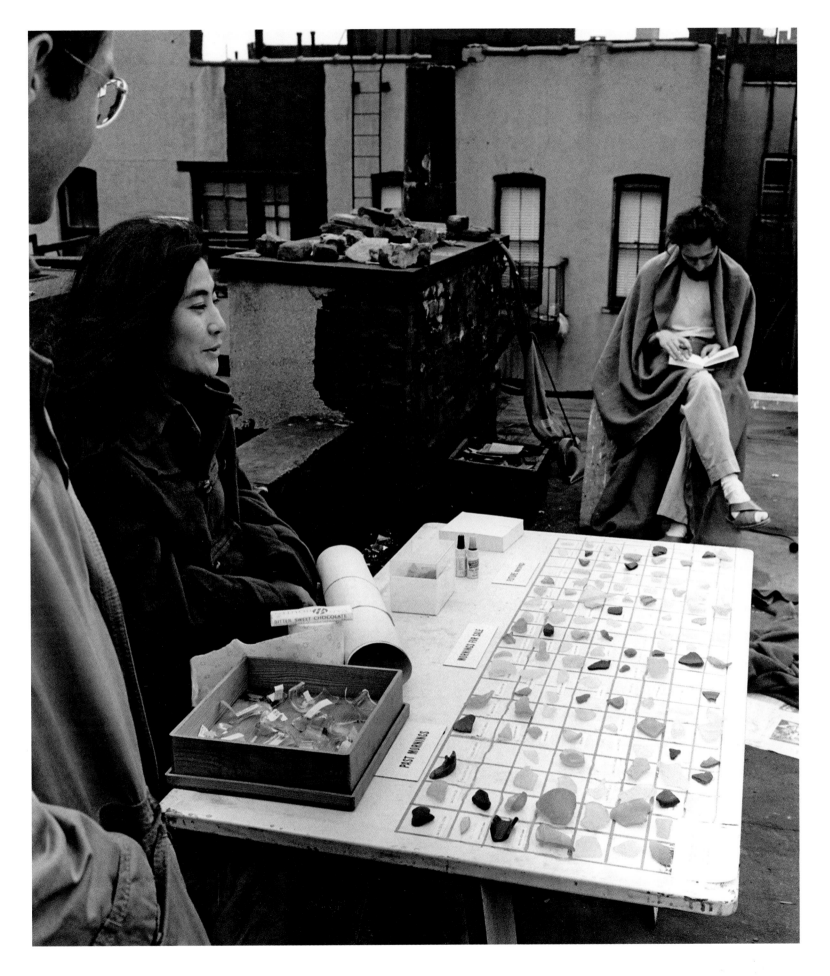

49

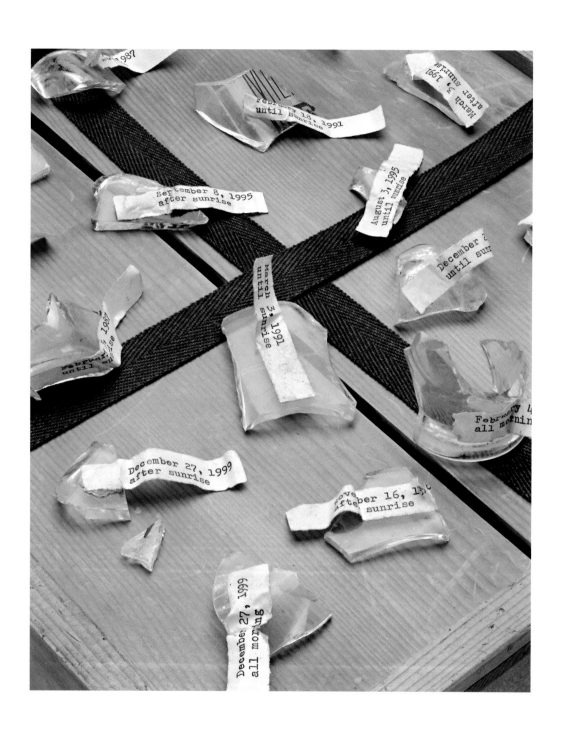

MORNING PIECE (Detail), 1964
Shards of glass, typewriting on paper,
glue, wooden box, cloth strapping

MORNING PIECE (Box), 1964
Shards of glass, typewriting on paper,
glue, wooden box, cloth strapping
Box: 16 × 34.75 × 34.75 cm

June 11, 1998
March 3, 1990
Feb. 3, 1987
Feb. 18, 1987
Sept 13, 1985

Types of mornings
A: all morning
B: until dawn
C: after dawn

Mornings
for
Sale

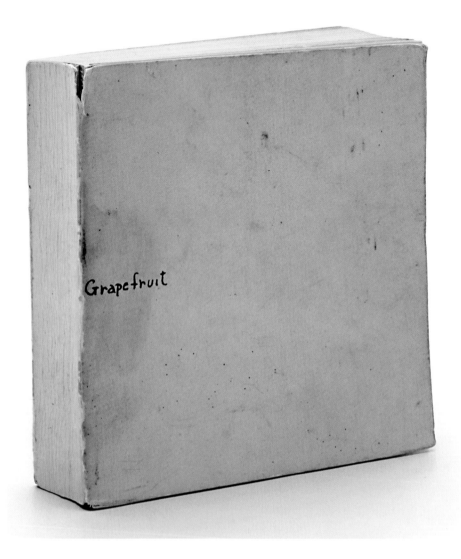

GRAPEFRUIT, 1964
Published by Wunternaum
Press, Tokyo
July 4, 1964
14 × 14 × 3.2 cm

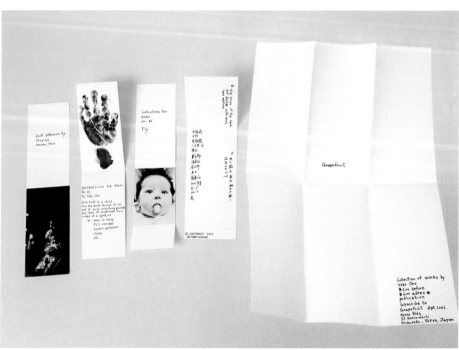

Announcement for **GRAPEFRUIT**, 1964
Envelope, four offset sheets
Various sizes

Yoko Ono and Fluxus

Jon Hendricks

Dear George:

Most of my pieces are meant to be spread by word of mouth, therefore, do not have scores. This means is very important since the gradual change which occurs in the piece by word spreading is also part of the piece. Paik suggested that I send you a piece he likes which is one of the word spreading pieces. I have thought over quite a bit about it, since he was right to suggest the piece because it is also one of the very few pieces that is easy to perform. But I think I will not change my mind about maintaining the piece as a word-spread piece........*

*word-spread pieces are not included in this text

Yoko Ono, *Grapefruit*, Tokyo 1964, n.p.

Yoko Ono's simple 1963 letter to George Maciunas, the founder of Fluxus, gives only a hint of the enormous impact that she had on the movement, and the deep relationship that they had. Ono's influence on Maciunas began when they met during the winter of 1960–61 during visits to her top floor Chambers Street loft, just a few blocks away from City Hall, the police headquarters, and the New York City, State, and Federal courts. It was a seedy part of town, almost completely empty at night, except for traffic heading toward or from the Brooklyn Bridge, and various down-and-out souls congregating at the bars, and the single-room occupancy hotel at the corner of Chambers and West Broadway—a hotel that Abraham Lincoln once stayed in. Few artists lived in the area, although Rauschenberg, Johns, and Twombly had lofts some distance away near the East River.

In the autumn of 1960, Yoko Ono decided to find a space where she could work freely with the radical ideas brewing in her mind, a space that could be shared with friends who she felt were moving in some related ways to her own radicality. She invited La Monte Young to join her in organizing a series of concerts, lectures, and events in her loft.

Yoko Ono performed in other artists' pieces and installed her own conceptual and participation artworks in the loft, showing *Smoke Painting*, *Add Color Painting*, *Painting to Be Stepped On*, *Shadow Painting*, *Kitchen Piece*, among other works. It was here that George Maciunas met Ono and first became aware of her conceptual work and the idea of presenting very new work by other artists in such a setting.

Maciunas had an ability to pick up quickly on good ideas and by March 14, 1961, had started his own series at his AG Gallery, 925 Madison Avenue, far uptown from Chambers Street, in one of the most fashionable locations in the city, studded with commercial art galleries and shops and not far from the Metropolitan Museum of Art, the Frick, and the Guggenheim Museum. But the AG was anything but commercial or fashionable; Maciunas had gotten a good deal on the space and renovated it himself with the help of a few friends, stripping the plaster down to bare brick walls and adding a simple shoji-like screen to diffuse light coming in from the wall of windows in the front. Together with Almus Salcius, he had earlier planned a series of concerts of Baroque music, mediocre abstract art shows, together with some poetry readings and film screenings. All this changed on meeting Yoko Ono and becoming acquainted with La Monte Young and the other Chambers Street artists.

In July 1961, George Maciunas invited Yoko Ono to exhibit her conceptual paintings at his AG Gallery, and although he believed strongly in these works, he felt there was little chance of selling any, so he asked her to also do some calligraphy to show as well, which he thought he could sell. The conceptual works were priced at around $300 and the calligraphy, considerably less. Maciunas photographed each of the conceptual works in the exhibition, showing great respect for the pieces. None sold.

During that same month of July 1961, George Maciunas simultaneously held four events at the AG Gallery: *Works of La Monte Young* (July 2 and 9); *Works of Henry Flynt* (July 15 and 16); *Works of Walter De Maria* (July 23); *Nothing* by Ray Johnson (July 30). Few people came to Yoko Ono's show and there were many opportunities to talk. Maciunas was deeply involved in plans to leave the gallery, because he couldn't pay the rent or utilities, and plotting plans to bring all of the new art and art forms together into one group—one movement.

He discussed these plans with Ono and asked if she could think of a name for the movement. She couldn't, and told Maciunas she wasn't very interested in groups anyway. The next day, he came to the gallery very excited. He had thought of the name, "FLUXUS."

That autumn, Maciunas helped Ono to prepare her concert at Carnegie Recital Hall, including making a series of photographs of her with her large, hand-painted poster, with the idea of using the photographs to make flyers for the concert, although they were not used.

Carnegie Recital Hall was the traditional venue for young musicians to make their debuts, pianists to perform Chopin, violinists to perform Paganini. Yoko Ono did something very different. There was darkness, vocal work that would later become some of Ono's defining sound, dance, amplified sound of a toilet being flushed, sounds recorded then played back forming layers of sound, and poetry that was not poetry. The performers included the preeminent New York avant-garde.

Maciunas departed for Wiesbaden just after the concert in the first days of December. Yoko Ono left for Tokyo in the first days of February 1962.

On his return to Europe in December 1962, George Maciunas brought with him detailed plans for Fluxus, outlines for a series of as many as 13 Fluxus concerts of very new music, and year-boxes containing radical art and its antecedents. Maciunas characterized the contents of the year-boxes (and by extension, the movement) as:

Anti art	Automatism	Happenings	Plastic arts
Concept art	Bruitisme	Theatre	Music
Indeterminancy	Concretism	Prose	Dance
Dada	Lettrism	Poetry	Cinema
Brutalism	Nihilism	Philosophy	

Maciunas was very taken with Ono's idea of using traditional spaces for revolutionary performances. The first large series of Fluxus concerts was held in an auditorium of the Museum Wiesbaden nearly a year later in September 1962, and when Fluxus returned to New York in 1964 and 1965, Maciunas rented Carnegie Recital Hall for both large Fluxus concerts, echoing Ono's earlier newly plowed furrows.

As Fluxus evolved those first years, Maciunas's plans included publishing collected scores by the major Fluxus artists: George Brecht, Dick Higgins, Yoko Ono, Nam June Paik, Benjamin Patterson, Tomas Schmit, Mieko Shiomi, Ben Vautier, Robert Watts, Emmett Williams, La Monte Young, and others. Unfortunately, Maciunas's intentions were greater than his means; he was financing all of the Fluxus events and publications himself, and basically had no income—except for occasional design work and failed schemes to distribute gourmet foods, or organize three-month long tours of Europe—having lost his job at the US military base near Wiesbaden because of ill health and left-leaning politics.

By 1964, Maciunas had been able to publish George Brecht's *Water Yam*, La Monte Young's *Compositions 1961*, Robert Watts's *Events*, Takahisa Kosugi's *Events*, Mieko Shiomi's *Events & Games*, but not Higgins's *Jefferson's Birthday* (later brought out by Higgins's Something Else Press as *Jefferson's Birthday/Postface*), Ben Vautier's *Complete Works*, which he self-published as *BEN DIEU,* nor Yoko Ono's *Complete Works*, although she had mailed the typescript and the letter about the work to Maciunas by the end of 1963.

When Maciunas failed to bring the book out, Yoko Ono published it herself as the Wunternaum Press in Tokyo on July 4, 1964. The book was entitled *Grapefruit*, printed by offset from Ono's hand-typed *Scores* primarily in English, but some also in Japanese (ill. p. 52). The book is square, printed black on white paper with thick paper covers and the handwritten word "Grapefruit" printed on the cover. Five hundred copies were printed.

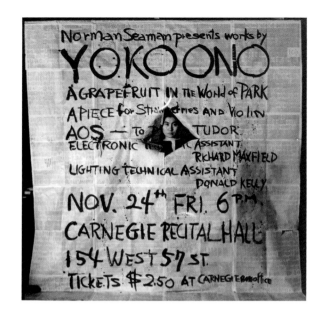

WORKS BY YOKO ONO
The artist with her poster for the concert,
Carnegie Recital Hall, 1961
Photograph by George Maciunas

BAG PIECE, 1964
Performed by Yoko Ono at PERPETUAL FLUXFEST
Presents Yoko Ono,
Filmmaker's Cinematheque, New York, June 27, 1965

Yoko Ono returned to New York City from Tokyo in late 1964, and immediately became engaged once again in the art life of the city, sending out a mail piece, *Draw Circle Event*, to her friends, preparing two solo concerts, and preparing for the large Fluxus concert, all to take place in 1965. In 1964 in Kyoto and Tokyo, she had performed *Cut Piece* as part of her concerts there, and back in New York on March 21, 1965, she gave a solo concert, *New Works of Yoko Ono*, at Carnegie Recital Hall, including *Cut Piece*, which was filmed by the Maysles Brothers. On October 3, she gave another solo concert at the Filmmaker's Cinematheque, 85 East 4th Street, New York City, as part of *Perpetual Fluxfest*. This concert included *Bag Piece*, which Maciunas photographed, preserving starkly beautiful images of biomorphous shapes undulating on stage.

Earlier, in the spring of 1965, Yoko Ono wrote *Pieces Dedicated to George Maciunas, The Phantom Architect*, dedicating this germinal group of conceptual architectural works that had been brewing in Ono's mind for more than fifteen years to the founder of Fluxus (ills. pp. 120, 121). These works have formed the foundation for a number of her subsequent works, such as *EnTrance*, *Imagine Peace Tower*, and *Amaze*.

While still in Tokyo in 1964, Yoko Ono did a street event, with her husband, selling future mornings, called *Morning Piece*, and also selling copies of *Grapefruit*.

On returning to New York, Ono again organized *Morning Piece*, this time dedicated to George Maciunas, who was perpetually without money; Ono suggested the work to Maciunas as a way of getting easy money (few mornings were sold). The event took place on the roof of the tenement at 87 Christopher Street, where she lived, in September of 1965 (ills. pp. 48–51). A photograph of the event by Peter Moore shows Yoko Ono in front of her trays of beach glass with dates and times of future mornings written on small pieces of paper; Tony Cox and Jeff Perkins huddled against the cold nearby. No other figures are visible in the photograph.

This simple conceptual event took place just days before the grand Fluxus concert that Maciunas produced at Carnegie Recital Hall, which helped to define the range for Fluxus events.

On September 25, 1965, a large number of Fluxus artists performed some of their works at The 83rd Fluxus Concert: Fluxorchestra at Carnegie Hall, organized by George

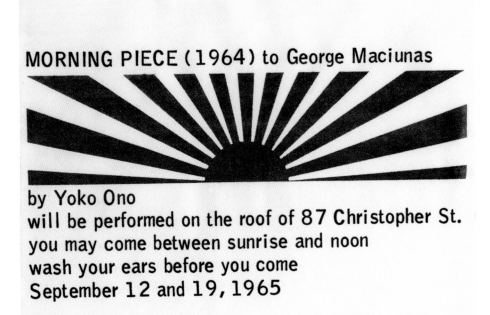

MORNING PIECE (1964) to George Maciunas, 1965
Flyer
Offset print on paper
21.6 × 27.9 cm

55

Maciunas at Carnegie Recital Hall. The conductor was La Monte Young. Yoko Ono's works were *4 Pieces for Orchestra to La Monte Young: Tear, Rub, Peel, Peal, Take Off*, and *Sky Piece to Jesus Christ*, a piece in which a group of chamber musicians plays a traditional classical work and continues to play as another group of performers bandage each member of the orchestra with hospital gauze until they are immobile and have to be carried off the stage. The subtitle "Jesus Christ" is, in a way, an homage to John Cage, who was called "JC" or, behind his back, "Jesus Christ." The work is also a declaration of liberation and separation from the powerful figure, healing but immobilizing the past so that art and music could get

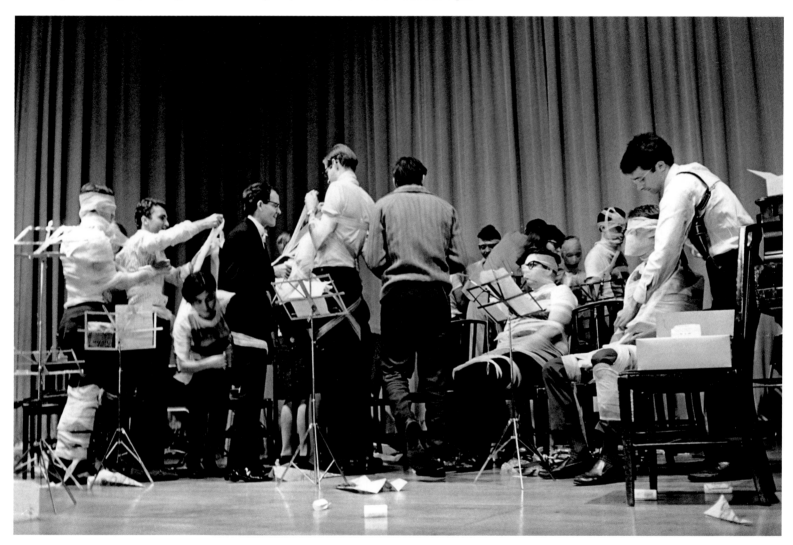

on with it, although Yoko Ono had clearly never been dominated by Cage's music and was a colleague and friend, never a disciple. As Nam June Paik had done five years earlier, when he performed *Etude for Piano Forte* by cutting off Cage's necktie, Ono's work was a public declaration of independence.

 During the winter of 1965–66, Yoko Ono composed the first version of her *13 Days Do-It-Yourself Dance Festival* and gave it to George Maciunas to publish in *Fluxus Newspaper, No. 7: 3 newspaper eVenTs for the pRicE of $1*, asking Maciunas to change what he wanted. He slightly edited the work and designed stunning and provocative graphics to go with it. Both the newspaper version and a rare boxed Fluxus Edition card version were produced. Yoko Ono was not altogether pleased with Maciunas's graphics, although she did reproduce one or two as artworks in ad spaces in the magazine *Art and Artists*. When she arrived in London in the late summer of 1966, Ono made drawings for the *13 Days Do-It-Yourself*

SKY PIECE to Jesus Christ, 1965
Performed by Yoko Ono (left), La Monte Young conducting,
Tony Cox (right), and the Fluxus Symphony Orchestra,
Carnegie Recital Hall, New York, September 25, 1965
Photograph by Peter Moore

Dance Festival event scores and slightly edited the piece once more. Then in 1967, she announced that people could send a pound, or a pound's worth of flowers and thirteen stamps, and receive the events through the mail. She also announced that the festival would take place from September 27 to October 9, 1967, "in your mind."

Eventually, the *13 Days Do-It-Yourself Dance Festival* was published in *Grapefruit* and became available to a broad public through numerous editions of the book; three of the pieces in the work—*Breath, Have You Seen the Horizon Lately?*, and *Dream* later became billboard pieces.

By 1966, Yoko Ono's film work included the sound tracks for Yoji Kuri's *Aos* (1964) and Takahiko Imura's *Ai* (LOVE) (1962); a series of conceptual film scores, *Six Film Scripts by Yoko Ono* (Tokyo, June 1964), and the three films for the *Fluxfilm Anthology*: *Film No. 4 (Bottoms)* (1955–56), *Film No. 1 (Match Piece)* (1966), and *Eye Blink* (1966).

Yoko Ono also performed in Chieko (Mieko) Shiomi's Fluxus film *Disappearing Music for Face*. The score reads "smile → no smile." Yoko Ono's work is "smile." In the Fluxus film, she performs "smile" believing that she is performing her own work. Later, Yoko Ono made a film entitled *Smile*, filming John Lennon performing her piece.

Disappearing Music for Face, *Film No. 1*, and *Eye Blink* were filmed at very high speed and then printed on a normal speed film, giving them an almost surrealist feeling. *Film No. 4* was expanded into an eighty-minute film by Ono in London in 1966–67, and it has become one of the classic avant-garde films of the period.

George Maciunas included the Fluxus version of *Film No. 4* in all Fluxus film packagings, including the *Fluxfilm Anthology*, long version and short version, as an 8 mm film loop in *Flux Year Box 2* and packaged as an individual Fluxus Edition, and also as a 16 mm short version packaged as an individual Fluxus Edition. Two images from the film were used for *Fluxus Wall Paper*. It was also planned to use the film for the Fluxus film environment capsule.

Nine years after showing Yoko Ono's *Paintings and Drawings* at his AG Gallery, George Maciunas invited her to do an ambitious Fluxus show in New York City. She accepted, but insisted that it be a joint Yoko Ono John Lennon event with a "chorus by Fluxus."

Bag Productions Inc.
Tittenhurst Park,
Ascot, Berkshire.
Ascot 23022

Dear George,
The reason I want this to be Yoko & John and not YOKO ONO is because the whole thing is nicer if it is like a dialogue between Yoko and John with a chorus by Fluxus. ...

Love,
John & Yoko

1. I am sending the original copy of "Fit to Die" poster we've made which is the second of our Peace Poster Event. (first was the "War is Over") I also send one without the "Fit to Die" red writing on so you can blow it up to a large size to maybe fill the shop window and then add the fit to die writing in red.

2. Also 4 photostat copies of A. B. drawing by John & Yoko which (you choose the one you like—large drawings or small drawings.) can be used as the cover of a catalogue for Yoko & John & Flux series in shop. The catalogue should have just three quotes from me re:

quotes from writings by Yoko Ono

1. It's sad that the air is the only thing we share. No matter how close we get to eachother, there is always air between us. It is also nice that we share the air. No matter how far apart we are, the air links us. (Re: Lisson Gallery catalogue)

and
2. Water Talk—(re: Grapefruit) Simon & Schuster copy

3. There's no two mouths alike in the world. Don't worry about being unique. The problem is how to be similar. (—Unit Magazine, London)

Also, our spoon pieces in the shop window should say

A. Three spoons by Yoko Ono
B. Four Spoons by John Lennon

So it is like A. B. works, you know.

MINIATURE PAINTING should be somewhere in "John Lennon as a Young Cloud" week and don't put anything under the microscope—let microscope have a title "John's smile". (you look in the microscope to see John's smile—imaginary, you know)

3. If you think it makes sense—Please print copies of Lisson Gallery catalogue and/or all the film catalogues, maybe, to sell or give them to people.

4. Also our "Making friends among Pigs" Poster (enlarge to shop window-size) which you can use for one of the week's shop window.

5. Also, Acorn Pieces catalogue of Coventry Sculpture Show—we have presented two Acorns in Coventry show—we planted them in one hole—one in the west of the hole and one in the east of the hole.

6. Also some week do you want to add Apple piece (fresh apple) re: Indica catalogue—which was for sale for 600 dollars (one apple) and it is now Collection of John Lennon (Just buy regular green apple from Grocery to use.

For George Maciunas

PROGRAM.

FLUXFEST PRESENTS Yoko Ono + John Lennon

1. Do-It-Yourself by Yoko & John & Everyone
2. Ticket by John & Everboat
3. Measure by Yoko & John & Hi-Red-Center
4. Blue Room by Yoko & John & Fluxmasterliars
5. Weight & Water by Yoko & John & Fluxfiremen
6. CAPSULE by Yoko & John & Fluxstatecenter
7. Portrait of John Lennon as a Young Cloud by Yoko & Everycloud
8. The Store by Yoko & John & Fluxfactory
9. Examination by Yoko & John & Fluxschool

1. Do-It-Yourself

I will leave it to your judgement as to the selection of my pieces for this week. But try to read Indica & Lisson catalogues and select some from them, too. John's piece instruction "take two eggs"—(1869, London Derry / John Lennon) and display two eggs if you want to.

2. Ticket ticket to anywhere (1970 London, John Lennon)

3. Measure
I want to give you my new piece in addition to my old one in Grapefruit.
Measure from the store to the nearest water (1970 London, Yoko Ono)
John's piece:
Measure from the nearest water to the store (1970 London, John Lennon)
add Hi-Red-Centre to this.

4. Blue Room
The whole room should be completely white with maybe one chair, one table (also white)

Display 2 sets of 4 spoons in the shop window One set should have a sign reading "3 spoons" by Yoko Ono London 1967 (It's in the Lisson Gallery catalogue)
The other set (Exactly the same set) should read "4 spoons" by John Lennon, London 1970

One soft rubber ball (white) somewhere in the room with a sign saying "This sphere will be a sharp point when it gets to the far side of the room in your mind" by Yoko Ono. 1964.

A standing needle somewhere in the room (re: Indica Gallery catalogue photo) with the sign saying "forget it" Yoko Ono 1966.
There should be another needle (exactly the same one next to it with a sign saying "needle" John Lennon 1970)

There should be a cup on a table with a sign saying "Not to be appreciated until it's broken" Yoko Ono 1966
"Mend" 1966 Y.O. (there should be broken pieces of a cup.

There should be a sign under the window saying
"This window is 2000 ft. long. Yoko Ono. 1967"
"This window is———ft. long (the actual footage) John Lennon 1970"

A big chest or box (also white) that occupies a large space and looks heavy with a sign saying "This is not here" Y.O. 1967

Other signs:
"A straight line exist only in your mind" Y.O. 66 / Y.O. 70
"This Line is part of a large sphere" (long straight Line, of part of the structure of the room) Y.O. 70

Use Ashtray (don't leave any Ashtray around)—Y.O. '66
NO SMOKING—J.L. '70
Do Not Disturb—J.L. '70
STAY UNTIL THE ROOM IS BLUE—Y.O. '66

Also, sign outside
Spring, rain, sky, wind, etc. (according to the weather of the day) by Yoko Ono '67.

5. Weight & Water
All the pieces should read Yoko & (whoever brought the piece)
John's pieces
Weight piece – A dry sponge (Yoko & John '70)
Water piece – A wet sponge (Yoko & John '70)

6. CAPSULE
Our contribution to this week will be a 8 mm home movie by John & Yoko and we will make it and send it to you—it will be the world premiere of this piece. Also, please display our film catalogues and sell them or give them away (you must reprint them 1000 or 2000 copies each?)

7. instructions for this is "Open and Close" by Yoko Ono 1967 London (there is a open and close piece in Grapefruit, too if you can find it, but this 1967 version is a theatre piece and there is three versions. One is many, many, doors, cupboards, etc, to open. Other is despite the instruction, when people come, there is nothing for them to open and close, third is all the things are closed tight so they cannot be "opened and closed". I think 1st version is best for this shop.

8. THE STORE
Select any of my pieces you like John's piece for this is tin money (with smooth surface) which you can put in vending machine instead of real money—to chat, you know. (1970, John Lennon)

Examination
John's question is "What time is it?" 1970, London
mine, you can select or make up. Or let people guess.
"guess what my question is" Y.O. 1970 London and put many other questions by many other artists please.

FLUXFEST PRESENTATION OF JOHN LENNON & YOKO ONO + *
AT 80 WOOSTER ST. NEW YORK – 1970
all photographs copyright nineteen seVenty by peTer mooRE
Fluxus Newspaper No. 9, page 1, 1970

The result was *Fluxfest Presentation of John Lennon & Yoko Ono* at 80 Wooster Street, New York, April 11–May 29, 1970. Lots happened, but not everything that was planned, and some of Ono's ideas that didn't happen were constructed by Maciunas in her retrospective at the Everson Museum in Syracuse, New York, October 9–27, 1971.

For the New York City events, Yoko Ono mailed instructions to George Maciunas for the events she wanted him to realize. Neither Ono nor Lennon were present. The event started at Joe Jones's *Tone Deaf Music Store* at 18 North Moore Street with numerous participation pieces by Yoko Ono: *Add Color Panting*, *Draw Circle Painting*, *Kitchen Piece*, *Painting to Hammer a Nail*, *A Grapefruit Banquet*, as well as several pieces by Maciunas, Lennon, Hi Red Center, and others. It was marvelously chaotic and cluttered. People wore masks of John and Yoko, and the events spilled out into empty North Moore Street. At a certain moment, a black limousine pulled up and two men in suits got out, each carrying a grapefruit into the shop. It was John and Yoko's *Grapefruit Delivery Event*. A week later, things moved to 80 Wooster Street.[1]

Later that year, Maciunas published *Fluxus Newspaper No. 9*, entitled *all photographs copyright nineteen seVenty by peTer mooRE*, which documented what happened.

In the spring of 1977, George Maciunas circulated plans among Fluxus artists to hold a Fluxus Festival at the former mansion and horse barns in Massachusetts, which Maciunas had bought with hopes of making a kind of new Fluxus Bauhaus in the country, away from the violence and harassment that he had experienced in the city in which he had created Fluxhouse Cooperatives—cheap artists' housing and performance spaces in what became SoHo. He had many plans for the country property, including making it into a cooperative, jointly owned by Fluxus artists. The Fluxfest planned for July and August 1977 was to end with a special *Yoko Ono & John Lennon Weekend: A Concert by or of Pieces by Yoko Ono and John Lennon in the Bandstand; Exhibits by Yoko Ono & John Lennon; A Food Event Featuring Edible Clothing Fashion by John Lennon*; and *Films by John Lennon and Yoko Ono*. Less than a year later, George Maciunas had died of cancer, and Fluxus came to a close.

[1] April 18–24 Tickets by John Lennon + Flux tours
April 24–May 1 Measure by John & Yoko + Flux doctors
May 2–8 Blue Room by John & Yoko + Flux liars
May 9–15 Weight & Water by John & Yoko + Flux faucet
May 16–22 Capsule by John & Yoko + Flux space center
May 23–29 Portrait of John Lennon as a young cloud by Yoko Ono & Every Participant

SMOKE PAINTING

Light canvas or any finished painting
with a cigarette at any time for any
length of time.
See the smoke movement.
The painting ends when the whole
canvas or painting is gone.

1961 summer

SMOKE PAINTING
(Score version), 1962
Ink on paper
25 × 38 cm

Thirty Instructions in Japanese

Thirty years ago, in 1962, I did an exhibition of instructions as paintings at Sōgetsu Art Center in Tokyo. A year before, I did a show of instruction paintings at AG Gallery in New York, but that was exhibiting canvases with instructions attached to them. Displaying just the instructions as paintings was going one step further, pushing visual art to its optimum conceptualism; it would open up a whole new horizon for the visual arts. I was totally excited by the idea and its visual possibilities. To make the point that the instructions were not themselves graphic images, I wanted the instructions to be typed. But in those days regular typewriters for the Japanese language were not available. Only professional printers and newspapers had typesetting machines. So I thought of the next best thing, which was to ask Toshi Ichiyanagi to print out the instructions by hand.
Yoko Ono, March 20, 1995, New York City

Quoted from *Yoko Ono: Instruction Paintings*, Published by Weatherhill, New York, 1995, pp. 5–6

PAINTING IN THREE STANZAS
(Score version), 1961
Ink on paper
25 × 38 cm

PAINTING IN THREE STANZAS

Let a vine grow.
Water every day.

The first stanza – till the vine spreads.
The second stanza – till the vine withers.
The third stanza – till the wall vanishes.

1961 summer

握手をする絵

仕意の臭に穴をあけ、そこか
ら手を出す。愛想笑いを
してしまうものはお客が来
た時、そこから握手をし、手
に依って会話をする。

PAINTING TO SHAKE HANDS
(Score version), 1962
Ink on paper
25 × 38 cm

PAINTING TO SHAKE HANDS
(painting for cowards)

Drill a hole in a canvas and put your
hand out from behind.
Receive your guests in that position.
Shake hands and converse with hands.

1961 autumn

頭の中で組みたてる絵
その一

四角‥
キャンバスが円になる迄頭の
中で変形して行く。その過
程に於ける或るところで止
め、その形から想起した色、
音、にほひ、或ひは物体を
キャンバスに張って置く。

**PAINTING TO BE CONSTRUCTED
IN YOUR HEAD**
(Score version), 1962
Ink on paper
25 × 38 cm

PAINTING TO BE CONSTRUCTED IN YOUR HEAD

Go on transforming a square canvas in your
head until it becomes a circle. Pick out any shape
in the process and pin up or place on the canvas
an object, a smell, a sound, or a colour that came
to mind in association with the shape.

1962 spring

Yoko Ono,
Instruction Paintings,
New York, 1995

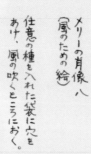

メリーの肖像 ハ
(風のための絵)

任意の種を入れた袋に穴を
あけ、風の吹くところにおく。

PAINTING FOR THE WIND
(Score version), 1962
Ink on paper
25 × 38 cm

PAINTING FOR THE WIND

Cut a hole in a bag filled with seeds
of any kind and place the bag where
there is wind.

1961 summer

メリーの肖像 三
（彼女の沢山の瞳）

任意の国のメリー宛にキャンバスを送りそのメリーの写真を貼ってもらひ、更に次の任意の国のメリーにそのキャンバスを回送して同じことをしてもらふ。写真は全部切手大のこと。キャンバスがメリーの写真で一杯になったら最初の差出人のところへ送り返してもらふ。また送り返されなくてもいい。メリーでないほかの名前でもよい。また假空の名前でもよい。その場合は、その名前の人間が見つかる迄諸国を回送すること。貼ってもらふのは写真でなくて数字でもいい。また昆虫を貼ってもらってもいい。

PORTRAIT OF MARY
(Score version), 1961
Ink on paper
25 × 38 cm

PORTRAIT OF MARY

Send a canvas to a Mary of any country
and have her paste her photograph.
Have her send the canvas to the next
Mary of any country to do the same.
When the canvas is filled up with
photographs of Marys, it should be
sent back to the original sender.
The name does not have to be Mary.
It, also, can be a fictional name, in
which case the canvas will be sent to
different countries until a person with
such a name will be found. The object to
paste on the canvas does not have to be
a photograph. It can be a numeral figure,
an insect or a finger print.

1962 spring

Piece for Nam June Paik no. 1

Water

3. 27. 1964 Yoko Ono

Piece for Nam June Paik no. 1, 1964
Ink on paper
28 × 21.7 cm

ONO'S SALES LIST These Works (c)copyright 1965 by Yoko Ono

orders & inquiries to Yoko Ono, rm711, 119w57th st, nyc 10019 usa

A. SELF PORTRAIT...........$1-
 types: with frame.......$5-

B. SOUNDTAPE of the SNOW FALLING at DAWN........25¢ per inch
 types: a. snow of India
 b. snow of Kyo
 c. snow of AOS

C. TOUCH POEMS*...........priced according to material...$150-to $10,000-
 types: a. paper set d. hair set
 b. flower set e. cloud set
 c. water set f. wind set

D. Machines*
 types: a. CRYING MACHINE-machine drops tears and cries for you
 when coin is deposited-......................$3,000-
 b. WORD MACHINE-machine produces a word when coin is
 deposited-...............................$1,500-
 c. DISAPPEARING MACHINE-machine that allows an object
 to disappear when button is pressed.........$1,600-
 d. DANGER BOX-machine that you will never come back
 the same from if you get in(we can not guarantee your
 safety in its use)-.......................$1,100-
 e. SKY MACHINE-machine produces nothing when coin is
 deposited-...............................$1,500-
 f. ETERNAL TIME-a beautiful ETERNAL TIME CLOCK that
 keeps eternal time-.......................$800-

E. Architectural Works*(priced according to contractors' arrange-
 ments and cost of property)
 types: a. LIGHT HOUSE-a house constructed of light from
 prisms, which exists in accordance with the
 changes of the day.
 b. WIND HOUSE-a house of many rooms designed so that
 the wind may blow through creating a different
 sound for each room.
 c. TRANSPARENT HOUSE-a house intended so that the people
 inside can not see out, and so that the people out-
 side can see in.

F. Paintings
 types: a. NAIL PAINTING.....FLOWER PAINTING.....SHADOW PAINTING,
 and many other great do it your self paintings....$50-
 b. PART PAINTING-details upon request, contains ten
 thousand parts-...........................$100-per 3sq inches
 c. INSTRUCTURE-scores-.................50¢ a piece
 d. PAINTINGS TO BE CONSTRUCTED IN YOUR HEAD-...scores 50¢ a piece

G. GARDEN SETS(priced according to contractors' costs, stones,
 pebbles, etc.)
 types: a. a shallow hole for the moonlight to make a pond
 b. a deep hole for the clouds to drip in
 c. elongated hole for fog ways
 e. stone settings for the snow to cover
 f. stones & pebbles set like a dry river bed

H. Letters
 types: a. letter to Ivan Karp...........original...$300-
 copies.........50¢
 b. reply from Ivan Karp.........original.........2¢
 copies.........50¢

I. EVENTS
 types: a. to let pink snow fall and cover your town-
 guaranteed not to be artificial-score........$1-
 performance....$2,000-
 b. circle event.....2"x3" free upon request
 40"x24".....................$150-
 c. hole event.......2"x3" free upon request
 40"x24".....................$150-

J. Record of Events-a complete record of all Events by Yoko Ono
 since 1951 with photographs and illustrations...........$7-

K. Dance Scores-twentyfive scores.......................$3-

L. Music Scores
 types: a. actual sound scores............................50¢
 b. IMAGINERY MUSIC-scores.....................75¢
 c. opera scores.............................$1-
 d. INSOUND MUSIC-scores......................$1.50

M. Underwear(custom made to order)
 types: a. special defects underwear for men-designed toaccent
 your special defects-in cotton..................$10-
 in Vicuna.................$175-
 b. UNDERWEAR TO MAKE YOU HIGH-for women, discription
 upon request-...........................about $10-to $35-

N. Books
 types: a. GRAPEFRUIT-published in Tokyo, July 4, 1964, a limited
 edition of 500 copies; in English & Japanese, over 200
 compositions in Music, Painting, Event, Poetry, and
 Object, since 1951.............................$10-
 b. GRAPEFRUIT II-over 200 compositions not published in
 GRAPEFRUIT, in Music, Painting, Event, Poetry, and
 Object,(including TOUCH POEMS); to be published in
 1966-pre publication price.....................$5-
 post publication price.....................$10-

O. SIX FILM SCRIPTS-includes WALK TO THE TAJ MAHAL-.........$3-

*patents applied for, machines;and models for Architectural Works,
 may be viewed by appointment, only written requests accepted

ONO'S SALES LIST, 1965
Offset with handwritten additions
35.6 × 21.7 cm

PAINTING TO HAMMER A NAIL, 1961/1966
Painted wood panel, nails, painted hammer, chain
Panel: 34.9 × 26.6 × 11.4 cm, hammer and chain: 92 cm long

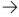

PAINTING TO HAMMER A NAIL IN, 1961/1967
Stainless steel, glass, chain
Engraved: Hammer a nail in for John. '67 London Yoko Ono
Panel: 30.5 × 20.5 × 10.2 cm, hammer and chain: 125 cm long

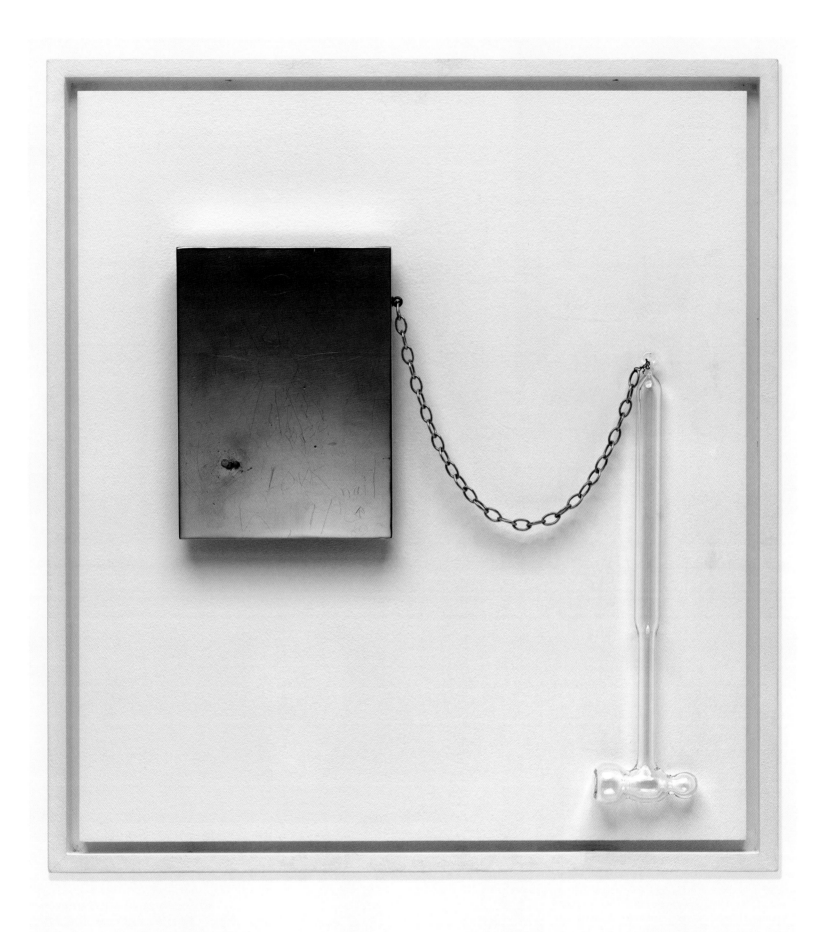

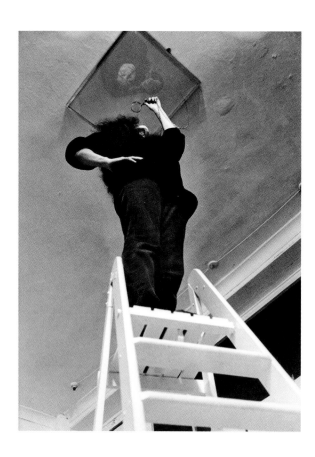

CEILING PAINTING, YES PAINTING, 1966
Installation views with the artist
at Indica Gallery, London, 1966

CEILING PAINTING, 1966

Climb up a ladder. Look at the painting on the ceiling
with a magnifying glass, and find the word 'YES.'
y.o. 1966

The interactive object known as *Ceiling Painting* was
an important work shown at Yoko Ono's 1966 Indica
Gallery show in London. The viewer is invited in his or
her mind to climb to the top of a white ladder, where
a magnifying glass, attached by a chain, hangs from a
frame on the ceiling. The viewer uses the reading glass
to discover a block-letter "instruction" beneath the
framed sheet of glass: it says "YES." It was through
this work that Ono and John Lennon met.

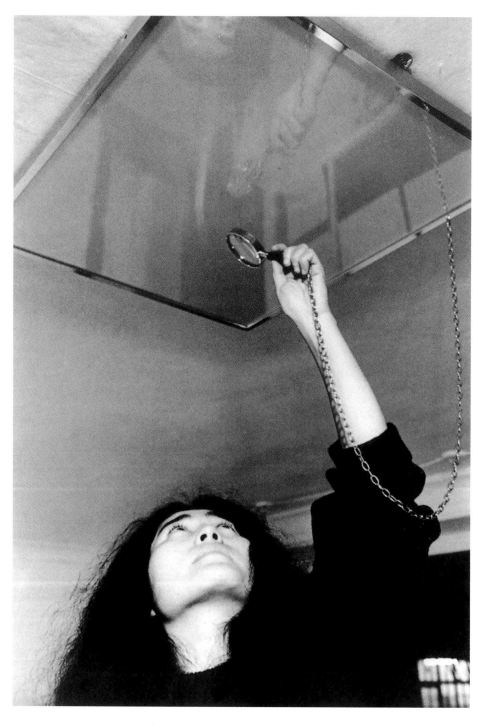

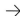

CEILING PAINTING, YES PAINTING, 1966
Text on paper, glass, metal frame, metal chain,
magnifying glass, painted ladder
Ladder: 183 × 49 × 21 cm, framed text: 2 × 64.8 × 56.4 cm

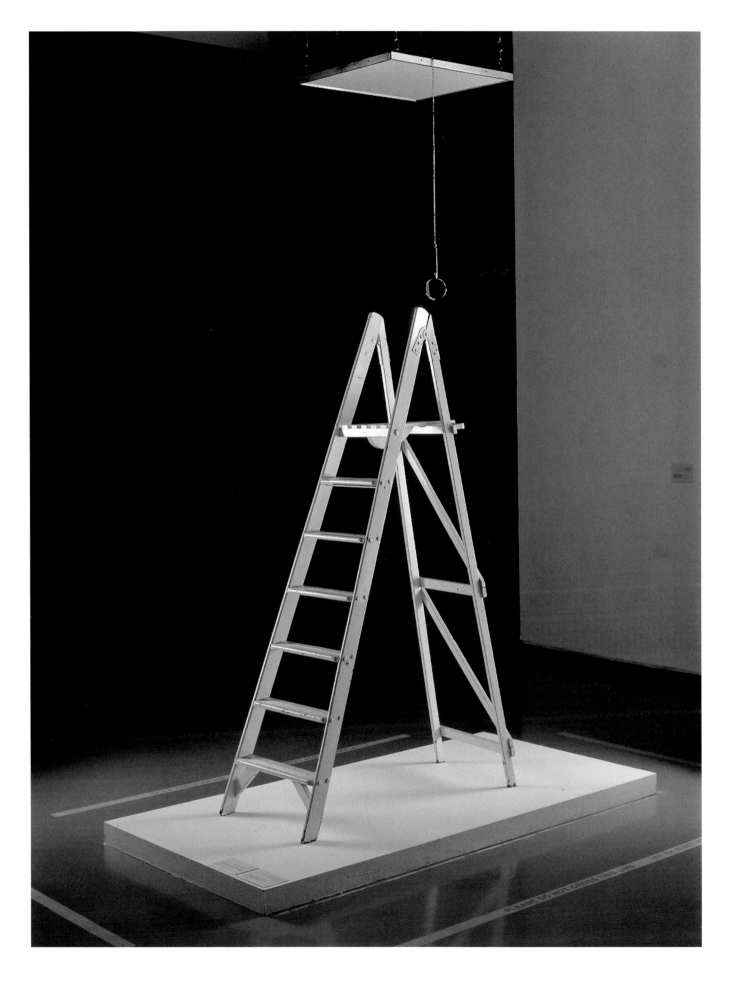

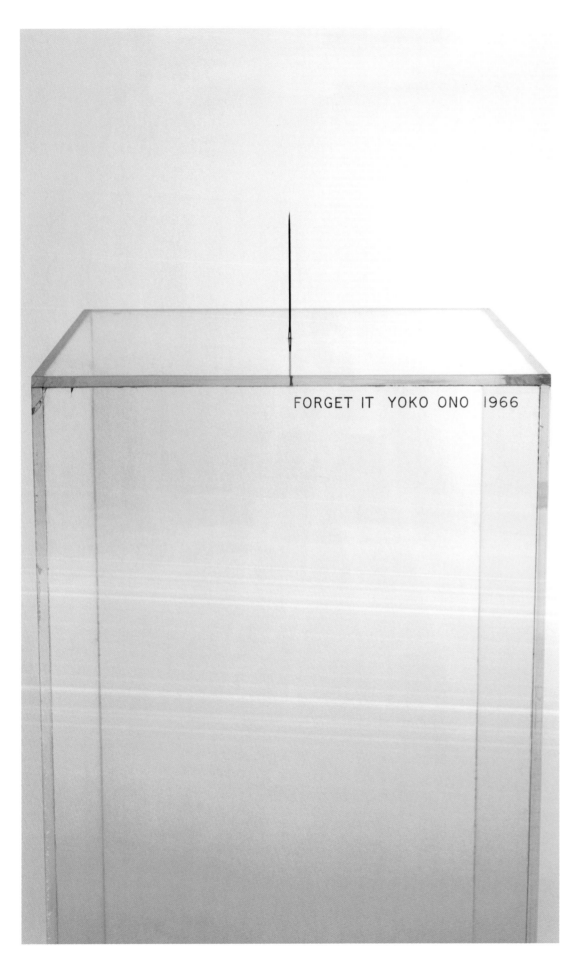

FORGET IT YOKO ONO 1966

FORGET IT, 1966
Stainless-steel needle on Plexiglas pedestal
Engraved: FORGET IT YOKO ONO 1966
Needle: 8.2 cm,
Pedestal: 126.5 × 30.5 × 30.5 cm

APPLE, 1966
Apple on Plexiglas pedestal with brass plaque
Engraved: APPLE
Pedestal: 91.5 × 25.4 × 25.4 cm

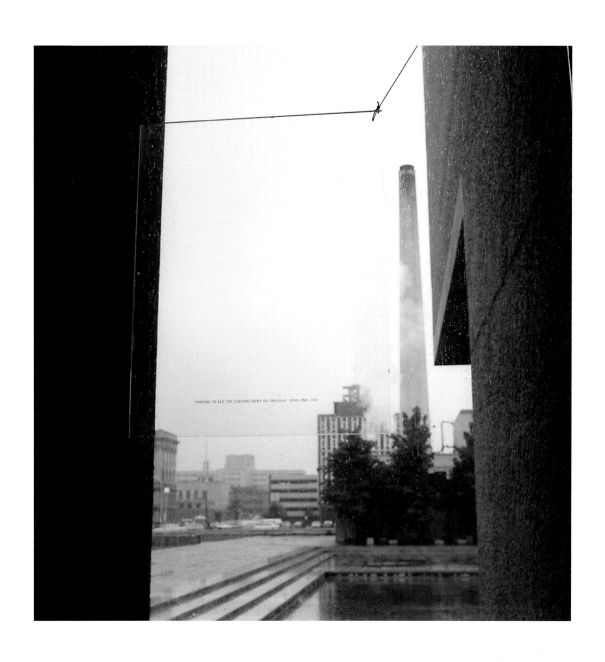

PAINTING TO LET THE EVENING LIGHT GO THROUGH, 1961/1966
Plexiglas
Engraved: PAINTING TO LET THE EVENING LIGHT GO THROUGH
YOKO ONO 1961
84 × 70 cm

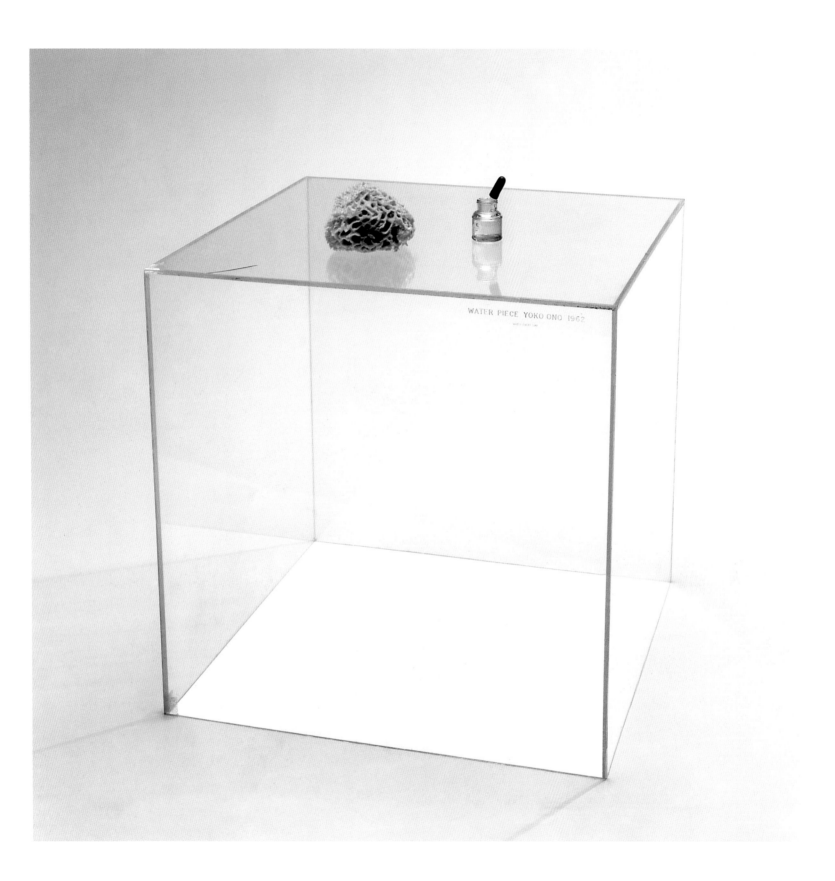

WATER PIECE (PAINTING TO BE WATERED), 1962/1966
Sponge, eyedropper, water in glass vial
on Plexiglas pedestal
Engraved: WATER PIECE YOKO ONO 1962
WATER EVERY DAY
Pedestal: 60 × 60 × 60 cm

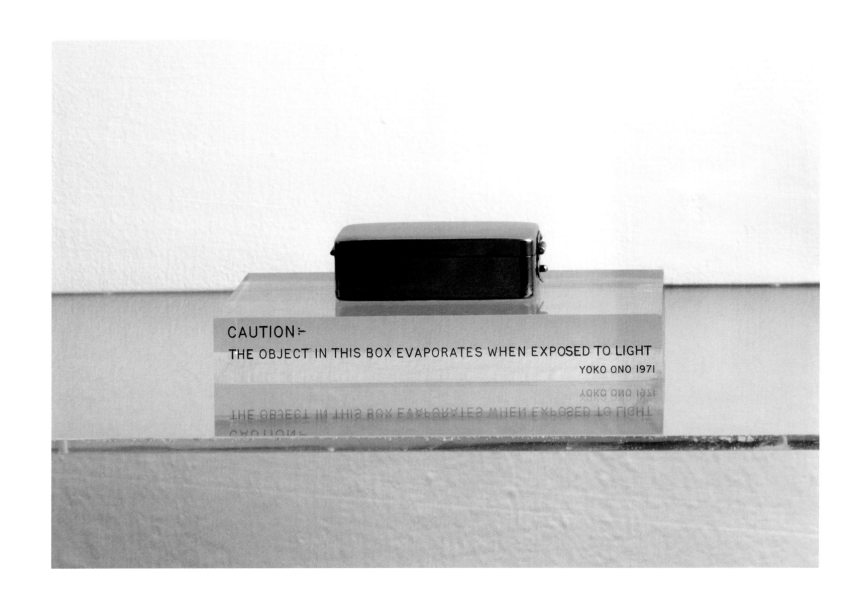

DISAPPEARING PIECE, 1971
Metal box on Plexiglas base
Engraved: CAUTION ÷ THE OBJECT IN THIS BOX
EVAPORATES WHEN EXPOSED TO LIGHT
YOKO ONO 1971
17.8 × 10.2 × 5 cm

ETERNAL TIME, 1965
Altered clock in Plexiglas box on
Plexiglas pedestal with stethoscope,
Plexiglas pedestal
Engraved: ETERNAL TIME
Pedestal: 101.5 × 20 × 20 cm

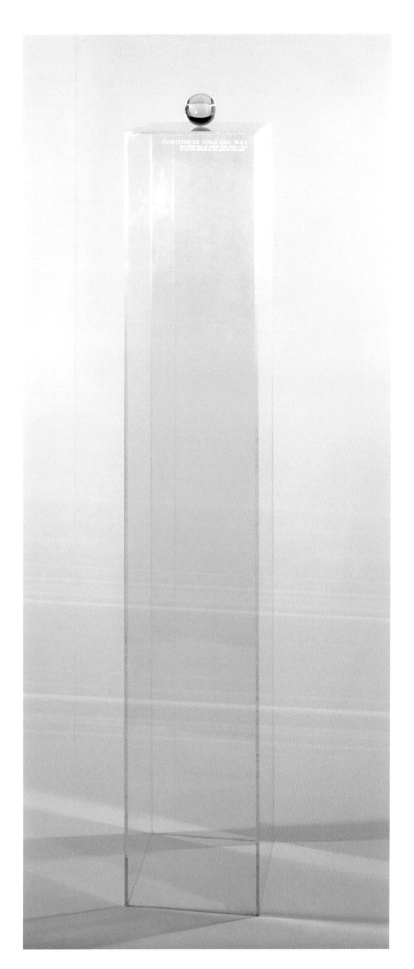

POINTEDNESS, 1964/1966
Crystal sphere on Plexiglas pedestal
Engraved: POINTEDNESS YOKO ONO 1964
THIS SPHERE WILL BE A SHARP POINT WHEN IT GETS
TO THE FAR CORNERS OF THE ROOM IN YOUR MIND
Pedestal: 143 × 26.6 × 25.4 cm, sphere: 6.6 cm

MIND OBJECT II, c. 1966/1967
Glass bottle on Plexiglas pedestal
Engraved: MIND OBJECT II
NOT TO BE APPRECIATED UNTIL ITS BROKEN
Pedestal: 139 × 26.5 × 26.5 cm, Bottle: 25 cm

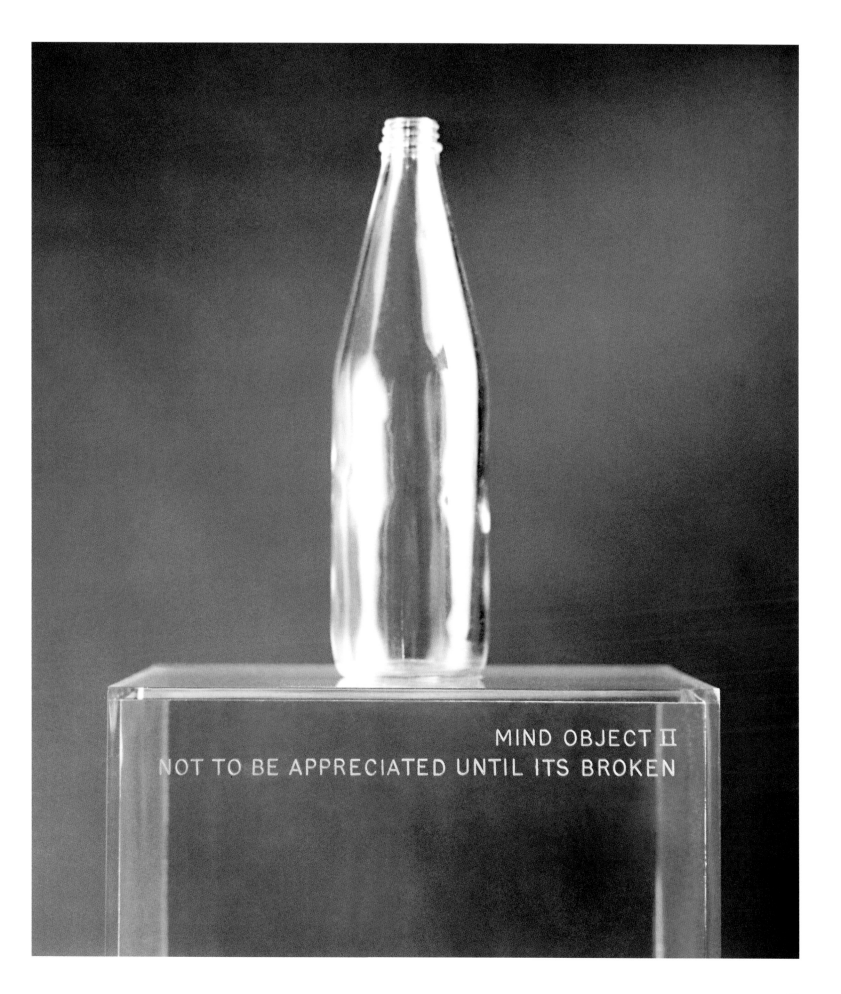

MIND OBJECT II
NOT TO BE APPRECIATED UNTIL ITS BROKEN

water talk

you are water
I'm water
we're all water in different containers
that's why it's so easy to meet
someday we'll evaporate together

but even after the water's gone
we'll probably point out to the containers
and say, "that's me there, that one."
we're container minders

For Half-A-Wind Show, Lisson Gallery,
London, 1967

WE ARE ALL WATER, 2006
Glass bottles, water, ink on paper;
installation:
wooden shelf, chair, table, cards, pens
Dimensions variable

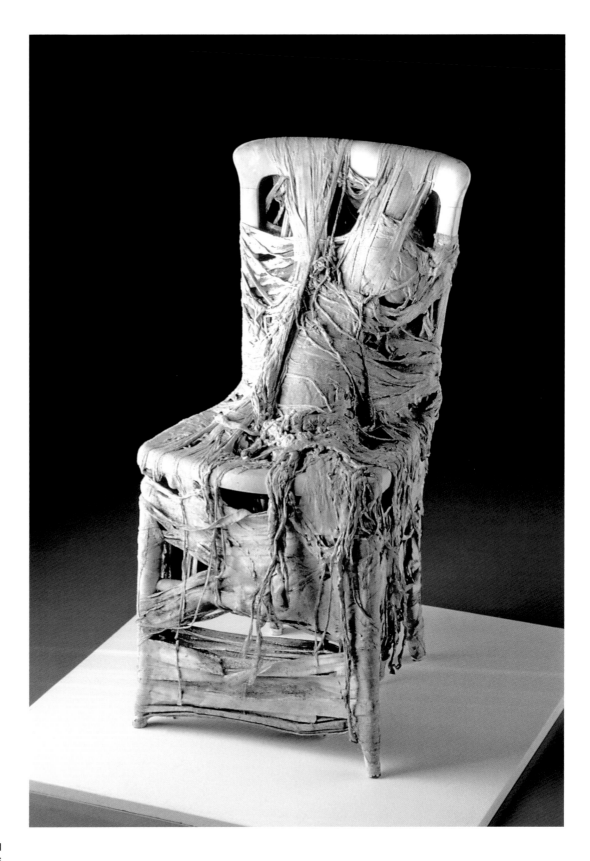

**WRAPPING PIECE FOR LONDON
(WRAPPED CHAIR)**, 1966
Wooden chair, gauze, white paint
83.2 × 40.6 × 39.4 cm

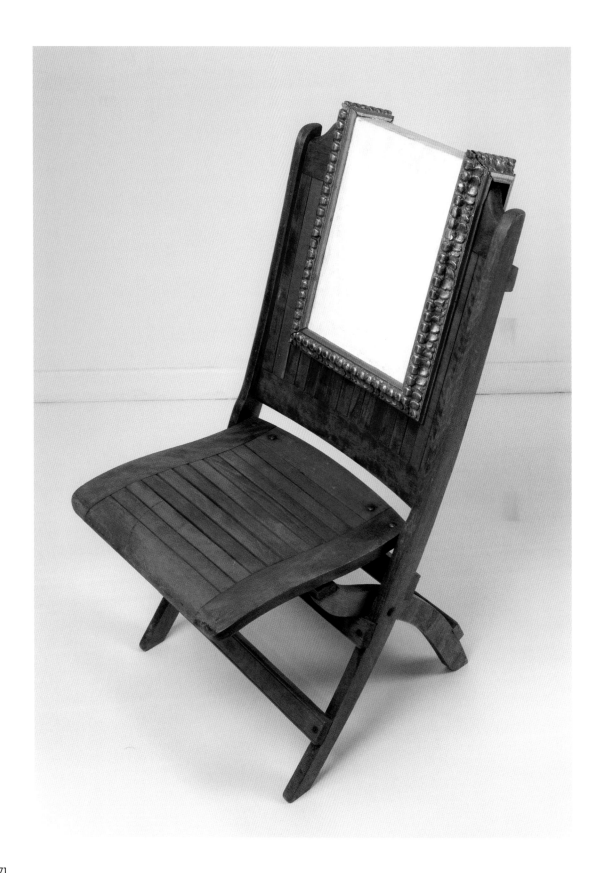

CHAIR PAINTING, c. 1966–71
Wooden chair, canvas over wood
with gilded frame

CORNER PAINTING, c. 1966–71
Canvas over wood with gilded frame
Each side: 41.9 × 24.9 cm

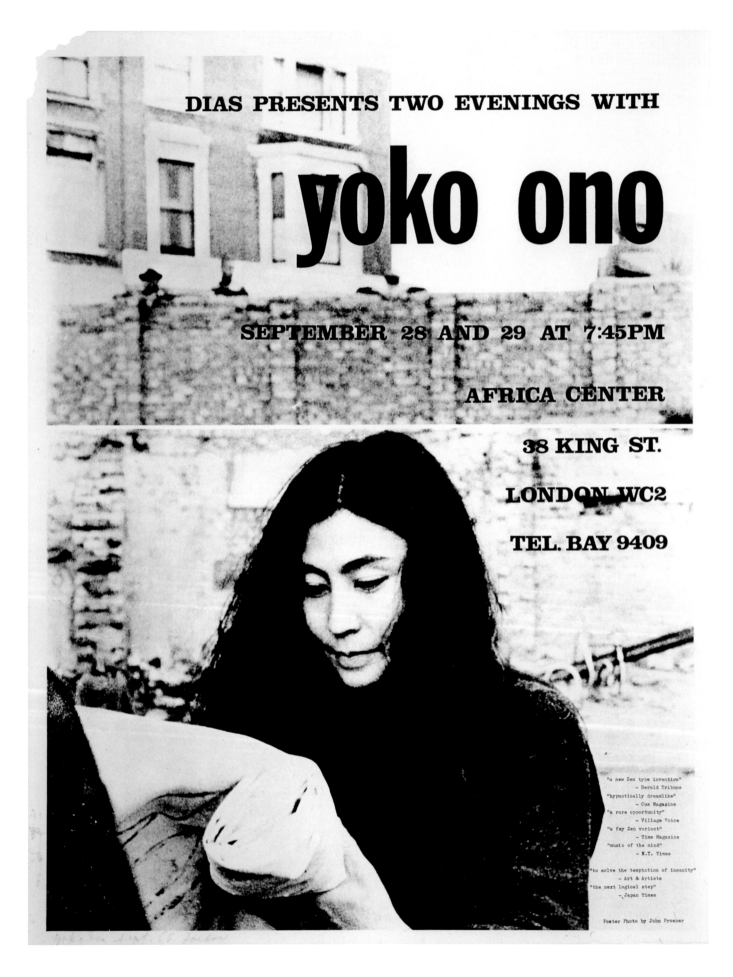

DIAS PRESENTS TWO EVENINGS WITH

yoko ono

SEPTEMBER 28 AND 29 AT 7:45PM

AFRICA CENTER

38 KING ST.

LONDON WC2

TEL. BAY 9409

"a new Zen type invention"
— Herald Tribune
"hypnotically dreamlike"
— Cue Magazine
"a rare opportunity"
— Village Voice
"a fey Zen variant"
— Time Magazine
"music of the mind"
— N.Y. Times
"to solve the temptation of insanity"
— Art & Artists
"the next logical step"
— Japan Times

Poster Photo by John Prosser

Yoko Ono's Bashō

A Conversation

Alexandra Munroe

> What I did, I had knowledge of what happened before me
> and I created my own fate based on that. Yoko Ono, 2012[1]

I recently sat down with Yoko Ono and asked her point-blank about her relationship to Asian aesthetics. I had worked with Ono for over twenty years and written about her art from various perspectives, including her role as a mediator of Zen ideas in the downtown art scene of 1960s' New York. But writing on this assigned topic for the Frankfurt show somehow made us both balk. Art and biography are not a matter of cause and effect; her being born Japanese does not make her art forever "Japanese." Artists make myriad choices about the world they feel compelled to mirror, examine, or reinvent; artists like Ono, working in the age of cosmopolitanism and globalism, segue among and between past and contemporary cultures from both near and faraway places, and still remain true to themselves. Does ascribing influences matter?

Sitting around her kitchen table on that autumn afternoon, Yoko Ono scoffed at being cast in some outmoded Orientalist suit. But gradually, memories began to drift by. Over the course of our conversation, a few distinct but unrelated images came into focus. No pattern emerges, but each transmission bears an aspect of Japan's psyche that may shed light on Ono's own amazing mind.

Scream

Yoko Ono and I looked back at what I had previously written. Seeking to contextualize her early epigrammatic language and events-based art in what I called the "Cage Zen" phenomena, I wrote the following on Ono in an earlier study[2]:

> From the late 1950s, reveling in an increasingly eclectic inventory of Asian thought traditions and in direct contact with avant-garde artists from East Asia, the artists associated with Fluxus and Happenings expanded, challenged, and radicalized the parameters of John Cage's Asian rhetoric and methodology. Allan Kaprow's 1959 event composition for *18 Happenings in 6 Parts*—with three simultaneous performances, eight overlapping sound tracks, and precise instructions for the audience— transformed central conditions of Cagean indeterminacy and interactive participation. By 1962, when Nam June Paik performed *Zen for Head* at the first Fluxus International Festival of Very New Music in Wiesbaden, the value shifts from intention to nonintention, from object to process, and from stasis to duration reflected the broader application of what Paik called the old "Zen–Cage thesis": "It is beautiful, not because it changes beautifully, but— simply— because it changes."[3]
>
>The proto-Fluxus and Fluxus scores, with their distilled conflation of image and word, epigrammatic structure, and frequent reference to nature, indeed mirrored

DIAS PRESENTS TWO EVENINGS WITH YOKO ONO, 1966
Poster
Silkscreen on paper
Africa Center, London,
September 28 and 29, 1966
53 × 40 cm

___1 Yoko Ono, interview with the author, November 18, 2012, New York. Unless otherwise stated, all Ono's quotes appearing in this essay are drawn from this interview.
___2 See Alexandra Munroe, "Buddhism and the Neo-Avant-Garde: Cage Zen, Beat Zen, Zen," in: Munroe, *The Third Mind: American Artists Contemplate Asia, 1860–1989* (New York: Guggenheim Museum, 2009), 201–08. The following passage and quotes are drawn from this chapter.
___3 Ibid. Nam June Paik, "To the 'Symphony for 20 Rooms,'" in La Monte Young (ed.), *An Anthology* (New York: La Monte Young and Jackson Mac Low, 1963), unpaginated.

haiku's poetics of pure actuality and metaphorics of immediacy. George Brecht, Yoko Ono, and La Monte Young experimented with what critics have called "*haiku*-like" and "Zen-like" language as art. Young edited a collection featuring scores and other writings titled *An Anthology* (1963); and Yoko Ono published a collection of her own poetry and instruction pieces as *Grapefruit* (1964).Their event scores or instruction pieces could be performed in the mind as a thought (their visualization being performative, like La Monte Young's score for "little whirlpools out in the middle of the ocean,"[4]) or as a live performance before an invited audience. They expanded upon Cage's scores by directing the viewer/listener from concrete experiences to a space composed entirely in the mind. Young's composition that reads "Turn a butterfly (or any number of butterflies) loose in the performance area...."[5] infers the existence of music beyond what is audible by the human ear. And Ono's *Instruction Paintings* call for paintings "to be constructed in your head." At her AG Gallery show, she showed this series as ephemeral objects whose "instructions" she read aloud for visitors to mentally realize (1961). At Sōgetsu Art Center in Tokyo the following year, Ono eliminated the object altogether and displayed the instructions, scribed by her husband, composer Toshi Ichiyanagi, alone on the gallery wall (1962). Writing on "idea art" as a kind of psychological metaphysics, Ono stated, "Instruction painting makes it possible to explore the invisible, the world beyond the existing concept of time and space. And then sometimes later, the instructions themselves will disappear and be properly forgotten."[6]

But now, fifty years later, Yoko Ono prefers to distance herself from that early association with Cage. Yes, she and her then-husband, the composer Toshi Ichiyanagi, had helped arrange Cage's 1962 trip to Japan and participated in his performances at Tokyo's vanguard Sōgetsu Art Center. But when she decided to leave Toshi, Cage meddled. "I was not a traditional Japanese woman, and this disappointed them," she recalled. "It has to do with submissiveness, which I certainly didn't have."[7] Cage, the New York master of all things Zen, was not Zen enough to see Ono's desperate need "to break out of social constraints, the suffocating sense of propriety." It was *this* Japan with its elaborate social mechanisms suppressing deviance in women that incited Ono "to break out, to scream." Japan as an object of oppression, as something to be totally free of, created the conditions for one of her boldest and most original acts:

8

VOICE PIECE FOR SOPRANO
to Simone Morris

Scream.
　　1. against the wind
　　2. against the wall
　　3. against the sky

1961 autumn

___4　Ibid. La Monte Young, "Composition 1960 #15 to Richard Huelsenbeck," in: *An Anthology*, unpaginated.
___5　Ibid., unpaginated.
___6　Yoko Ono, quoted in "Yoko Ono: Instruction Painting," in: *Yoko at Indica*, exh. cat. (London: Indica Gallery, 1966), n.p.
___7　Yoko Ono, interview with the author, November 18, 2012, New York. Unless otherwise stated, all Ono's quotes are drawn from this interview.
___8　Yoko Ono, *Grapefruit. A Book of Instructions and Drawings*, New York, 1970, o.S.

Wakon yōsai

Yoko Ono's upbringing straddles the prewar, wartime, and postwar periods of modern Japanese history. But to a remarkable degree, her mentality was shaped by the particular modernity of the preceding Meiji era (1868–1911). She was born to fabulous wealth on her mother's side, and genuine nobility and educational pedigree on her father's side. Both lineages came into power during the Meiji era, whose national slogan of postfeudal modernization was *wakon yōsai*, or "Japanese spirit, Western technology."

"My household was exactly like this," Ono recalled over tea. "We were trained in Japanese spirit and Western skills." Adapting Western ways was "convenient and fun" but you never strove to imitate and always had pride in being Asian. Part of the Meiji heritage is the acute historical consciousness of being at the threshold of great change, as Japan turned away from 250 years of isolation and willfully sought to catch up and achieve parity with the West as a modern, technological power grounded in its own unique philosophical outlook. "I always felt that I had to give something to the world," Ono told me. Seeing an interconnected and contemporaneous human project encompassing the East and West, she understood, "I am the one to bring on the new world."

Music was central to the Ono family, and Yoko moved with ease between the two worlds of classical Japanese and classical Western training. Her father, Yeisuke, had given up a career as a concert pianist to become a banker, and encouraged his eldest child to fulfill his own lost dream. At Tokyo's prestigious Gakushūin School (School of the Free Spirit), a progressive school for girls, as well as with home tutors, Yoko received rigorous musical training in German lieder singing, Italian opera, and classical piano. Although she would later rebel against the formalism of her early education and reject her father's will, these years provided the foundation of her work as a composer and vocal artist. What John Lennon called Ono's "revolutionary … sixteen-track voice" is grounded in this foundation of classical training.

Yoko Ono was also exposed to Japanese instrumentation and musical notation through her mother, who played the stringed *koto* and *shamisen*. Scores did not exist until modern times. Book notations for flute, percussion, and stringed instruments were based on the Chinese tradition and featured columns of dots representing time progression (usually every four beats) and syllables written in the phonetic alphabet *katakana*, called *shoga*. These sounds were used as a way to memorize the instrumental part by singing it percussively. The open spaces of Japanese notation impressed Ono, who found its range of interpretation significantly different from "the rigid length of each note in Western notation." In Japan, music is almost entirely an oral tradition, transferred from master to disciple. In this sense, musical teaching was part of the same culture as monastic forms of Zen Buddhism, where enlightenment passes through direct experience between the minds of master and student, without the mediation of religious texts or ritual.

Taking *wakon yōsai* to another level, Yoko Ono's art and music would later combine the concepts of structuring empty space and transmission from Japanese music and combine it with Western avant-garde practices to pose her own musical culture. Ono's seminal texts "On insound" and "On instructure," which accompanied her 1964 exhibition and concert in Kyoto, reveal her approach to both music and object-making as a *practice*, an unfinished *process* of concept transmission:

On insound
IN: like really in-within-inner-non-un-insane-crazed…
Insound is a practice rather than music.
Most of the insound pieces are spread by word of mouth.
The following is one of the insound pieces.

 Stay in a room for a month.
 Do not speak.
 Do not see.
 Whisper at the end of the month.

A word-of-mouth piece, a strip-tease piece and an audience
piece will be performed in this concert.

On instructure
Something that emerged from instructure and yet not quite
emerged-not quite structured-never quite structured…
like an unfinished church with a sky ceiling.

The instructures will be exhibited in the lobby.

9

Fumi-e

Among the works that Ono exhibited at George Maciunas's AG Gallery in New York in July 1961 was *Painting to Be Stepped On*. Featured as one of her *Instruction Paintings*, this work consisted of a torn painting lying on the floor that visitors were invited to step on. Unlike any other work in this groundbreaking show that made interactive exchange the condition of an artwork, *Painting to Be Stepped On* was based on a specific historical reference. *Fumi-e*, literally "stepping-on picture," was a practice enforced by the religious authorities of the Tokugawa shogunate (reign 1600–1868) as a means to identify and root out Christians. Attacked in the late 1500s using brutal public crucifixions of European and Japanese Catholics in Nagasaki, and officially outlawed in 1614, Christianity was seen as a foreign threat to Japanese sovereignty and its closed-door policy. For over two centuries, suspected Christians were made to walk on images bearing the likeness of Christ or the Virgin Mary; those who refused were imprisoned, tortured, and often executed. It's no wonder that Japan has more martyrs than any other country in the modern age: 40,000.

"Imagine their courage," Yoko Ono reflected recently of those who refused to trample on what they believed to be sacred images. That a conceptual power could be strong enough to inspire one's own death is an extraordinary thing for a conceptual artist to contemplate. The combination of extreme conceptualism and violence both physical and psychic describes much of Ono's art, especially after John Lennon's murder in 1980. For *The Family Album* (1993), she produced a series of everyday household objects marked with signs of violent death. A dressing mirror shattered by a bullet hole, some bent hangers manipulated to abort a fetus, a smashed baseball bat are cast in bronze and painted with a blood-red patina.

___9 *On Insound* and *On Instructure* in the program to *Contemporary American Avant-Garde Music Concert*, Yamaichi Hall, Kyoto, 1964, reproduced in Alexandra Munroe and Jon Hendricks, *Yes: Yoko Ono* (New York: Harry N. Abrams and Japan Society, 2000), p. 12.

The text for *Family Album Exhibit C: Box (Mindbox)* (1993), a solid, dark bronze box with painted blood seeping from its lid, reads:

> One day, quite suddenly, after so many
> years, blood started to flow out of the little
> black mind box I thought I had discarded.

> y.o. 1993 summer

Bashō

"There is a *haiku* by Bashō," Yoko Ono was eager to share with me. She wrote it down from memory in her elegant Japanese cursive script, and confessed, "This is me!" It goes:

旅 に 病 で 夢 は 枯 野 を か け 廻 る

This is said to be Matsuo Bashō's final *haiku*, pronounced before his disciples on his death-bed in 1694. There are hundreds of translations. She and I came up with this one:

My journey over, my dreams race around the withered moors.

Why, I wondered later, is this her favorite poem? Like so much of her art, the mind is the protagonist and its work is unfinished. Her early instructions call for "paintings to be constructed in your head," her 1967 Lisson Gallery show was titled "Half-A-Wind: Unfinished Paintings and Objects by Yoko Ono," and the first album she released with John Lennon was called *Unfinished Music No. 1: Two Virgins*. Her lifelong activism charged with hope is symbolized by the Imagine Peace Tower in Reykjavík of 2008, a giant light beam projected into the sky: a reaching away from the tired world. Like Bashō's poetics, her work makes the unseen seen and distills the everyday into moments that feel piercingly real. Perhaps, Ono's *Scores*, films, music, objects, performances, and installations are each like a seventeen-syllable poem— a percussive hint awakening self-realization. Her influential 1966 text *To the Wesleyan People* predicts how Ono's art functions, for herself and for us all:

> The mind is omnipresent, events in life never happen alone and history is forever increasing its volume…. At this point, what art can offer (if it can at all—to me it seems) is an absence of complexity, a vacuum through which you are led to a state of complete relaxation of mind. After that you may return to the complexity of life again, it may not be the same, or it may be, or you may never return, but that is your problem.[10]

10 Yoko Ono, "To the Wesleyan People" (1966); reproduced in ibid., p. 291, and in this book on p. 182.

Some ideas expressed in this essay are based on previous writings found in Alexandra Munroe and Jon Hendricks, *Yes: Yoko Ono* (New York: Harry N. Abrams and Japan Society, 2000) and in Alexandra Munroe, *The Third Mind: American Artists Contemplate Asia, 1860–1989* (New York: Guggenheim Museum, 2009).

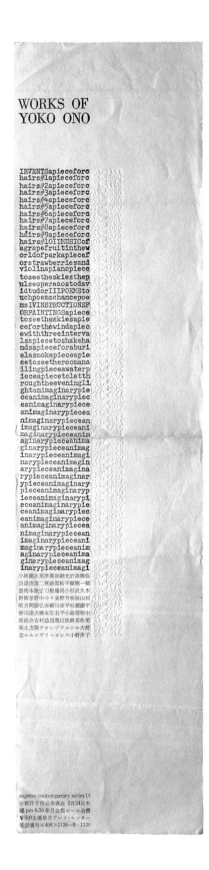

WORKS OF YOKO ONO, 1962
Program/catalog announcement
Offset and letterpress on paper
Sōgetsu Art Center, Tokyo, May 24, 1962
47.6 × 11.4 cm

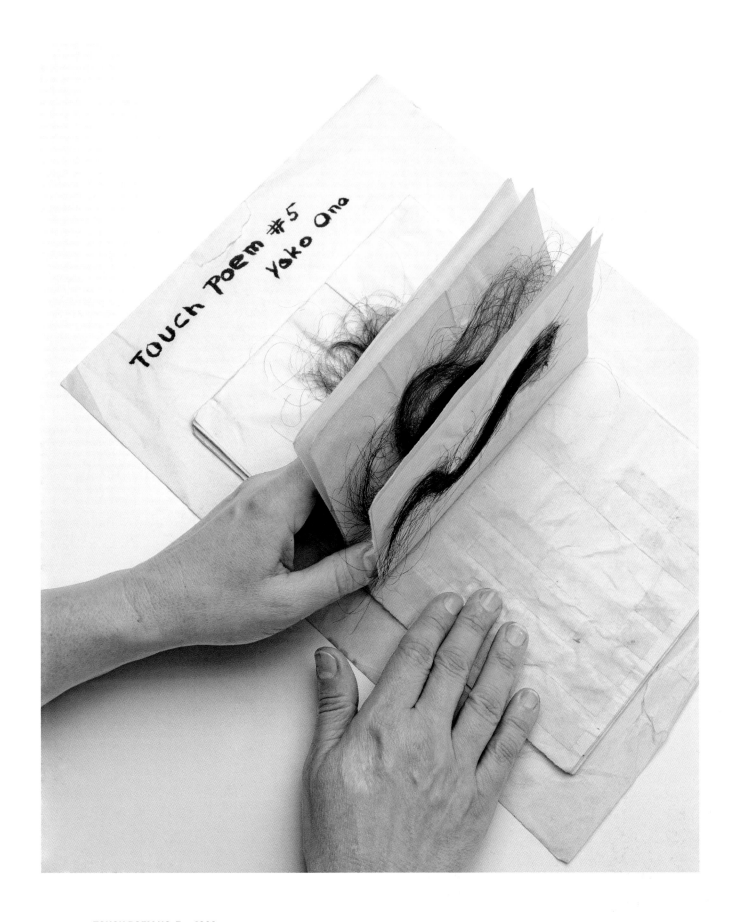

TOUCH POEM NO. 5, c. 1960
Human hair, ink on paper,
17.1 × 12.7 cm

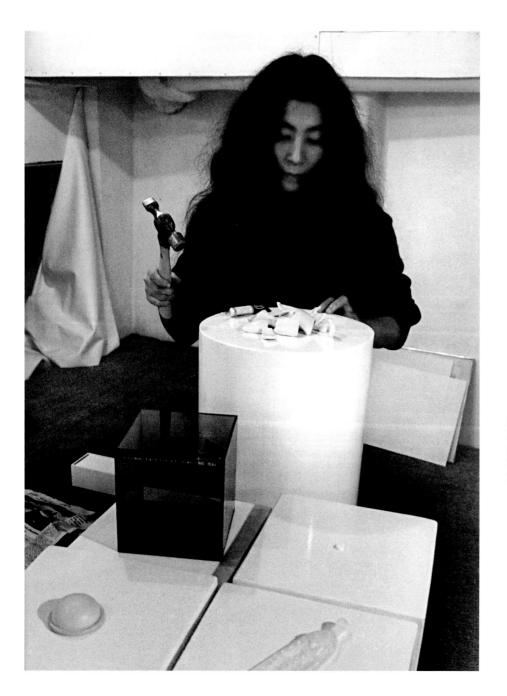

MENDING PIECE, 1966
Photograph of the artist
preparing the piece at
Indica Gallery, London,
1966

MENDING PIECE, 1966
Broken cup, tube of glue, thread spool
Installation view at Indica Gallery,
London, 1966

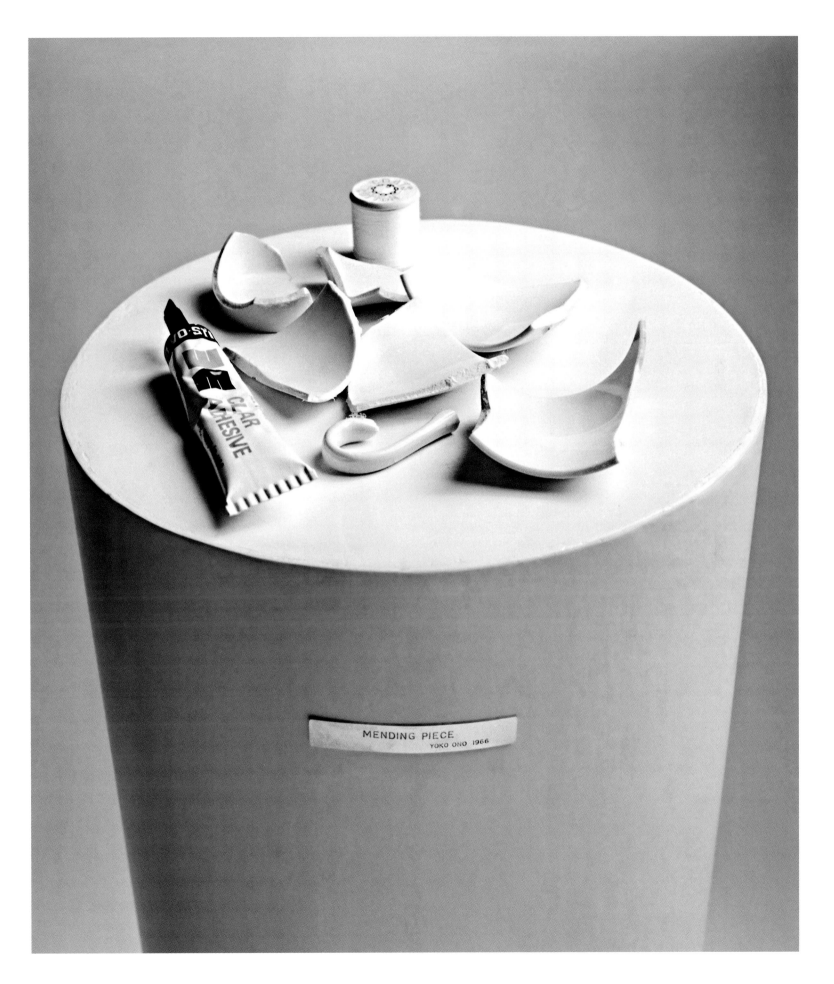

MENDING PIECE

YOKO ONO 1966

ADD COLOR PAINTING, 1960/1966
Installation view at
Everson Museum, Syracuse, New York, 1971

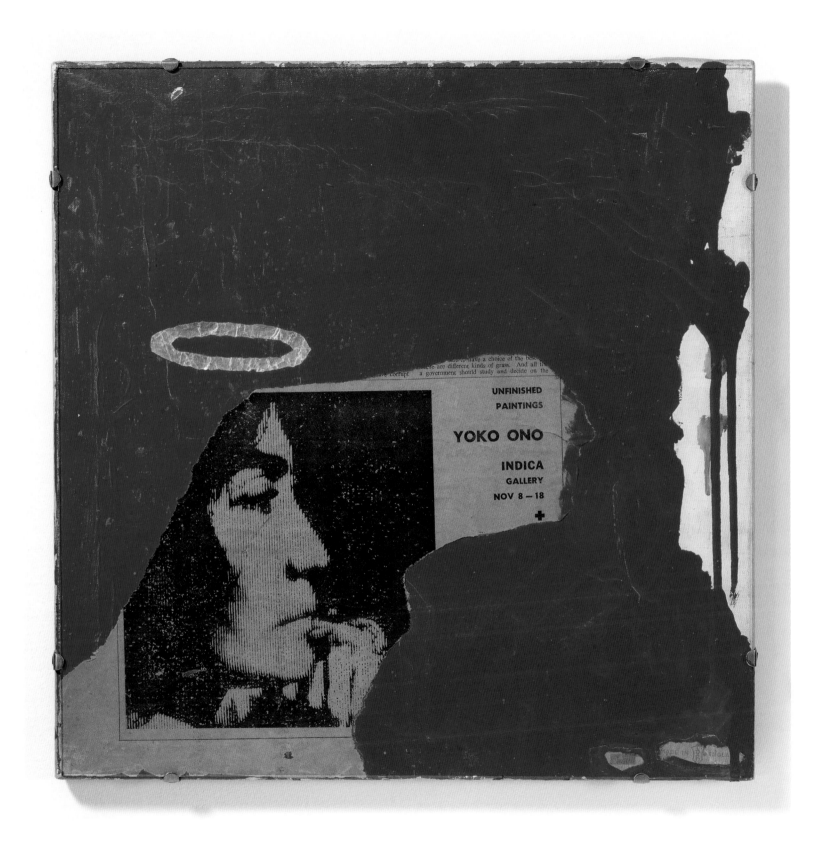

ADD COLOR PAINTING, 1960/1966
Paint, newspaper, tin foil on canvas
40 × 40 cm

This line is a part

This line is a part of a very large circle.
Instruction for **BLUE ROOM EVENT**, 1966
Installation with handwritten texts
Installation dimensions variable

98

of a very large circle

WHITE CHESS SET, 1966
Installation view, detail,
at Indica Gallery, London, 1966

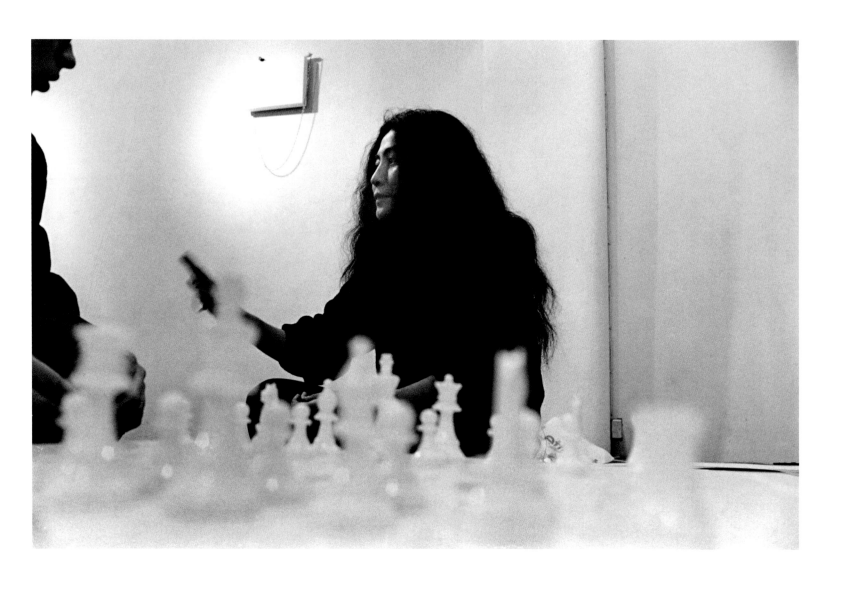

WHITE CHESS SET, 1966
Installation view with the artist at
Indica Gallery, London, 1966

Name: *Charlotte Moorman*
Age: Sex: Male Female
Occupation: music...
Please check the following
data:

1) I like
 dislike to draw circles.

2) I have always drawn circles
 never
 well.

3) I am a better circle-
 was now.
 drawer in the past.
 when I was ___ MONTHS OLD (age).

Other comments regarding your
circle experience: THE ABOVE CIRCLE DRAWING
 IS A SECRET WHACKLE

DRAW CIRCLE

©1964 YOKO ONO

Send to:

YOKO ONO

EMPIRE STATE BLDG.

N. Y. C. 1, N. Y.

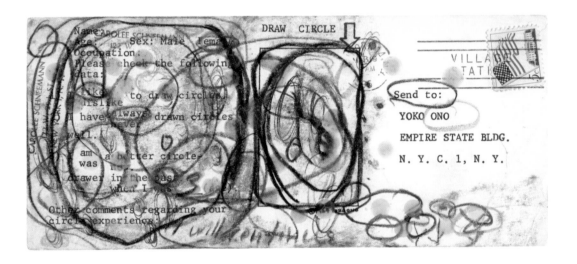

DRAW CIRCLE

Send to:

YOKO ONO

EMPIRE STATE BLDG.

N. Y. C. 1, N. Y.

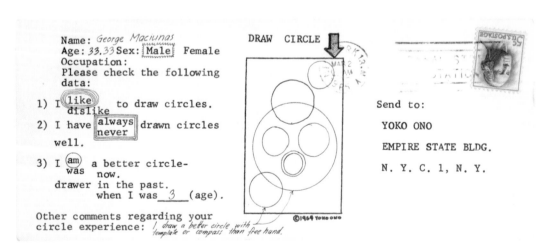

Name: *George Maciunas*
Age: 33.33 Sex: Male Female
Occupation:
Please check the following
data:

1) I like to draw circles.
 dislike

2) I have always drawn circles
 never
 well.

3) I am a better circle-
 was now.
 drawer in the past.
 when I was 3 (age).

Other comments regarding your
circle experience: *I draw a better circle with
template or compass than free hand.*

DRAW CIRCLE

©1964 YOKO ONO

Send to:

YOKO ONO

EMPIRE STATE BLDG.

N. Y. C. 1, N. Y.

DRAW CIRCLE EVENT, 1964
As completed by Charlotte Moorman,
Carolee Schneemann, and George Maciunas
Offset on paper, ink, pigment, etc., mailed
8.9 × 21.6 cm each

SOUNDTAPE OF THE SNOW FALLING AT DAWN, 1963/1965
Soundtape, metal container, offset on paper
Closed container: 5 × 2 cm

9 concert pieces for John Cage

by YOKO ONO

Dec. 15'66 London

© copyright 1966 Yoko Ono

9 Concert Pieces for John Cage, 1966
Title page
1 of 15 loose leaves
Ink on paper
26 × 20 cm

To John:

Since my pieces are meant to be spread by word-of-mouth, most pieces only have titles or very short instructions. Therefore, passing words as to how they were performed previously has become a habit.

my music is performed only to induce a situation in which people can listen to their own mind music. Therefore, maximum silence is required in presenting the pieces.

Also, every performance should be considered a rehearsal and unfinished.

There are 13 pieces here. Please select the 9 you like.

9 is a spiritual number which has a meaning of being unfinished.

Yoko Ono

9 Concert Pieces for John Cage, 1966
To John:
1 of 15 loose leaves,
Ink on paper
26 × 20 cm

Touch Piece

touch.

by Yoko Ono

This piece was performed many times in different places of Europe, United States and Japan. Usually. the lights are put off and the audience touch eachother from 10 minutes to sometimes over two hours. In Nanzen temple in Kyoto, 1964, it lasted from evening till dawn. In London, people started to whistle the theme song of "Bridge of River Kwai", which became a chorus.

Touch Piece, 1964/1966
From *9 Concert Pieces for John Cage*
Ink on paper
26 × 20 cm

Hide Piece

Hide.

by Yoko Ono

This piece was first performed in New York, Carnegie Recital Hall, 1961, by turning off the light completely in the concert hall including the stage, and Yoko Ono hiding in a large canvas sheet while La Monte Young and Joseph Byrd made soft voice accompaniment. In 1962 Tokyo, also, in total darkness, performers hid behind various things on the stage, while Tone, as a solo performer, struggled to get out of the bag he was put in. In London 1966, Jeanette Cochrane Theatre, Yoko Ono brought out a 3 foot pole on the centre of the stage and hid behind it.

Hide Piece, 1961/1966
From *9 Concert Pieces for John Cage*
Ink on paper
26 × 20 cm

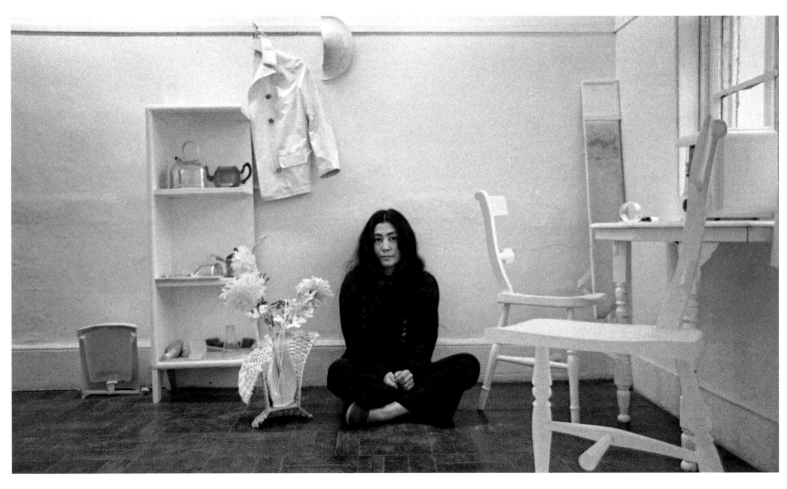

HALF-A-ROOM, 1967
Installation views with the artist
at Lisson Gallery, London, 1967

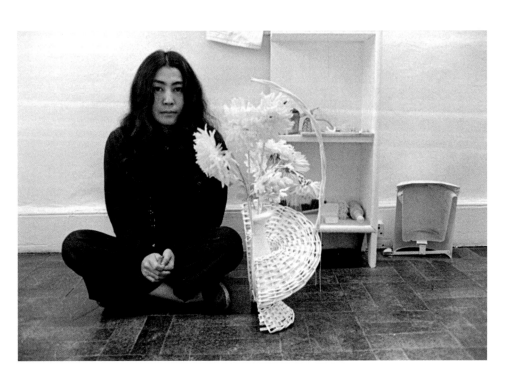

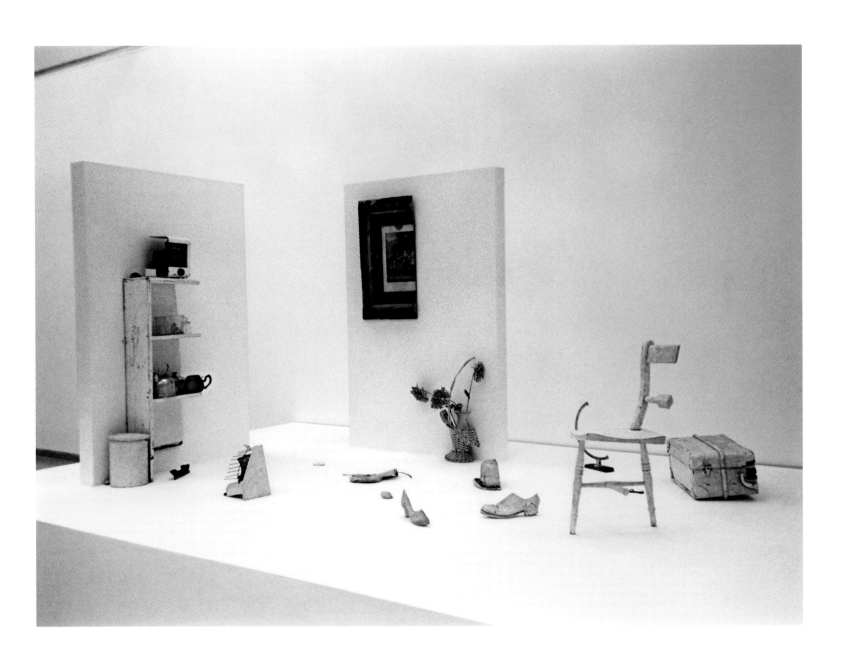

HALF-A-ROOM, 1967
Furniture and other objects
cut in half, painted white
Installation view at The Israel Museum,
Jerusalem, 2000
Dimensions variable

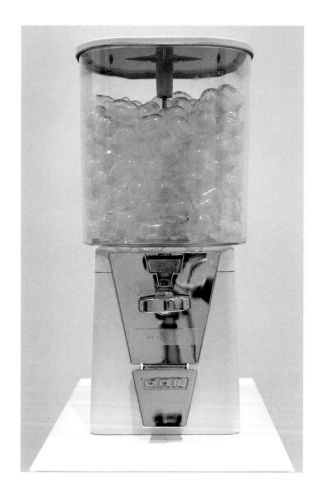
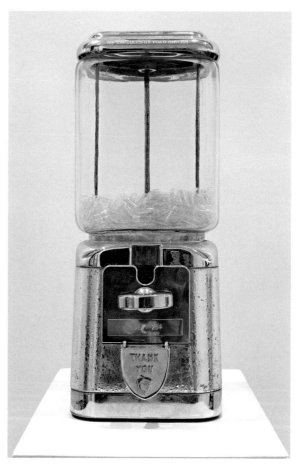

AIR DISPENSERS, 1971
Installation views, Everson Museum,
Syracuse, New York, 1971

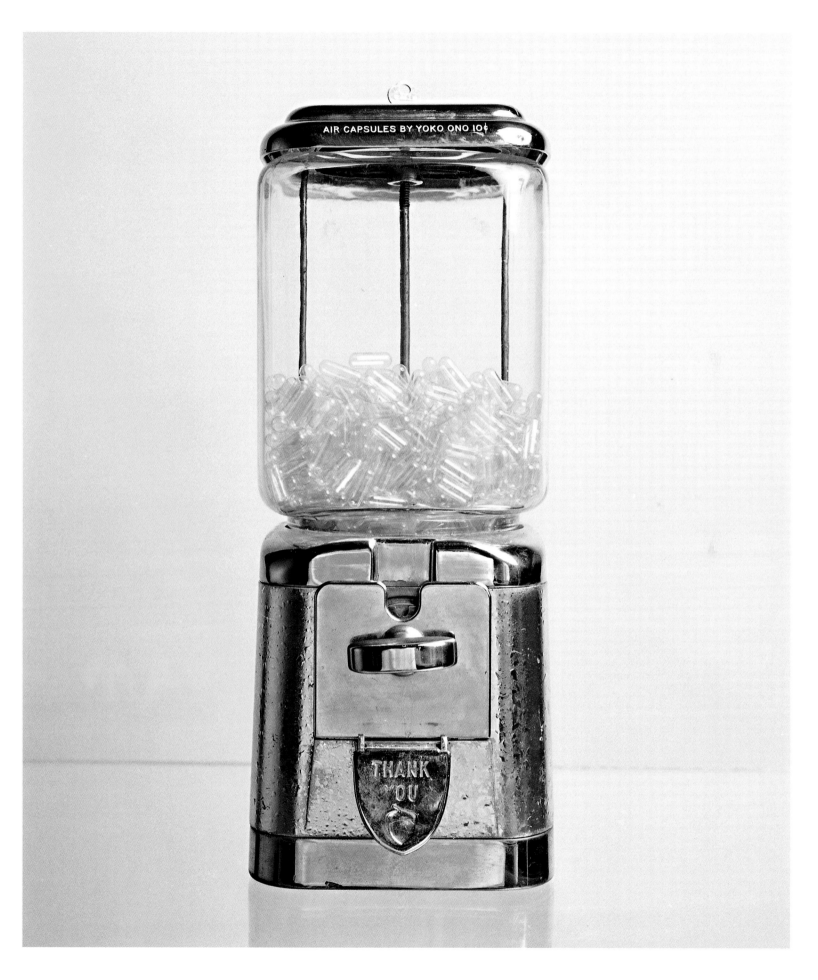

SKY MACHINE, 1961/1966
Dispensed cards with the word
"SKY" inscribed in pencil
2.5 × 4.4 cm each

SKY MACHINE, 1961/1966
Stainless-steel dispenser, handwritten
paper cards, metal pedestal
Inscribed: WORD MACHINE PIECE #1
'SKY MACHINE' BY YOKO ONO 1961,
REALIZED BY ANTHONY COX 1966
Dispenser: 130 × 41 × 41 cm

Bronze Age

[...] A friend casually suggested I should do some objects in bronze. The suggestion was so offensive to me that my smile froze and tears ran down my cheek. "This man doesn't know anything about my work," I thought. I realized then that I had an absolute fear of bronze. But why? Then the thought of the sixties flashed in my mind. The air definitely had a special shimmer then. We were breathless from the pride and joy of being alive. I remembered carrying a glass key to open the sky.

I thought I had moved forward right into the eighties and further. But a part of me was still holding onto the sixties sky. The eighties is an age of commodity and solidity. We don't hug strangers on the street, and we are also not breathless. When the two big boys shake hands at the summit, maybe it's better that they exchange bronze keys rather than glass ones. In my mind, bronze started to have a warm shimmer instead of the dead weight I had associated it with. Bronze is OK. I thought. Eighties is OK. It has to do. One day, I would become a person who could handle bronze with grace and ease.

y.o. '88
New York

FOUR SPOONS, 1988
Patinated bronze
Engraved: FOUR SPOONS Y.O. 88
2.9 × 19.7 × 19.7 cm

UNTITLED, 1988
Patinated bronze
4 × 11.5 × 14.5 cm

THREE SPOONS, 1967
Silver spoons on Plexiglas pedestal
with silver plaque
Engraved: THREE SPOONS
YO 67
Spoons: 15.2 cm
Pedestal: 139.7 × 28.5 × 28.5 cm

\rightarrow

EVERSON MUSEUM CATALOG BOX,
folded and unfolded, 1971
Design by Yoko Ono with George Maciunas
Mixed media
Closed: 16 × 15 × 18 cm

A BOX OF SMILE, 1967
Sterling silver, mirror
Engraved: A BOX OF SMILE Y.O. '67
Closed: 6.8 × 6.4 × 6.4 cm

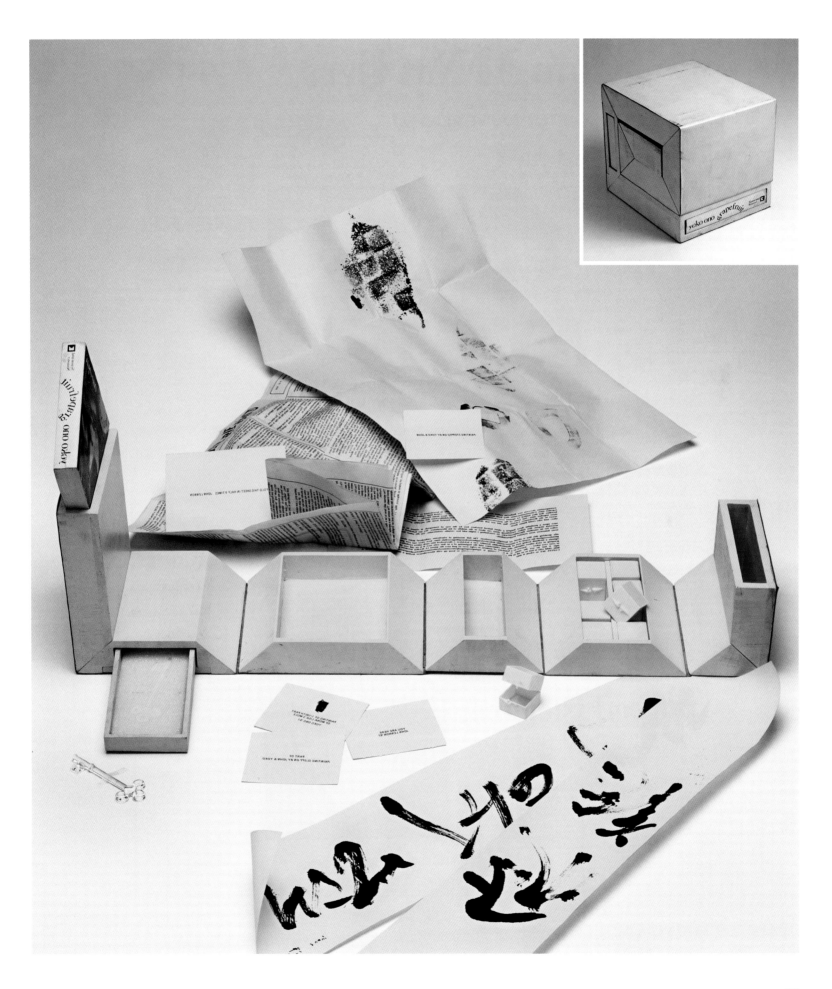

"BURN THIS NEWSPAPER AFTER YOU'VE READ IT."

"And you know, Yoko is the world's most famous unknown artist. Everybody knows her name, but nobody knows what she does." —John Lennon

GOING PLACES MEETING PEOPLE

DAILY SKETCH, Thursday, November 10, 1966

THE HONOURABLE ART OF SELLING AN APPLE FOR £200

FOR an artist, one might think colour is all important. But, apparently, not for Miss Yoko Ono, the Japanese organiser of "Events."

"I am unable to think in terms of colour," she explains. "So I do everything in white. Those who buy my works can make them whatever colour they like. Which is why Japanese brides are married in white."

Yesterday her exhibition of unfinished paintings and objects were on view at the Indica Gallery in St. James's, London.

Unfinished? Some apparently were not even started. Like the blank canvas "Shadow Piece" on which admirers make their own art by projecting shadow figures on the canvas.

One of the most expensive items on show was a glass case with an apple on top—a mere £200.

"There is the excitement of the apple decomposing, and then the decision as to whether to replace it, or just thinking of the beauty of that apple after it's gone," said Miss Ono.

Bicycles

On Thursday, Miss Ono is to present her London premiere of "A Grapefruit in the World of Park" at the Jeanetta Cochrane Theatre.

It will include "The Slipping Movement" when 100 bicycles will be ridden on stage, and Miss Ono is interested in hearing from anybody who wants to perform and help ... particularly bicycle owners.

And apple growers?

MISS YOKO ONO — MOUTHPIECE

THE DAILY TELEGRAPH AND MORNING POST

'Music' with no audible sound

By SEAN DAY-LEWIS

AFTER exercising both the Metropolitan Police and the London Fire Brigade with assorted burnings, slashings, choppings and attempted animal sacrifices in the last few weeks, the operations of the Destruction in Art Symposium are now coming to an elevated conclusion.

Last night Yoko Ono, said by her programme to "enjoy a reputation as a lecturer in classical calligraphy, poetry and music," and her assistants gave the first of two performances "of her music work" at the Africa Centre in King Street.

Anthony Cox, who acted as her chairman and principal assistant and regards her work as "very significant," has written that her "music is diametrically opposed to that of John Cage in philosophy and has no audible sound in the conventional sense."

"It is indeed what an ignorant listener, uninitiated into the way of 'destructive auto-destruction in art,' would call, for want of a better word, silence."

But all rules, like all art are made to be destroyed and the evening ended with "Dawn Piece," in which each member of the audience obeyed her instructions to shout the few words that came into his head for five minutes. She appeared satisfied with the appalling din that ensued.

Miss Ono, respectfully applauded and nearly invisible behind her hair, began with "Line Piece," in which some scarcely profoundly painted a white line and another assistant, with still greater profundity, rubbed it out.

Next came "Bag Piece," with simultaneous performance of Bicycle Piece for Orchestra, in which she and Mr. Cox disappeared into a black canvas bag for 20 minutes during which time they were said to have undressed and dressed again.

The accompanying bicycle which was pedalled slowly round them was an interesting machine with two wheels, handlebar, saddle and a useful luggage rack.

In "Cut Piece" Miss Ono sat looking inscrutably Japanese (she is actually Japanese) while members of the audience, took it in turns to cut off her clothes with a pair of scissors. After 40 minutes she was naked and somebody put up a notice saying "The body is the scar of the mind."

Miraculously still unscarred, Miss Ono then turned to her "Wall Piece," in which she banged her head against the stage and gracefully added that "If you wish to participate you can."

Many did and as a reward each "listener" was presented with a green tea to destroy as best he could as he left the hall.

THE FINANCIAL TIMES
Thursday September 29 1966

Yoko Ono by CORNELIUS CARDEW

Yoko Ono—" born in bird year, when spent her childhood and adolescence collecting skies and seaweeds, and in late adolescence gave birth to a grapefruit and now is at present travelling as a private lecturer" (so says the programme) —is a name previously known to the writer only as the owner of a spacious loft in New York where some of the most experimental and spectacular events in new music were permitted to happen in the early sixties. In Yoko Ono's loft practically the total oeuvre of LaMonte Young was programmed for a single evening—however, his "Drew a straight line and follow it" being still incomplete after four hours, it was conceded that the rest of the programme would have to be postponed. This is of course all hearsay, and events 3,000 miles away are inevitably invested with a legendary character to compensate for the absence of the actual experience.

Now Yoko Ono is in London, preceded by a friendly double spread in Arts and Artists. Last night a big black hat and move see her perform at the Africa erotic and tenderly suggestive way Centre. Instead of a taxing even to the accompaniment of "Bicycle ing of extended and experimental Piece for Orchestra"—a man work, however, she gave what can riding a white bicycle around the only be described as a highly auditorium as slowly and noise polished recital of her work, consistently as possible veniently broken down into short "pieces," which were received by the majority of the audience with the kind of reverence usually given to concert pianists. In fact, Yoko Ono is not a musician but a painter, which possibly accounts for her choice of this kind of format.

The character of the works was curiously moral and naïve. Certain pieces definitely do you good: "Bag Piece" for instance, which is a kind of living sculpture Yoko and her husband disappear into about inside it in a delicately suggestive way to the accompaniment of "Bicycle Piece for Orchestra"—a man riding a white bicycle around the auditorium as slowly and noiselessly as possible.

But my conviction of the uplifting quality of the work began to waver in the celebrated "Cut Piece" which followed. It was impossible to dismiss the compulsion of the audience to cut and Yoko Ono's compulsion to be cut. In cutting off pieces of her clothing, members of the audience show unmistakable signs of artistic striving, and the far for part is equally unmistakably striving towards a kind of nerveless detachment, so that all emotional interplay is precluded. As the piece progresses one becomes aware of another kind of nudity underneath the clothing of her skin, and this inner amorphous nude shape is visible only in her eyes, fixed unwinkingly on the audience.

The audience is crucial to Yoko Ono's art, but the other participation pieces seemed like gratuitous games which could not take effect in the short time allotted to them. It is to be hoped that in the second concert (this evening at 7.45 at the Africa Centre, King Street, Covent Garden) she will be able to devote more time and intensity to this side of her activity.

4th ANNUAL NEW YORK AVANT GARDE FESTIVAL

YOKO ONO, composer in five arts, creator of "Music of the Mind,—" in which mostly non-sound situations are given for the audience to listen to their mind music created "In result of participating in the given situations— will open the festival at dawn with a sunrise event." Two other works will be performed, Aos (audience will be requested to shout for five minutes) and Cut Piece (in which members of the audience may cut portions of Miss Ono's costume).

SEPTEMBER 9, 6 AM TO MIDNIGHT, FRIDAY

The Listener
NO. 1963 THURSDAY NOVEMBER 10 1966

Round the art galleries

Ways of simplifying
by PAUL OVERY

At the Indica gallery there is a show of work by Yoko Ono, who is Japanese and lives in New York City. Yoko Ono gave two performances in London recently at the Africa Centre and is giving another at the Jeanetta Cochrane theatre on November 17. She makes no real distinction between works that can be performed and works which can be exhibited. In both, the spectators come to share the creative role with the artist. Similarly one of her works can exist either as an executed piece, or merely as a set of instructions, for example, 'Painting to be stepped on'—' Leave a piece of canvas or finished painting on the floor or in the street'. It is the idea that is important, not its execution, and once you've got the idea you can use it just as well as the artist can. Previously in art the idea has been obscured by the importance of the way it has been transferred into the material. A smoke-coloured tube of perspex comes with a soft cloth and is called 'Cleaning Piece'. A sheet

of perspex is broken in two; the instructions are 'mend in your mind'. A chess set is painted entirely white. You may play if you can remember which are your pieces.

Yoko Ono's work is exhilarating because it makes us aware of our potentiality as creators. Because we know we can carry out these ideas just as well as she can, all barriers between artist and public are broken down. The purpose of Yoko Ono's work is to simplify, to cut through intellectual complexity to arrive at some degree of self-knowledge. How this works can perhaps be best illustrated by one of her performances, 'Strip Tease for Three'. At the beginning three chairs are put on the stage. Nothing happens, the audience grows impatient. Then the three chairs are removed. The performance is over before one realizes that it has begun. The performance is 'nothing', but in retrospect that nothing has become something. One's initial frustration at being 'cheated' is followed by the realization that one was wrong to expect anything, that nothing was promised. Frustration becomes revelation. The work on show at Indica challenge us in a similar way.

LONDON GALLERIES
by Norbert Lynton

There is another exhibition that asks to be described as strange, and that is the Yoko Ono show at the Indica Gallery (6 Masons Yard, St James's, SW1). Yoko Ono, an American lady, is known for gently subversive "happenings" rather than for art objects and her exhibition is really a happening too. Male and female contraceptives and The Pill are offered up on three pedestals, whether for sacrifice or worship I know not, and there are some unfinished paintings on the walls together with pots of paint and brushes in case you wish to help. The fact that the gallery was locked up when I called there and that I had to observe all this through the window added another emotional dimension to the experience but was probably not part of the programme.

THE GUARDIAN
London Tuesday November 22, 1966

SUNDAY TELEGRAPH
January 1, 1967

A nice roll in the stone

From America, new bundles for New Britain?

THIS "event," to which a number of Greenwich Villagers were recently introduced, is known as "The Stone." It is a specially designed room with dead white walls, but one is transparent, and has a flashing light behind it. Bulbs in the ceiling are switched on and off through a continuous cycle, which alternately brightens and darkens the chamber. From hidden speakers come the taped strains of a guitar making sounds which are vaguely Oriental.

The people, who are both actors and audience, are enclosed in loose-fitting black muslin bags, through which they can see, but cannot be seen. If they feel like it, they can undress inside their bag. They can walk about, or crawl, they can go to sleep or they can sing and yell.

The concept of this exercise, which was devised by the Japanese "add-colour" artist Yoko Ono (Mandrake, Nov. 27, 1966), and her American husband, artist Antony Cox, is to produce a sense of well-being and tranquillity, to get the sort of "lift" that can be obtained with drugs, but without taking them. It has been described by the Greenwich Village newspaper as "a mental sauna bath," and as a new art form "affording a rare opportunity to impersonate a stone."

Miss Yoko Ono herself says that she conceived "The Stone" as an "event," which is defined as an inner gathering, as opposed to a "happening," which provides opportunities for audience participation.

The idea of the bag occurred to her in Japan. One day guests were coming for the evening, and, as Miss Ono explains it, "I just couldn't stand the tension of meeting them face to face—I'm the sort of person who is always trying to escape from tensions—so I made a bag for myself. I wanted to see the people, but wanted to see them while I was in a bag."

When the friends arrived and asked Mr. Cox where Yoko was, he said "There she is," pointing at the bag.

The idea of a special room followed, and now there are plans to produce "The Stone" at an off-Broadway theatre, and even to produce "bagwear" commercially.

"We feel that everyone should have a bag in their wardrobe," says Miss Ono. "When they're concealed, they're revealed." It has been suggested that every office should have a supply of bags, too. If their employees took refuge in them occasionally during working hours, it would relieve their tensions.

Possibly it would not have the same happy effect on employers. "Where's my secretary?" "In the bag, sir."

No. 3 NOV. 14-27

The Most Beautiful Apple

Yoko Ono, the Japanese avant garde artist composer who has been in England this summer, is presenting an evening of new works entitled "Music of the Mind" at the Jeanetta Cochrane Theatre, Southampton Row, Holborn on Thursday, November 17. This will be her last big concert in London.

Yoko Ono calls, as Aos Events, a new form of concert art not to be confused with "Happenings." Her new opera, "A Grapefruit in the World of Park" will be presented for the first time in London. Yoko Ono is currently having a one-man show of her Unfinished Paintings and Objects at Indica Gallery in Mason's Yard, Duke Street, Saint James, S.W.1 until November 18. Work shown at the second concert will include more time and intensity to this side of her activity.

The other participation and Objects at Indica Gallery which rushed around the art which is essentially showing "this is the most beautiful apple I have ever seen" and "that is the very essence of a needle." Or so the story goes.

Yoko asks anyone who is interested in performing and helping with the production of her music to please telephone Holborn 4815; all persons who own bicycles are also asked to phone immediately.

Yoko Ono performs her work CUT PIECE at Carnegie Hall

Concept-art, where you can be an Artist, goes further and involves the audience as in Ono's CUT PIECE, where each member of the audience is asked to come up on the stage one at a time and remove the performer's clothing with a large pair of tailor's shears. The performer sits motionless through the whole operation in a kneeling position until all the clothing has been removed or everybody has had a chance to cut, usually about an hour. In contrast to the rest of the concert which is usually filled with restlessness in the audience, this piece always takes place in complete silence, with periods of several minutes elapsing before the next performer (member of the audience) gets enough courage to come up on the stage. Usually only one third of the audience performs while the rest apparently consider the prospect.

Coughing is a form of love.

All streets are invisible. The visible ones are fake ones, though some visible ones are the end parts of the invisible ones

Teeth and bones are solid form of cloud.

Paper is marble cut so thin that it has become soft. (Make marble out of toilet paper.)

Plastic is a portion of sky cut out in solid form. (Collect many pieces of plastic and look through them to see if they look blue.)

If you wear a clothes long enough it becomes part of you and you will suffer from serious physical maladjustment when you take it off. A princess died from taking off vines that had covered her for 5 years. A prince, when his encircling vines were removed, was found to be non-existent.

When you leave things, you leave your spirit behind, too. But if you don't leave them, you age.

Your brother is the man you killed in the past world. He was born in your family because he wanted to be near you

There is a wish man in the corner of the world whose daily task is to send good-will waves to the world to clear the air.

Men used to walk on hands upside down, but they changed to present form because it was considered less obscene.

What is a circle event?

Do your circle event in the "Stone" pamphlet (53 cents)—and 99 per cent of the world is dead bodies and tombs. We are remaining 1 per cent ... (or are we?).

There are one thousand suns arising every day. We only see one of them because of our fixation on monistic thinking.

Piano keys are flower-petals turned hard.

MENDING PIECE 1 1966

BIOGRAPHICAL STATEMENT

Yoko Ono was born in Tokyo in 1933. Her father was a successful banker; her mother enjoyed her affluence and loved parties and dances. Yoko attended a fashionable school and crown prince Akihito was among her classmates. In 1944 she was evacuated to the countryside just as the United States began its air raids over Japan. She swapped family valuables for food during the war in order to ward off starvation. In 1952, the Ono family moved to New York City and Yoko attended Sarah Lawrence College for three years. She left school to join the New York avant garde art scene. She maintained a loft and gave concerts and gallery shows. Her marriage to Japanese pianist, Tochi Ichiyonagi, ended in divorce, and she married independent film producer Antony Cox. They have a seven-year-old daughter, Kyoko. The Coxes moved to London where Miss Ono's film, Bottoms, a montage of 365 British backsides, created quite a stir. Miss Ono published at her own expense a limited edition of Grapefruit, her book of instructions. "BURN THIS BOOK AFTER YOU'VE READ IT," she instructed from the fly leaf. A friend took her at her word and burned 250 copies, half of the book's first printing. Simon and Schuster published the book officially in 1970 and will publish an up to date version in the fall. John Lennon met Yoko Ono at a gallery show of her works. They were married on March 20, 1969 in Gibraltar.

PI PAINTING TO BE STEPPED ON 1961

This painting stems from FUMIE meaning stepping painting, in the 15th century in Japan during the persecution of the christians by the feudal lords, suspected christians were lined up and asked to step on a painting of Christ or the Virgin Mary, those who would not step on the painting were crucified.

FILMS	CHAMBER MUSIC
JAZZ	HAPPENINGS
DANCE	EVENTS
ELECTRONIC MUSIC	MUSIC BIKE
	POETRY

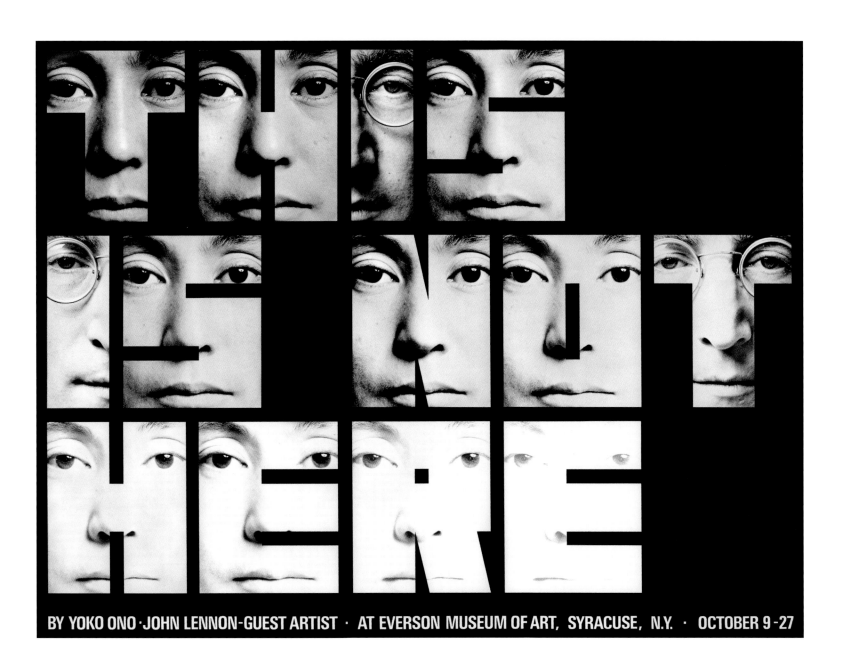

THIS IS NOT HERE

BY YOKO ONO·JOHN LENNON-GUEST ARTIST · AT EVERSON MUSEUM OF ART, SYRACUSE, N.Y. · OCTOBER 9-27

THIS IS NOT HERE, 1971
Publication in newspaper format
Edited by John Lennon with Peter Bendry,
designed by John Lennon
Everson Museum of Art, Syracuse,
New York, October 9–27, 1971
Offset on paper
55 × 42 cm

THIS IS NOT HERE, 1971
Poster
Everson Museum of Art, Syracuse,
New York, October 9–27, 1971
Offset on paper
46 × 61 cm

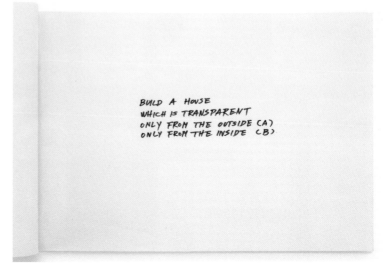

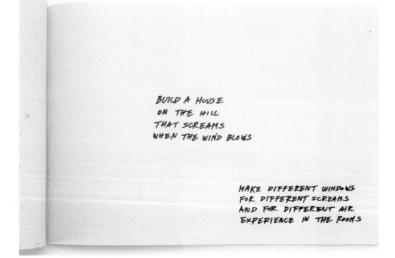

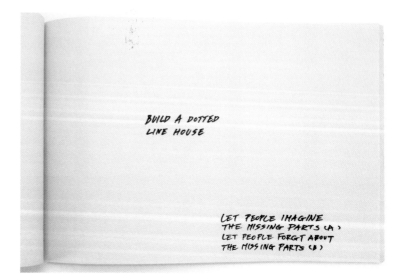

PIECES DEDICATED TO GEORGE MACIUNAS,
THE PHANTOM ARCHITECT, 1965
Ink on paper
15 × 23 cm

BUILD A HOUSE
THAT SERVES ONLY
TO MAKE WAY FOR
THE MOONLIGHT

TERRACE FOR PEOPLE
TO GET MOONBURN,,
CUPS, PONDS, BATHTUBS
TO BE FILLED ONLY WITH
MOONLIGHT, ETC

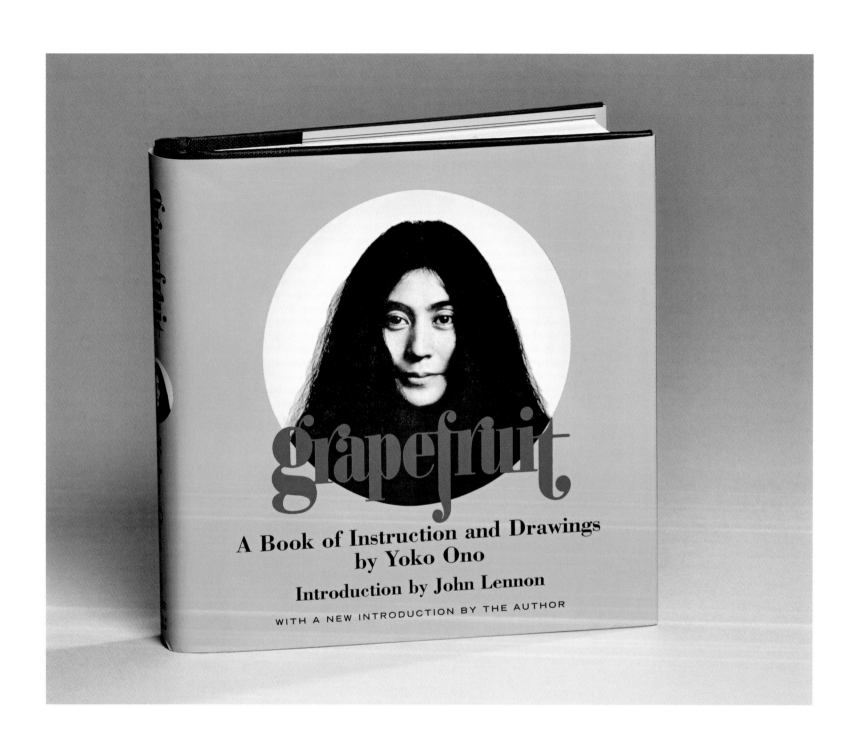

GRAPEFRUIT
Artist's book, published by
Simon & Schuster, 2000

122

Yoko Ono beyond Categories

Kerstin Skrobanek

Yoko Ono's art has always moved between categories. She has worked with literature and music and created works concerned with the theme of painting. Some of her ideas have been realized in sculptural form or in installations, others in the medium of film. Working with language has always been extremely important to her. In the late 1950s, she created so-called *event scores*, a form of sheet music in words, rather than notes, that provided directions for physical actions (*Balance Piece;* ills. pp. 138, 139), poems in palpable form (*Touch Poem*; ill. p. 93), canvases to be laid on the floor to be walked on (*Painting to Be Stepped On*; (ill. p. 18), and usable sculpture, such as the *Air Dispenser* (ills. pp. 110, 111). Ono's works are hybrids that consistently exhibit characteristics of two (and sometimes three) genres and media. The artist uses this type of synthesis to break away from customary modes of perception and offer new sensory impressions to recipients, be they viewers or users. The following remarks will focus on two works, *Grapefruit* and *Sky TV,* which not only represent media hybrids, but also reflect the hybrid cultural background of the artist herself, who spent her childhood and youth moving back and forth between the US and Japan.

Ono's book *Grapefruit. A Book of Instructions and Drawings*, published in 1964, covers the years 1955 to 1964. During that period, most of the *Event Scores* mentioned above were written on sheets of paper or small cards. Ono regarded her *Scores* as material manifestations of ideas she conceived and stored in her memory. Some of these concepts she passed on solely in oral form. In preparation for her first solo exhibition at George Maciunas's AG Gallery in 1961, she began writing several of her concepts on small cards. Occasionally, she would simply note them down on the backs of invitation cards she found lying around in Maciunas's gallery.

Maciunas, who had planned to publish scores written by various artists as a "complete works" compendium, also promised Yoko Ono that he would publish her concepts as a Fluxus edition. Because Maciunas had taken on a large number of projects in the early 1960s, however, and soon reached the limits of his financial capacities, Ono decided to publish her concepts or *Scores* herself. At the time, publishing them in book form appeared to be the least complicated way of making her "collected works" available to a broad public.[1]

That decision is interesting not only because it marks the first point at which Ono appears as a publisher, but also because it prompts us to think about the form in which the artist records her instructions and concepts. These short texts offer clear evidence of Ono's interest in literature, and they exhibit (although this was not intended by the artist) striking affinities with Japanese *haiku* poetry. At first glance, *Grapefruit* has the appearance of a small volume of poetry, but a closer look reveals that it departs radically from the underlying intention of *haiku* by virtue of its appellative structure. A *haiku* is a poem of three or four lines (seventeen syllables) that describes a nature scene:

> An ancient pond
> A frog jumps in
> The splash of water
>
> Matsuo Bashō, 1686[2]

The reader of *haiku* becomes an observer, who reconstructs the moment described in the poem in his mind. Because of the ways in which the animals, which are always the protago-

[1] The author wishes to thank Jon Hendricks for this background information.
[2] English translation from Wikipedia (http://en.wikipedia.org/wiki/Matsuo_Bash%C5%8D). On the structure of *haiku*, see Dietrich Krusche, *Haiku. Japanische Gedichte* (Munich, 1995) 118.

nists in these scenes, behave in nature, emotions such as grief, melancholy, joy, and hope are awakened in the reader. Many of these poems also mention the season in order to reinforce the underlying mood of a scene:

On a withered branch
A crow has alighted:
Nightfall in autumn

Matsuo Bashō, latter half of the 17th century[3]

In contrast to the *haiku* poets, Yoko Ono does not describe scenes that can be reconstructed in a reader's mind. Instead, she gives directions, as indicated by the word "instructions" in the title. She places the human being and the human body as a single large sense organ in the foreground and shifts the action to the context of the big city, the environment in which she lives and works. It is important to recognize that these instructions can be followed in two ways. The recipient can actually carry out an instruction and do what is written on the card—walk through a building, for example, as instructed in "Building Piece for Orchestra." Or he can play it out in his imagination. Ono's concept goes beyond the contemplative effect of *haiku*, which is meant to sensitize the reader to moods and to generate images that stand for insights and nuggets of wisdom. Ono is not interested primarily in having her *Scores* acted out, but rather in inspiring readers to reflect upon a concept and apply it to their own life practice.

Grapefruit contains instructions for musical compositions, paintings, and performances and is meant to prompt an acoustic, visual, or physical experience, which is imagined at first and then, in a second step, alters our perception of the reality of our own lives.

CITY PIECE

Walk all over the city with an empty
baby carriage.

1961 winter

Yoko Ono incorporates the seasonal reference, which is accomplished in *haiku* through a description of the landscape, into the date entry, which thus takes on meaning in its own right.

It is left to the reader to decide whether to actually follow the instruction or simply to imagine the situation presented here. In this instance, the artist opens up above all an imaginary space in which such themes as loneliness and the feeling of being lost in a big city are juxtaposed with the image of the child as a metaphor for emotional security and a sense of family. In this way, the instruction comes another step closer to the contemplative, meditative effect achieved by *haiku*. Yet while *haiku* is always meant to generate an exclusively intellectual response, the *Event Score* always retains its appellative character.

Such instructions or *Event Scores* played an important role within the Fluxus movement, which was born around 1961 and in which Yoko Ono was also involved within the context of her friendship with George Maciunas. They emerged within the circle associated with John Cage, who taught at the New School of Social Research in the late 1950s and whose courses were attended by some Fluxus artists.[7] The third version of his famous piece entitled *4'33"* was published by Henmar Press in New York in 1960. This so-called *tacet* version

BUILDING PIECE FOR ORCHESTRA

Go from one room to another
opening and closing each door.
Do not make any sounds.
Go from the top of the building
to the bottom.

1963 winter

4

The conceptual reality, as it were becomes a concrete "matter" only when one destroys its conceptuality by asking others to enact it, as, otherwise, it cannot escape from staying "imaginary".

Yoko Ono, *The Word of a Fabricator*, 1962[5]

If my music seems to require physical silence, that is because it requires concentration to yourself—and this requires inner silence which may lead to outer silence as well.

Yoko Ono, *To the Wesleyan People*, 1966[6]

___3 English translation quoted from http://www.scribd.com/doc/77219249/Autumn-Night-by-Matsuo-Basho.
___4 Yoko Ono, *Grapefruit. A Book of Instructions and Drawings*, New York, 1970, n.p.
___5 Quoted from Alexandra Munroe and Jon Hendricks (eds.), *Yes Yoko Ono*, exh. cat. (New York, 2000), 168.
___6 Ibid., 288.
___7 Gerhard Rühm, "Biografie John Cage (1912–1992)," in: Wulf Herzogenrath and Barbara Nierhoff-Wielk (eds.), *"John Cage und"… Bildender Künstler – Einflüsse, Anregungen*, exh. cat. Akademie der Künste, Berlin / Museum der Moderne, Salzburg (Cologne, 2012), 299.
___8 On the different versions of *4'33"* see Dörte Schmidt: "It's important that you read the score as you're performing it". Die Fassungen von Cages *4'33"* aus philologischer Sicht, in *Transkription und Fassung in der Musik des 20. Jahrhunderts. Beiträge des Kolloquiums in der Akademie der Wissenschaften und der Literatur, Mainz, vom 5. bis 6. März 2004*, edited by Gabriele Buschmeier, Ulrich Konrad, and Albrecht Riethmüller (Stuttgart 2008), 11–43; for specific remarks regarding the *tacet* version, see pp. 22–27.

PAINTING TO SEE THE ROOM

Drill a small, almost invisible, hole in the center of the canvas and see the room through it.

1961 autumn

PULSE PIECE

Listen to each other's pulse by putting your ear on the other's stomach.

1963 winter

is the best-known version of *4'33"* and the first to be published.[8] It is also one of the earliest examples of a set of musical instructions containing no written notes.[9] The word *tacet* alone denotes the absence of an instrumental voice. Cage's teaching and the publication of this score provided important impulses to the use of notations or instructions written in words outside the field of music.

4'33" consists of three spans of time reserved for the perception of silence. Pianist David Tudor, who carried out the premiere performance, sat down at the piano and closed the fallboard. He then sat silently at his instrument and counted out the first interval of thirty seconds. The sound of the piano was not heard during either of the two other intervals (2'23" and 1'40"), yet the audience was compelled to realize that the room was not really silent after all. All attention was attracted to the sounds made by people in the room and to the noise outside the building.[10] In the *tacet* version, Cage's interest in the score as a composer shifted noticeably for the first time from structural silence to what is audible apart from silence. And thus it is enough to note down the temporal structure and the absence of the sound of an instrument, which can be done in the form of a text. That, in turn, inspired visual artists to focus less on an outcome, an artifact, and more on the underlying process, while involving the viewer at the same time. What then became important was what took place at a certain location within a certain period of time. The idea was to offer the recipient an aesthetic experience gained not only through the eyes, but through all of the senses. The focus of dialogue between artist and audience shifted from material production to perception.[11]

These instructions issued by Yoko Ono, short texts, which exhibit a concrete poetic structure and thus qualify as literature, can either be accepted as such or taken as guidelines for the actual production of a painting, a piece of music, or a performance. Thus they

LIGHTING PIECE

Light a match and watch till it goes out.

1955 autumn

___9 Liz Kotz, *Words to Be Looked At* (Cambridge, MA, et al, 2007), 59–98.
___10 Ibid., 15.
___11 On reassessments of aesthetic experience as a process since the 1960s, see Juliane Rebentisch, *Ästhetik der Installation* (Frankfurt am Main), 79–101, here 12–14.
___12 In Yoko Ono's oeuvre, we find not only a mixture of different genres, but also references from one genre to others. For example, the event score entitled *Lighting Piece* (1955) was realized as a film under the title *One* in 1966. These references within a given work, which function through individual concepts or images, such as sky or light, are found frequently in Yoko Ono's oeuvre. On Yoko Ono's films, see Maeva Aubert, *Flux Film Anthology*, DVD and booklet, Paris (Re:Voir Video) 1998.
___13 Bruce Altshuler, "Grapefruit," in: Alexandra Munroe and Jon Hendricks (eds.), *Yes Yoko Ono*, exh. cat. (New York, 2000), 82.
___14 Works of art deliberately positioned between categories would later be referred to by some as Intermedia. The term was established in the literature of art history by the American Fluxus artist Dick Higgins in his essay entitled "Intermedia," which was published in his *Something Else Newsletter* in 1966. See Lisa Moren, *Intermedia. The Dick Higgins Collection at UMBC* (Maryland, 2003), 38–43.
___15 Unfortunately, it is no longer possible to determine which television set was used for the first presentation of *Sky TV* or what it actually looked like, as no photographic evidence has survived. *Sky TV* was most probably first presented at the Indica Gallery in London in 1966. In the catalog for this exhibition, *Sky TV* is listed under "Works in The Show not Illustrated in this Catalogue." The author wishes to thank Jon Hendricks for this information. It is interesting to note that *Sky TV* was described in this publication as a *furniture piece*.

occupy positions between the genres of literature and painting, literature and music, and literature and performance.[12] In that sense, the title of the book appears all the more apt, as the grapefruit is a cross between an orange and a pomelo, and for Ono herself a symbol of her own identity, a combination of Japanese and American influences.[13]

Working between media boundaries is only natural for an artist who was also trained as a composer and studied philosophy. In dealing with different genres, media, and materials, she focuses above all on selecting the resource that enables her to express her concept or her idea in the clearest possible way.[14]

Yoko Ono's *Sky TV* was conceived in 1966. A television set showed a section of the sky and passing clouds.[15] Viewers could take the time—something they might rarely do otherwise—to gaze into the heavens and dream. With the aid of state-of-the-art video technology (the portable Sony Portapak camera had just been introduced to the market), Ono transported a piece of the sky to the exhibition room at the gallery. The simultaneous transmission also represented highly sophisticated technology. The camera was pointed from a gallery window toward the sky, and original images were transmitted to the television set instantly. *Sky TV* was one of the very first video installations ever exhibited, and at the time

one of only a few that presented live images from the immediate vicinity of an exhibition room.[16]

Sky TV also combines several different media: sculpture, visual imagery, and video installation. During the first presentations in the 1960s, the work exhibited a marked sculptural aspect, as television sets were large, cube-shaped objects that took up considerable space in those years. A similar transmission shown on a flat-screen TV today would give much greater emphasis to the pictorial character of the work. The underlying tension in *Sky TV* emerges from the combination of ultramodern technical advances and the traditional Western definition of the picture or painting as a window, which can be traced back to Leon Battista Alberti's text entitled *De Pictura* (*On Painting*), published in 1435. According to Alberti, a painting resembles an open window through which we can gaze at the world. In the Japanese culture in which Yoko Ono was socialized, the idea of the picture as an imaginary window does not exist, a circumstance that is attributable to the differing concepts of architecture in these two cultures. While the walls of a house in Western civilization serve as a partition between the inside and the outside, thus making windows necessary as aids to gaining an outlook and a view of the world, in Far Eastern architecture, the environment is regarded as an integral part of interior design. In his essay entitled "Der Blick durch das Fenster," Hans Belting points out that the relationship between outside and inside in Asian living quarters remains constantly open thanks to the use of sliding walls and doors. A view of the outside world can always be gained simply by shifting the position of a door. Accordingly, "Until the advent of Western influence in the late 19th century, the type of painting that represents a fixed point by virtue of its window form and brings the outside world into interior space as a framed view was unknown in Asian pictorial culture."[17]

Yoko Ono refers to the (Western) concept of the picture as a window and thus makes the viewer an observer who is inspired by the installation to move beyond the boundaries of his own limited field of view. He is called upon to look at a part of nature that could be anywhere and is therefore non-specific and, precisely because of its indeterminate character, offers tremendous potential for association. Moreover, the focus on passing clouds adds a strong meditative element to the whole. By observing nature and natural events—as described above with reference to *haiku*—the human being comes to himself and perceives himself as part of the cosmos. Ono very skillfully combines the idea of the TV as a telescopic view with the concentrated introspection of Zen Buddhism.[18] The supposed window on the world becomes an introspective view through the choice of the sky motif. The viewer is returned to himself, to his own wishes and longings.

Sky TV demonstrates in exemplary fashion how Yoko Ono dissolves the boundaries between the traditional genres and media by combining them. An object from the everyday world, one that is familiar to us and allows us to come closer, serves as a shell. Yet our expectations regarding the function of the apparatus are not fulfilled, nor does the work conform to the convention of the picture as a window on the world in a strict sense. As we observe a section of the sky, we experience the freedom Ono makes available for our imagination. She breaks down traditional media boundaries in order to break away from the rigid perceptual habits that influence our interaction with art. She prescribes no interpretations, but instead appeals to the viewer: *Look beyond yourself*. Every viewer is free to choose how he wishes to respond to the artist's offer. The same applies to *Grapefruit.* Whether we follow the *Instructions* in the *Event Scores* is left up to us. In any event, the artist sensitizes us to the world around us and creates an imaginary space for feelings and insights that are capable of stimulating change. Ono shakes off the shackles of convention in terms of both the production and the reception of art in order to help us develop a new, more attentive view of the world.

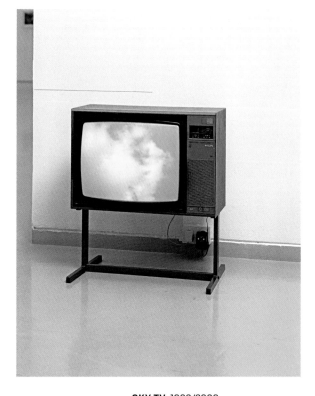

SKY TV, 1966/2000
TV monitor, closed-circuit video camera
Dimensions variable
Installation view at The Israel Museum,
Jerusalem, 2000

___16 Chrissie Iles, "Sky TV," in: Munroe, Hendricks et al. (eds.) 2000 (see footnote 9), 226.
___17 Hans Belting, "Der Blick durch das Fenster. Fernblick oder Innenraum?" in: Corsepius K. and Mondini et al. (eds.), *Opus Tessellatum. Modi und Grenzgänge der Wissenschaft. Festschrift für Cornelius Claussen* (Hildesheim/Zurich/New York, 2004), 21.
___18 On the idea of television as a telescopic view of distant lands, see Lambert Wiesing, *Artifizielle Präsenz. Studien zur Philosophie des Bildes* (Frankfurt am Main, 2005), 101.

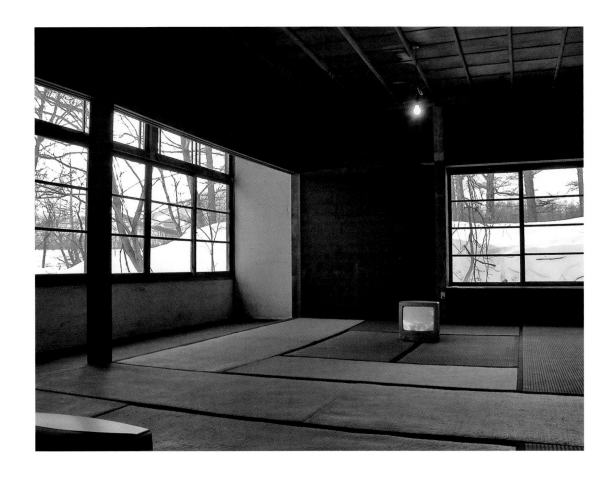

SKY TV, 1966/2005
TV monitor,
closed-circuit video camera
Dimensions variable
Installation view at
Tokachi Millennium Forest,
Shimizu, Hokkaido, Japan

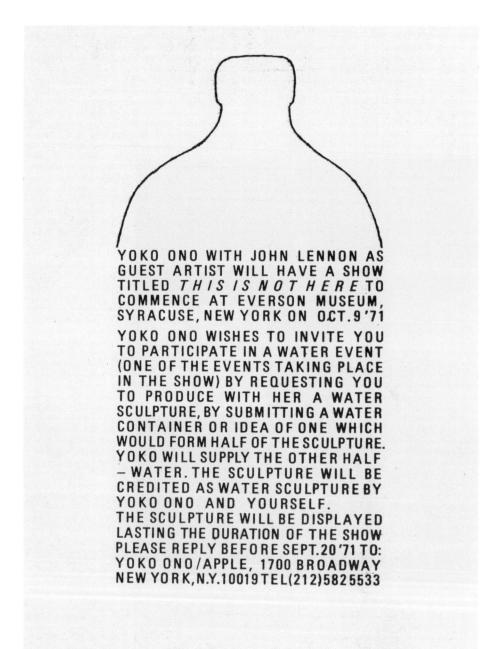

WATER EVENT, 1971
Invitation
Everson Museum, Syracuse,
New York, October 9–27, 1971
Offset on paper
16 × 12 cm

\rightarrow

WATER EVENT, 1971
Installation view at Everson Museum,
Syracuse, New York, October 1971

WATER EVENT by Yoko Ono and: Eric Andersen – Opus 81 ¦ Robert Barry – a piece of parched land ¦ Tom Basalari – a compass ¦ Judith & Julian Beck – ¦ Marna & Larry Bell – text ¦ Peter Bendry – steam engine ¦ Alex & Ronnie Bennett ¦ Charles Bergengren – light bulb ¦ Jeff Berner – bottle with cork ¦ David Bourdon – ice tray ¦ George Brecht – water still ¦ Dennis Brennan – bottle ¦ John Cage – himself ¦ Dick Cavett – top hat ¦ Ornette Coleman – intercourse ¦ Joseph Cornell – india ink bottle ¦ Philip Corner – listening sink ¦ Gregory Corso – spider ¦ Crawdaddy – rest room event ¦ Jed Curtis – dirt on water ¦ Allan D'Arcangelo – 12 Apostles ¦ Douglas Davis – electronic ocean ¦ Jane Davis – plastic pillow ¦ William DeKooning ¦ Brian Dew – gargle & perspire ¦ John Dunbar – tree ¦ Bob Dylan – his record ¦ Pieter Engels – love affair for liquified persons ¦ Robert Filliou – eyes ¦ Fluxworkers – water drunk in one year ¦ Richard Foreman – hollow soap ¦ Ellen Frank ¦ Charles Frazier – purification by fire & water ¦ Ken Friedman – table setting ¦ David Frost – microphone ¦ Steve Gebhardt – water level, floating letters ¦ Henry Geldzahler – pearl in ice ¦ Gary Giemza – bottle ¦ Mindy Godshalk ¦ Peter Hamburger – electric water ¦ Richard Hamilton – plastic bag ¦ Al Hansen – water mattress ¦ George Harrison – milk bottle ¦ Kevin Harrison – religious artifact no. 41 ¦ Patti Harrison – egg ¦ Susan Hartung – red on the right ¦ Jon Hendricks – salt ¦ Geoff Hendricks – mason jars ¦ Davi Det Hompson – yoko ono's eyes ¦ Mr & Mrs Nicky Hopkins – ¦ Dennis Hopper ¦ Douglas Huebler – letter (kiss) ¦ Jasper Johns – message ¦ Ray Johnson – letter ¦ Joe Jones – water beater ¦ Allan Kaprow – water on hotplate ¦ Mr & Mrs Jim Keltner – bottle of Musk ¦ Per Kirkeby – a boat ¦ Alison Knowles – ice cube ¦ Paul Krassner – grape ¦ Tim Leary – capsule ¦ John Lennon – Napoleon's bladder & flowers ¦ Charles Levine – wood cube ¦ Carla Liss – blue paper ¦ George Maciunas – H$_2$ & O$_2$ in pressurized tanks ¦ J. O. Mallander – text ¦ Joan Mathews – reservoir ¦ Gordon Matta-Clark – proposal for well in museum ¦ Charles McCarry – verse, the invisible water clock ¦ John Herbert McDowell – letter ¦ Taylor Mead – bottle ¦ Jonas Mekas – dream of self as vase, with goldfish ¦ Eric Michaels – envelope ¦ Spike Milligan – bottle ¦ Juliette Mondot – cactus ¦ Barbara Moore – paper bag & box of jello ¦ Peter Moore – nose dropper ¦ Victor Musgrave – binoculars ¦ Jack Nelson – mixed media sculpture ¦ Max Neuhaus – water whistle, bathtub accessory version ¦ Jack Nicholson ¦ Isamu Noguchi – rock ¦ Yoko Ono – drip music into oliphant ¦ Donna Ontaws – water on the knee ¦ Nam June Paik & Shigeko Kubota – their hands ¦ May Fung Yee Pang – battery ¦ John Peel – soccer ball ¦ Jan Penovich – museum boiler ¦ Hala Pietkiewicz – sweet pie ¦ Pulsa group – devination rod, clouds over loam, peaches ¦ Jock Reynolds – handkerchiefs for tears ¦ Dan Richter – dehydrated soup ¦ Sanejouand – chair ¦ Italo Scanga – glowing water ¦ Sara Seagull – toilet ¦ Norman Seaman & Family – ¦ George Segal ¦ Jason Seley – bumpers ¦ Shael Shapiro – gallon drunk each day by visitors ¦ Hugh Shaw – 2 glasses & 2 unlighted bulbs ¦ Mieko Shiomi – blue surface ¦ Howard Smith ¦ Michael Snow – waiter ¦ Phil Spector ¦ Mr & Mrs Richard Starkey – ring ¦ Shuzo Tagiguchi – drowned blotting paper ¦ Shinjiro Tanaka – message ¦ Julias Tobias – 20 bags of wet sand ¦ Ben Vautier – the museum ¦ J. Vona – water recycle ¦ Klaus Voorman ¦ Kieth Waldrop – plastic bubble ¦ Rosemarie Waldrop – hose ¦ Peter Wallach – ready made ¦ Andy Warhol – video tape ¦ Bob Watts – VW ¦ Julie Winter – duck in a pool ¦ Winfried Wolf – fire brigade ¦ Jud Yalkut – water wall no. 2, text ¦ La Monte Young – ¦ Frank Zappa – nostalgia piece for ernie's car

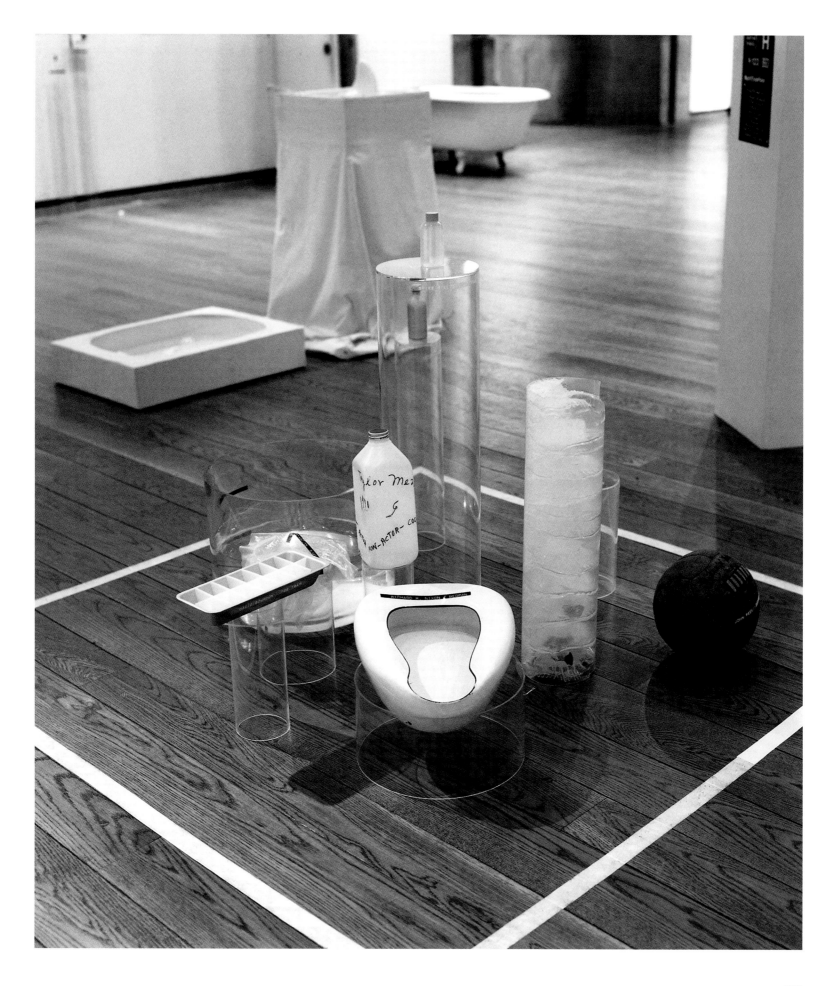

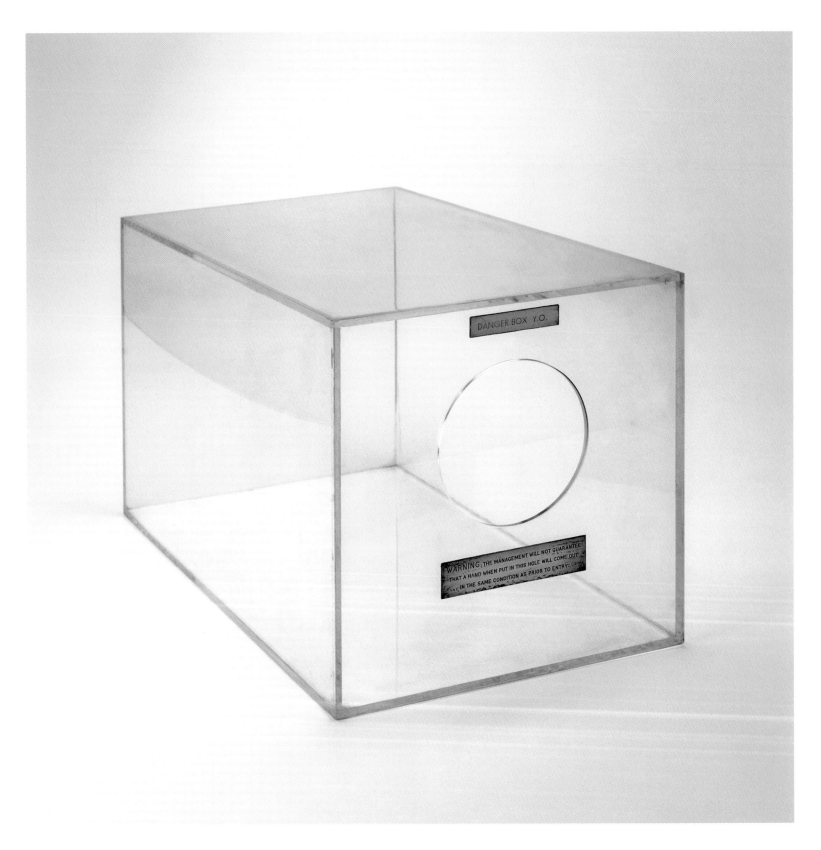

DANGER BOX, 1971
Plexiglas pedestal, silver plaque
Inscriptions: DANGER BOX Y.O.
WARNING: THE MANAGEMENT WILL NOT GUARANTEE
THAT A HAND WHEN PUT IN THIS HOLE WILL COME OUT
IN THE SAME CONDITION AS PRIOR TO ENTRY
30.5 × 30.5 × 61 cm

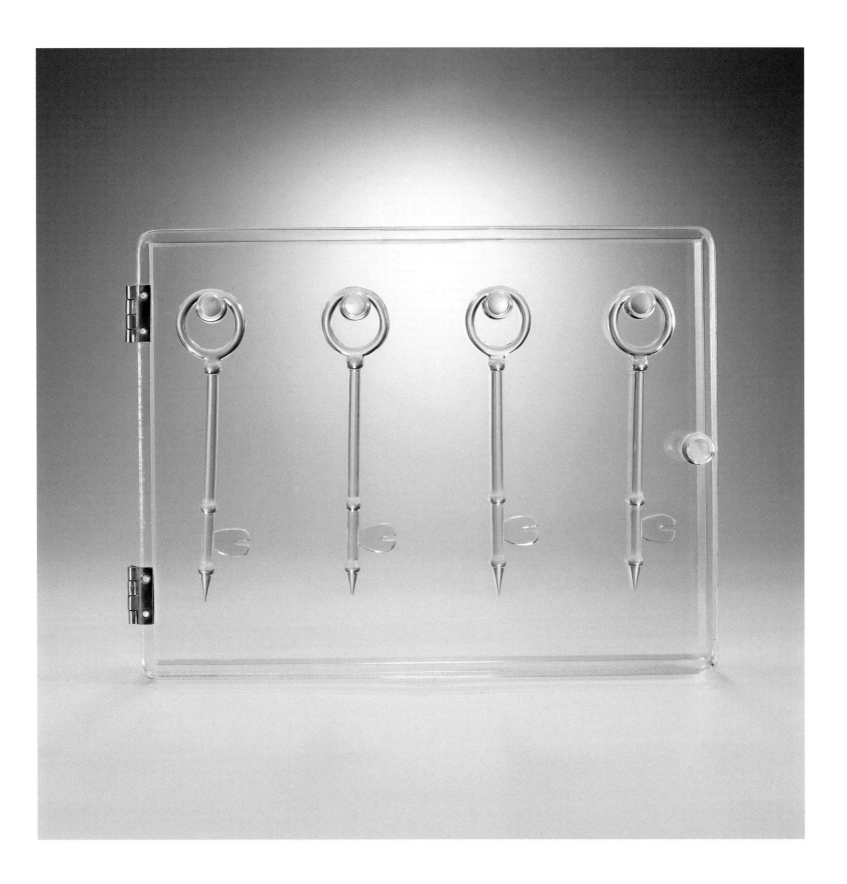

GLASS KEYS TO OPEN THE SKIES, 1967
Glass keys in Plexiglas box with brass hinges
Box: 20.25 × 27 × 4.5 cm, keys: c. 14 cm each

FRANKLIN SUMMER drawings, 1995–
Installation view with the artist, 2002

Y.O. 2001

Y.O. 2000

FRANKLIN SUMMER, 1995–
Ink on paper
Each 17.3 × 11.3 cm

Y.O. 2000 – 2001

Y.O. 2001

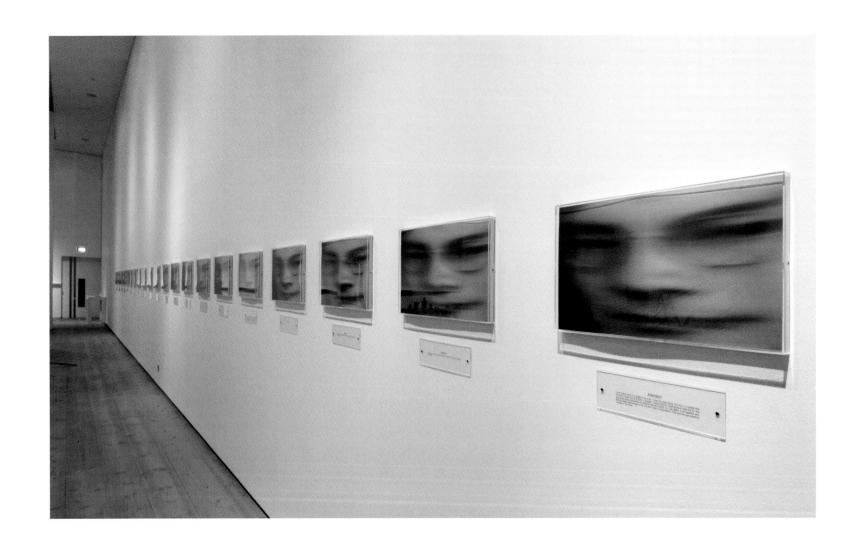

VERTICAL MEMORY, 1997

It was created putting together photographs of my father, my husband, and my son. I selected photographs of them facing the same direction, overlapped them and morphed it. Every photo represents the man who was looking over me in a precise moment when I went through an important situation of my life.
Yoko Ono

VERTICAL MEMORY, 1997
21 framed prints with texts
Iris prints, Plexiglas, texts
Frames: 32 × 49.5 × 4 cm
Texts: 9 × 28.5 cm

Doctor 1

I remember being born and looking into his eyes. He picked me up and slapped my bottom. I screamed.

Father

I was two-and-a-half when I arrived in San Francisco on a liner to meet him for the first time. He came on board, kissed my mother, and then looked at me looking up at him.

Stranger

My mother was late in coming home to the hotel we had been staying at. I went in front of the elevator and waited for her. A man who came out of the elevator told me that I should not be standing there and he would help me find my mother. I remember him being very kind, but my mother got very upset about it all.

BALANCE PIECE, 1997
Instruction drawing
Ink on paper
24 × 25 cm

Balance Piece

a) Build a room with a strong
electric magnet set on the left side
wall so everything in the room is drawn
to the left a little in time.

This will be a good balance for your
mind which is going to the right
a little in time.

BALANCE PIECE,
1958/1997
Instruction
Ink on paper
17 × 11 cm

1958 winter

y.o.

BALANCE PIECE, 1997/2010
Mixed media
Installation dimensions variable
Installation view
with the artist at Macro, Rome

CRICKET MEMORIES, 1998

This work is a metaphor for catastrophic loss in our lives—referring not just to one time or one country, but all countries—all lives, and the horrors committed by one people against another. Visitors are invited to write down their own CRICKET MEMORIES.

CRICKETS

These crickets were captured
in these regions in these dates
as indicated on the labels

y.o. 98

June 28, 1914 Sarajevo, Bosnia	August 6, 1945 Hiroshima, Japan	June 16, 1976 Soweto, South Africa
December 13, 1937 Nanking, China	October 23, 1956 Budapest, Hungary	December 8, 1980 New York City, NY
July 17, 1942 Stalingrad, U.S.S.R.	March 10, 1959 Tibet	April 5, 1992 Sarajevo, Bosnia-Herzegovina
January 18, 1943 Warsaw, Poland	March 16, 1968 Mai Lai, Vietnam	
February 13, 1945 Dresden, Germany	April 17, 1975 Phnom Penh, Cambodia	

CRICKET RECORDS

write your own

y.o. 98

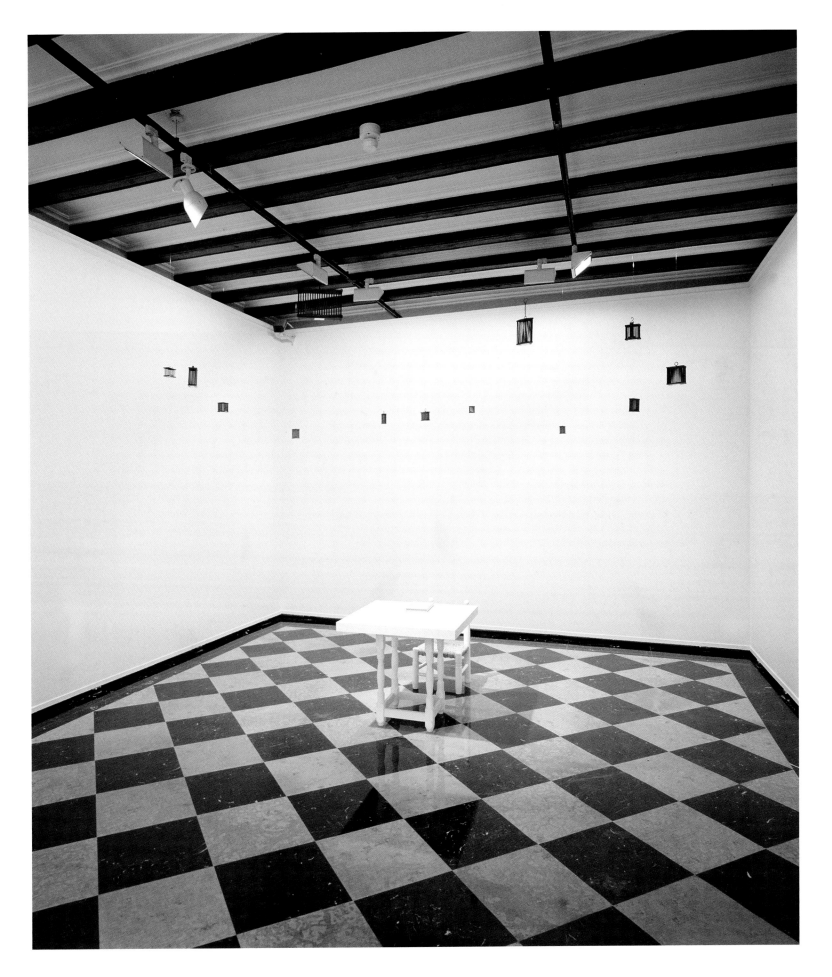

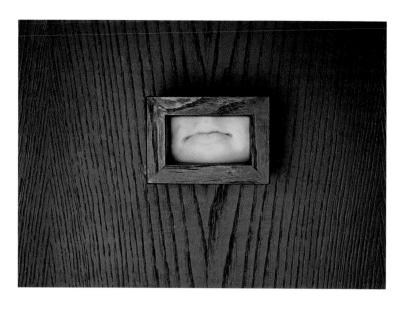

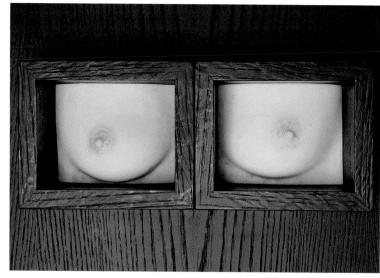

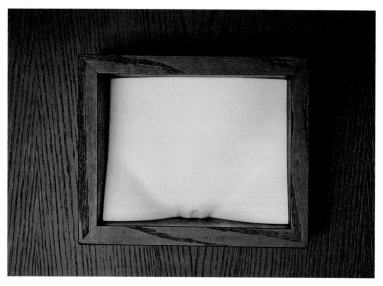

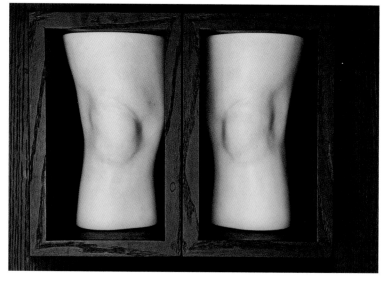

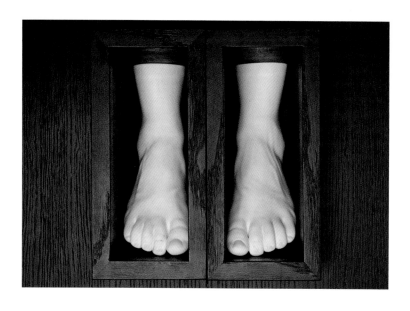

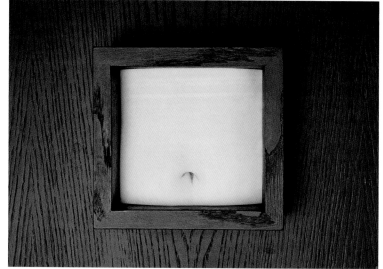

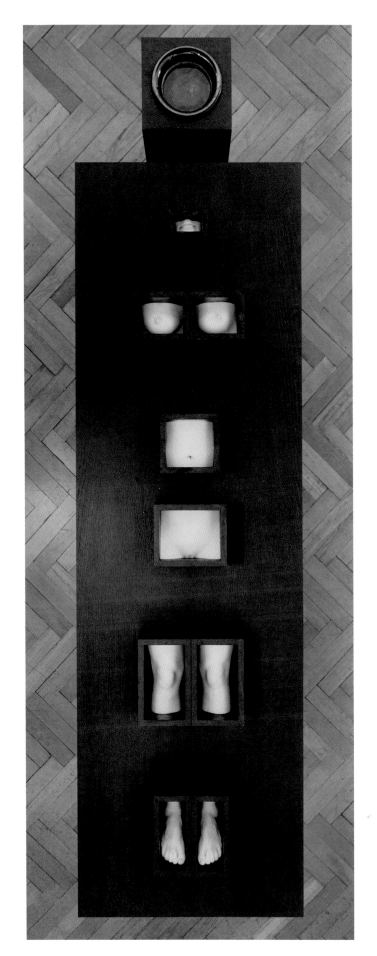

TOUCH ME, 2008/2009
Wood, marble, ceramic, cloth
Table: 61 × 244 × 76 cm,
pedestal with ceramic bowl:
76 × 30 × 30 cm

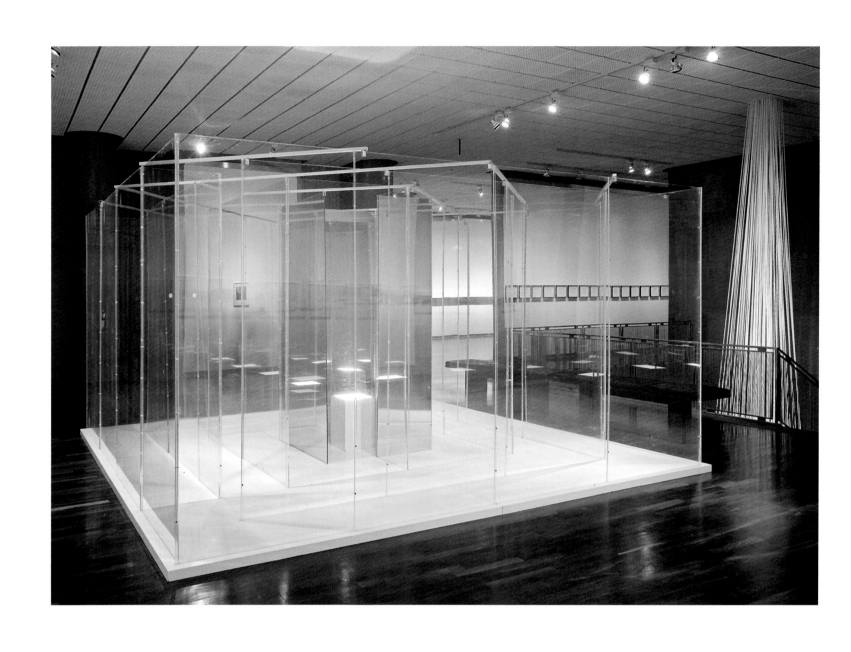

AMAZE, 1971
Plexiglas, metal, wood, light box
244 × 488 × 488 cm
Installation view
at Kunsthalle Bielefeld, 2008

MORNING BEAMS, 1997/2012

One day I went into my kitchen in the morning and found that the room was filled with all sorts of light beams emanating from various objects.
y.o. 1998

CLEANING PIECE, 1996
RIVERBED, 1997

Cleaning Piece was conceived as a kind of *Balance Piece*. There was a pile of river stones and, at some distance, two squares. One marked "mound of joy," one marked "mound of sadness." People could take a stone and place it in either area. Over time, the two piles attained a symmetry. In London in 1997, Yoko Ono changed the first pile of rocks into *Riverbed*, spreading the stones out to become a passage to another side, joining *Morning Beams* to the whole.

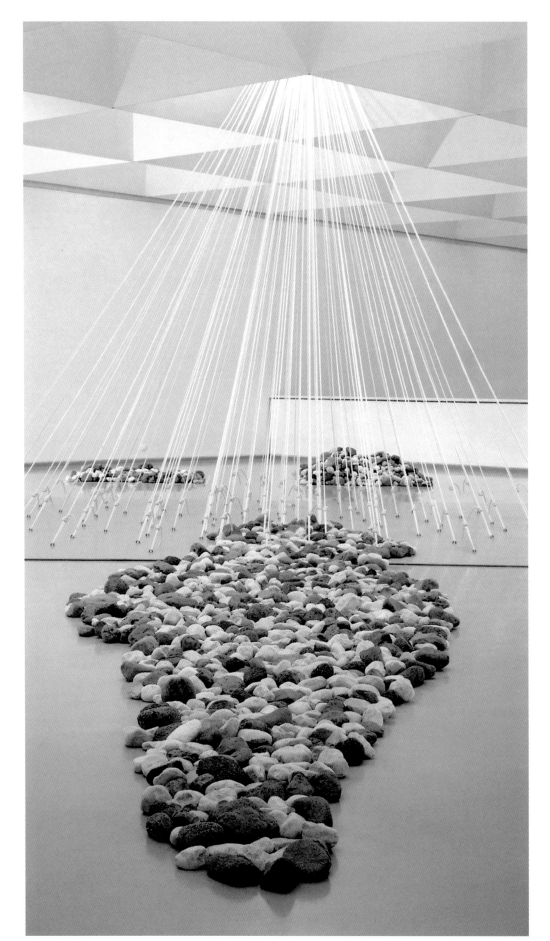

MORNING BEAMS / RIVERBED, 1996
Nylon ropes, stones
Installation dimensions variable
Installation view at
The Israel Museum, 2000

EN TRANCE (Revolving Door Version), 1998
Glass, metal, beaded curtain
Installation dimensions variable
Installation view at André Emmerich Gallery, New York, 1998

WISH TREE, 1996
Pomegranate tree, paper, string, pens
Installation dimensions variable
Installation view with the artist at
Lonja del Pescado, Alicante, 1997

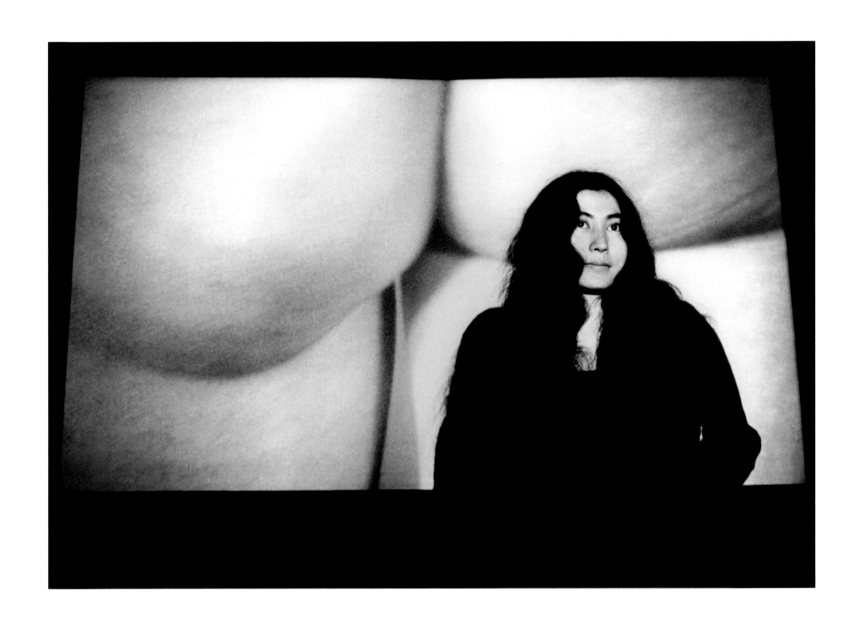

FILM NO. 4 (Bottoms), 1966
Photograph of the artist with a projection
of the film in London, 1967

Yoko Ono's Films

Kathleen Bühler

"Every breaking away from the conventional, dead, official cinema is a healthy sign. We need less perfect but more free films. If only our younger filmmakers—I have no hopes for the old generation—would really break loose, completely loose, out of themselves, wildly, anarchically! There is no other way to break the frozen cinematic conventions than through a complete derangement of the official cinematic senses." (Jonas Mekas, February 4, 1959[1])

Seven years after making that statement, Yoko Ono fulfilled the wishes of her friend Jonas Mekas—a Lithuanian-born filmmaker, film critic, and writer who has lived in the US since the 1950s—although not "wildly, anarchically," but in a coolly calculated manner;[2] for as she wrote in 1971 during the Cannes Film Festival, "Violent revolutionaries' thinking is very close to establishment-type thinking and ways of solving problems. I like to fight the establishment by using methods that are so far removed from establishment-type thinking that the establishment doesn't know how to fight back."[3] Fluxus films are based on simple concepts, entirely in keeping with the spirit of Zen and similar to those that underlie the actions of Ono, who was born in Japan but has spent much of her life in America. Ono concentrates on minimal plot lines characterized by a frugal use of cinematic resources, which enable her to achieve poetic effects much like those of *haiku* while promoting insights into broader contexts. Aside from the status of women in society, which Ono examines in her films, she also addresses issues of concern to the peace movement in several of these works. Moreover, all of her works reflect her strong belief in the power of imagination as well as her goal of questioning the passiveness of consumer society through poetic and absurd actions.[4]

A Blending of Disciplines in Underground Cinema

Like many artists of her generation, Yoko Ono was attracted to the medium of film in the 1960s. Even before she began making films, she published film concepts consisting of simple instructions. One of the distinctive hallmarks of these instructions was that they could be carried out by anyone. After her first experiences with music and performance, some within the context of the Fluxus and happening movements, she seized the opportunity to make her first film in 1966 and realized a total of nineteen films ranging in length from one to eighty minutes by 1972. Several of these works were produced in collaboration with her husband-to-be, John Lennon.[5] Ono's background in experimental music and her conceptual works of art earned her a place from the outset in the underground film scene in New York, where Jonas Mekas was one of its most committed spokespeople. Although most experimental filmmakers took up the camera themselves and employed it as a vehicle for personal expression, Ono preferred to have one or two people assist her. As a conceptual artist, the actual process of filming was of secondary importance to her.

The cinema and art scene of those years was receptive to a combination of mutually enriching influences from visual art, film, dance, music, theater, and literature. Performances were presented in countless street cafés, jazz bars, private lofts, and film clubs. Joint projects were developed and realized. Ono's first two films, *Eye Blink* and *Match Piece*, were also products of this context.[6] The artist recalls: "One day, George [Maciunas] called me and said he's got the use of a high-speed camera and it's a good opportunity, so just come over

——1 Printed in Jonas Mekas, *Movie Journal. The Rise of a New American Cinema, 1959–1971* (New York, 1972), 1.
——2 From 1959 to 1971, Mekas authored a film column in the New York newspaper *The Village Voice*, in which he reviewed the most recent underground films. He was also a cofounder of the Anthology Film Archives in New York. Cf. Mekas 1972 (see footnote 1), IX.
——3 Quoted from Barbara Haskell and John G. Hanhardt (eds.), *Yoko Ono. Arias and Objects* (Salt Lake City, 1991), 108 f.
——4 Yoko Ono: "Above all, my works protest this incredible materialism and technical progress that obscure the essential things in life," quoted and translated from "'Jeder muß etwas dazu tun ...'. Ein Gespräch von Andreas Denk," in: *Kunstforum International*, vol. 125 (1994), 278.
——5 This article focuses on only a few of Yoko Ono's films and is concerned primarily with the era of underground cinema in the 1960s and 1970s. Thus the discussion does not include later films such as *A Blueprint for the Sunrise* (2000), her recreated multimedia installation *Smilesfilm* (2010/2012), or her music videos from the years 1965 to 1995.
——6 These were included along with *No. 4* in the Fluxus film anthology. Since George Maciunas issued that work repeatedly in different constellations, the same film is identified by different numbers. Cf. Jon Hendricks, "Uncovering Fluxus – Recovering Fluxus," in: Thomas Kellein (ed.), *Fluxus* (London, 1995), 128 f.

[to Peter Moore's apartment on East 36th Street] and make some films. So I went there, and the high-speed camera was set up and he said, 'Give me some ideas! Think of some ideas for films!' [I]t was the kind of opportunity that if you can get it, you grab it. So I'm there, and I got the idea of *Match* and *Eye Blink* and we shot these. *Eye Blink* didn't come out too well. It was my eye, and I didn't like my eye."[7]

Fluxus Films

Both *Eye Blink* (1966) (ills. pp. 154, 155) and *Match Piece* (1966) (ill. p. 153) can be classified as Fluxus films. This movement initiated and dominated by George Maciunas was based on a radical revolutionary concept of art as a collective undertaking. It stood in opposition to everything—as Thomas Kellein writes—that was obscure, magical, ritualistic, or existential, and attacked the conventional theatrical self-centeredness of the art of the period with unpretentious sight gags, concerts, and actions.[8] Fluxus films are also innovative explorations into the possibilities offered by the medium. They tell no stories, nor do they document events. They focus on an isolated, minimal action. *Eye Blink*, for example, shows the blinking eye of the artist, and *One (Match)* a close-up of a match being lit and burning out. Both black-and-white films were shot with Maciunas's high-speed camera, which captured 2,000 images per second, instead of the twenty-four recorded by standard film cameras. As a result, processes that cannot be observed with the naked eye are stretched in time; played back at normal speed, an event that lasts a second can be extended to as long as five minutes.[9]

The third Fluxus film, *No. 4* (1966) (ills. pp. 148, 150, 151, 156), was shot with a standard 16 mm camera and shows a sequence of moving images of the bottoms of a group of New York artists and friends of Yoko Ono.[10] The silent parade is amusing, sensual, and rebellious at once, and the reference to the excretory organ is entirely in keeping with the spirit of Fluxus—the name "Fluxus" is derived from, among other meanings, the medical term for spontaneous intestinal outflow. At the same time, however, the desire to develop new images of the body and liberate it from traditional notions of gender-specific characteristics and sexual projections was an early indication of Ono's feminist orientation.

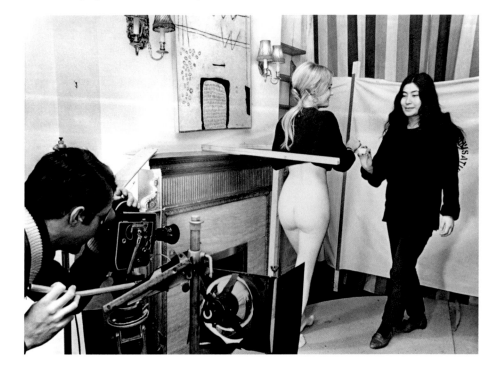

Production still from
FILM NO. 4 (Bottoms), 1966
Winter 1966/67, London

——7 Quoted in Scott MacDonald, *A Critical Cinema 2. Interviews with Independent Filmmakers* (Berkeley, Los Angeles/Oxford, 1992), p. 145. The fact that Yoko Ono didn't like her eye may be one of the reasons why this film is rarely shown at her exhibitions.
——8 Thomas Kellein, "I make jokes! Fluxus Through the Eyes of 'Chairman' George Maciunas," in: Kellein 1995 (see footnote 6), 18.
——9 Both films were shot with stationary cameras and are the first known examples of a mini-genre within underground cinema, namely the "single-shot film," which is apparently or actually filmed with a single shot. Cf. MacDonald 1992 (see footnote 7), 140.
——10 The group included Geoffrey Hendricks, Ben Patterson, Philip Corner, Bici Hendricks, Pieter Vanderbeek, Carolee Schneemann, James Tenney, and Yoko Ono's daughter.

Sensual Anticipation of the Structural Film

The success of *No. 4* prompted Yoko Ono to shoot a longer version of the film after her move to London that same year. For eighty minutes, *No. 4 (Bottoms)* (1966/67) presents an even larger number of rear ends in close-up.[11] The artist found the performers through friends and word of mouth, as well through newspaper ads. The shooting turned into a happening, a veritable meet-and-greet for the London art and theater scene, and attracted considerable media interest. For the first time, the artist combined the filmed images with a sound collage composed of excerpts from discussions recorded during the shooting sessions. The people interviewed talk about their hopes for a film career, about their frustration at what they considered the frivolous nature of their roles, about their fear of excessive self-exposure, the possible reactions of the audience, the artistic character of the film, and the purpose of the action. The film ends in self-irony with the remark that people evidently take everything too seriously.

About midway through the film, Yoko Ono explains her aim of "expanding consciousness" by enabling viewers to perceive the innocent beauty of a generally neglected part of the body from a new point of view. And it is indeed astounding to see how Ono succeeds in evading all of the voyeuristic traps associated with this particular motif. This she accomplished for the most part through her choice of pictorial detail, which shows only a cross formed by the crease between the buttocks and the folds of the bottom positioned in the center of the image. Thanks to this device, the unexpected individual form of movement is revealed, and the bottom is not stylized as a suggestive lure, as some participants feared. George Maciunas was the first to note parallels to structural film.[12] During its heyday from the late 1960s to the late 1970s, representatives of this new film movement investigated the formal resources of film, dismantled cinematic illusion, and reflected upon the essence of visual perception. It was a self-critical undertaking that also questioned institutions. Its appeal consists even today in the combination of strict concept and sensual beauty. And that also applies to *No. 4 (Bottoms)* and its "erotic conceptualism."[13] While the film adheres on the one hand to strict formal principles, it also reflects on the process and the goals of filmmaking per se. Ono employed these principles herself in an intelligent attack on the widespread consumption of erotic images of the body through the medium of film.[14]

Feminist Statements

While most of the many depictions of nude bodies and sexual activity in underground films may be regarded as critical commentaries on the hypocritical conventions of Hollywood movies as they were perceived by underground filmmakers, they could not prevent the portrayal of women as sex objects even in underground cinema. Few artists succeeded in articulating genuine alternatives. The New York performance artist and filmmaker Carolee Schneemann shot an erotic film entitled *Fuses* (1964–67) from a decidedly feminine point of view.[15] In her film, she presents a couple engaged in sex and shows both the male and female bodies in states of erotic ecstasy. Using an unusual stylistic device meant to ensure a non-prejudiced, non-sexist cinematographic approach, the artist assigns the viewer's vantage point to a cat that appears early in the film. Two movies by Yoko Ono also address the subject of the prevailing conventional, predominantly male vantage-point strategy in mainstream cinema and subvert it in innovative ways. Produced in 1970, her short film *Fly* (ill. p. 159), to which she added a sound track herself, explores the female body from the perspective of an animal. As the film focuses on the single fly rather than the woman, the insect is shown in close-up, while the landscape of the woman's body is presented merely as a

FILM NO. 4 (Bottoms),
Fluxfilm No. 16, 1966
Film still
16 mm film
b/w, silent, 5:30 min.

—11 The concept called for fifteen-second shots of 365 people—one for each day of the year. The artist did not insist on the exact number, as it was important for the concept, but not for the impact of the film itself. Cf. MacDonald 1992 (see footnote 7), 148.

—12 George Maciunas, "Some Comments on 'Structural Films' by P. Adams Sitney" (1969), reprinted in P. Adams Sitney (ed.), *Film Culture Reader* (New York, 2000), 349. Maciunas worked for Jonas Mekas at the film journal *Film Culture* and experienced all of the new currents firsthand. On the comparison of Fluxus films with Structural films, see Tod Lippy, "Disappearing Act. The Radical Reductivism of Fluxus Film," in: Cornelia Lauf and Susan Hapgood (eds.), *Fluxattitudes*, exh. cat. Hallwalls Contemporary Arts Center (Buffalo, NY, 1991), 35–41.

—13 Cf. Chrissie Iles, "Erotic Conceptualism: The Films of Yoko Ono," in: Alexandra Munroe and Jon Hendricks (eds.), *Yes. Yoko Ono* (New York, 2000), 201–07.

—14 On Yoko Ono's "proto-feminist" views, see Kristine Stiles, "Unbosoming Lennon: The Politics of Yoko Ono's Experience," in: *Art Criticism*, vol. 7, no. 2 (1992), 21–52.

—15 For discussion of the origin and interpretation of this film, see Kathleen Bühler, *Autobiografie als Performance. Carolee Schneemanns Experimentalfilme* (Marburg, 2009), 77–119.

fragmentary background.[16] In this way, Ono undermines the conventional economy of the cinematic view, which presents an image of the female body that is as complete and undisturbed as possible, and thus prevents its constant exhibition as an object of lust with subtle humor. In an introduction, the artist also emphasizes the "autobiographical" references to the fly and the woman. On the one hand, she notes, the insect shown flying around freely in the film reveals her yearning for personal freedom, which is why she mimics its movements with controlled, improvised vocal sounds. On the other hand, *Fly* addresses the passive role assigned to women in society. The naked, motionless female body still conforms to the conventions of female behavior dictated by society in 1970, she says.[17]

In contrast, her film *Rape* (ill. right), also shot in London in 1969, presents a dramatic intensification of male visual lust. The film was produced in collaboration with John Lennon and shifts from a fixed camera position to a form of moving documentary cinematography and narrative structure. Based on a concept developed in 1967/68, one cameramen and one soundman follow a young woman selected at random from the street and stalk her for two days, apparently filming her without her consent. The film crew do not speak to her, nor do they retreat; instead they pursue her stubbornly even into her flat, provoking reactions of desperation. Several reviewers expressed doubts about the authenticity of the situation presented in the film and focused on parallels to the presence of the media in the life of the artist, who had been working together with Lennon since 1967. Yet *Rape* remains an enlightening exposé on the consequences of unbridled, sexually motivated visual lust.

Production photograph from
RAPE, 1969

Love and Political Commitment

Yoko Ono also produced *Film No. 5 (Smile)* (1968) (ill. p. 161), which once again exhibits close affinities with Fluxus films, in collaboration with John Lennon. The film was also shot with a high-speed camera, although this time in color and with sound. It shows John Lennon smiling quietly in two scenes. When the film is played back at normal speed, viewers see the musician smiling in slow motion for fifty-one minutes, accompanied by background noises in the garden. During the first two-thirds of the film, nothing happens. Lennon's facial features remain motionless. Afterward, he presents a captivating smile twice in succession. Originally produced as a substitute for a film that would show every person on earth smiling,[18] it evolved into a stunning portrait of her beloved companion and artistic partner, who remained dedicated to the aesthetic and political visions he shared with Ono until his violent death. Given his eventual fate, the portrait now stands as a wonderful memorial to his consistent commitment to peace and universal understanding during the era of the Vietnam War and the Cold War. That same spirit underlies the cinematic balloon flight entitled *Apotheosis* (ill. p. 160), which—as the Greek title suggests—depicts an ascension to heaven. The camera mounted on the balloon documents the flight of a hot-air balloon over a desolate English winter landscape toward the sun above the clouds. At the moment in which the balloon breaks through the clouds and into the brilliant sunlight, the religious connotations of the title—which suggest an act of deification—are expressed metaphorically, and a vision of boundless freedom is conveyed through cinematic means.

——16 Several precursors to the presentation of the nude body in experimental cinema have been identified, including, for example, Willard Maas and Marie Menkens, *Geography of the Body* (1943), cf. Bühler 2009 (see footnote 15), 84 f.
——17 Chrissie Iles, "Fly, 1970," in: Munroe and Hendricks 2000 (see footnote 13), 218.
——18 Haskell and Hanhardt 1991 (see footnote 3), 116.

FILM NO. 1 (Match Piece),
Fluxfilm No. 14,
1955/1966
Filmstrip
16 mm film
b/w, silent, 5 min.

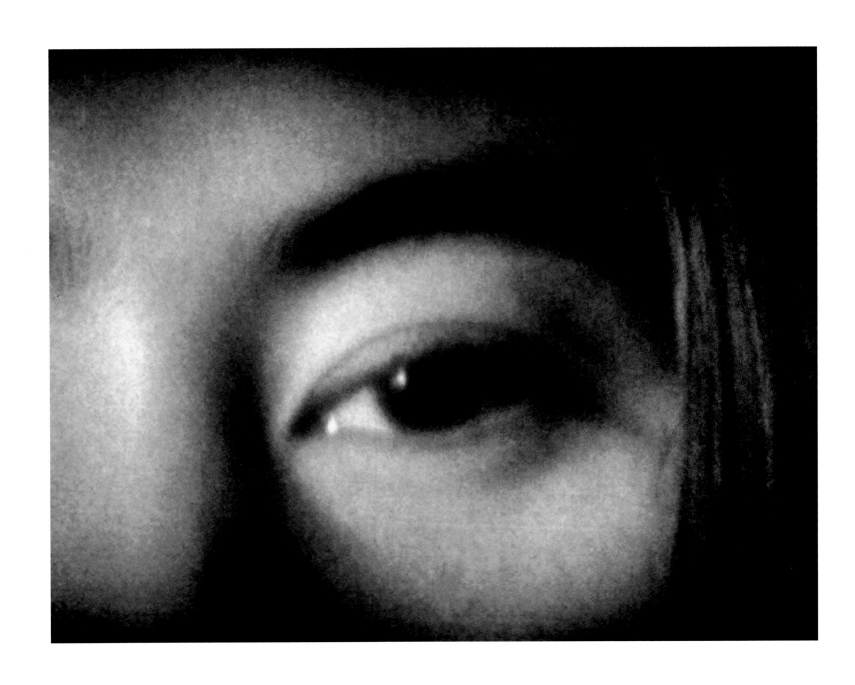

EYE BLINK, *Fluxfilm No. 9*, 1966
Film stills
16 mm film
b/w, silent, 2:40 min.

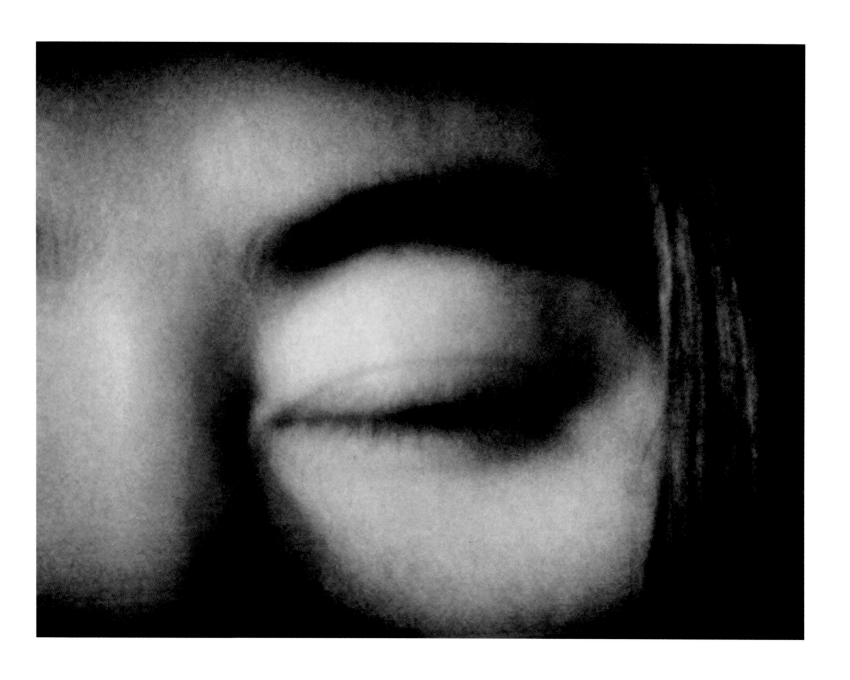

FILM NO. 4 (Bottoms), *Fluxfilm No. 16*, 1966
Filmstrip
16 mm film
b/w, silent, 5:30 min.

A FILM OF MANY HAPPY ENDINGS

yoko ono

FILM NO. 4

PRODUCED BY ANTHONY COX X London

PLUS YOKO ONO'S NEWEST FILM "WRAPPING EVENT,"
NOW AT THE JACEY-TATLER CHARING X ROAD GER. 4815

"Yoko Ono's beautifully absurd film of 15 second shots of bare behinds moving. Not only do you see people literally caught with their pants down, but you hear them with their mental pants down too"

THE LISTENER

"Nothing but illness or an Act of God would keep us away"

WHAT'S ON

"It's the end....the absolute end....the bottom. It is fascinating that it should have been made at all – extraordinary that it should be shown"

EVENING NEWS

"Ono-ism...there is only one Buster Keaton and Yoko Ono is his prophet."

NEW SOCIETY

"Succeeds in that it operates on several levels at once – the formal, the sexual, the sociological."

SPECTATOR

"We see fat bottoms, thin bottoms and every other kind of bottom, ranging from the elegant to the elephantine and the frankly revolting."

DAILY MAIL

"It reveals character, ingenius editing often makes it astoundingly funny and sometimes it is even touching."

PUNCH

FILM NO. 4 (Bottoms), *Fluxfilm No. 16*, 1967
Poster for film screening
Offset on paper
30 × 20.5 cm

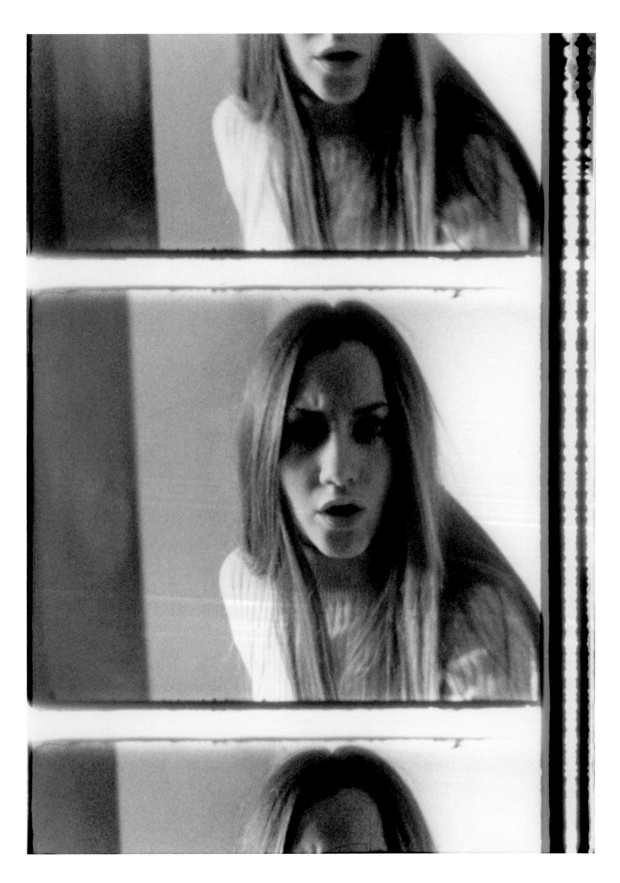

RAPE, 1969
Performed by Eva Majlata
Directed in collaboration
with John Lennon
Filmstrip
16 mm film
Color, sound, 77 min.

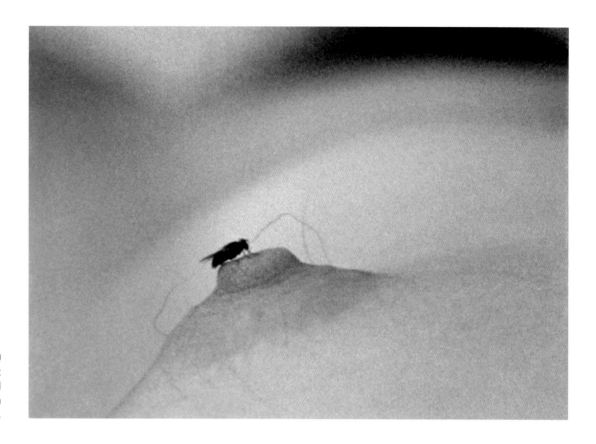

FLY, 1970
Performed by Virginia Lust
Film still
16 mm film
Color, sound, 25 min.

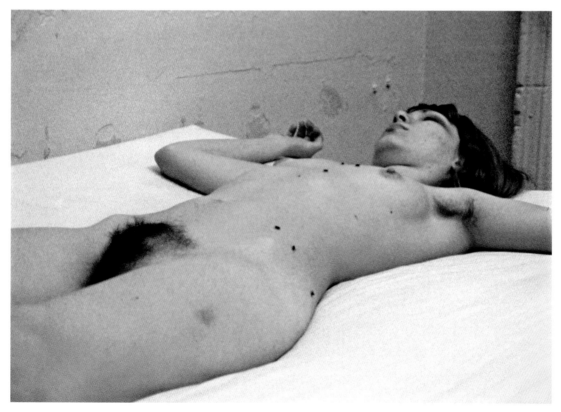

FLY, 1970
Performed by Virginia Lust
Film still
16 mm film
Color, sound, 25 min.

EASTMAN 15

APOTHEOSIS, 1970
Directed in collaboration with John Lennon
Filmstrip
16 mm film
Color, sound, 18 min.

FILM NO. 5 (Smile), 1968
Performed by John Lennon
Film still
16 mm film
Color, sound, 51 min.

ERECTION, 1971
Directed in collaboration with John Lennon
Film still
16 mm film
Color, sound, 55 min.

FREEDOM, 1970
16 mm film
Film still
Color, sound, 1 min.

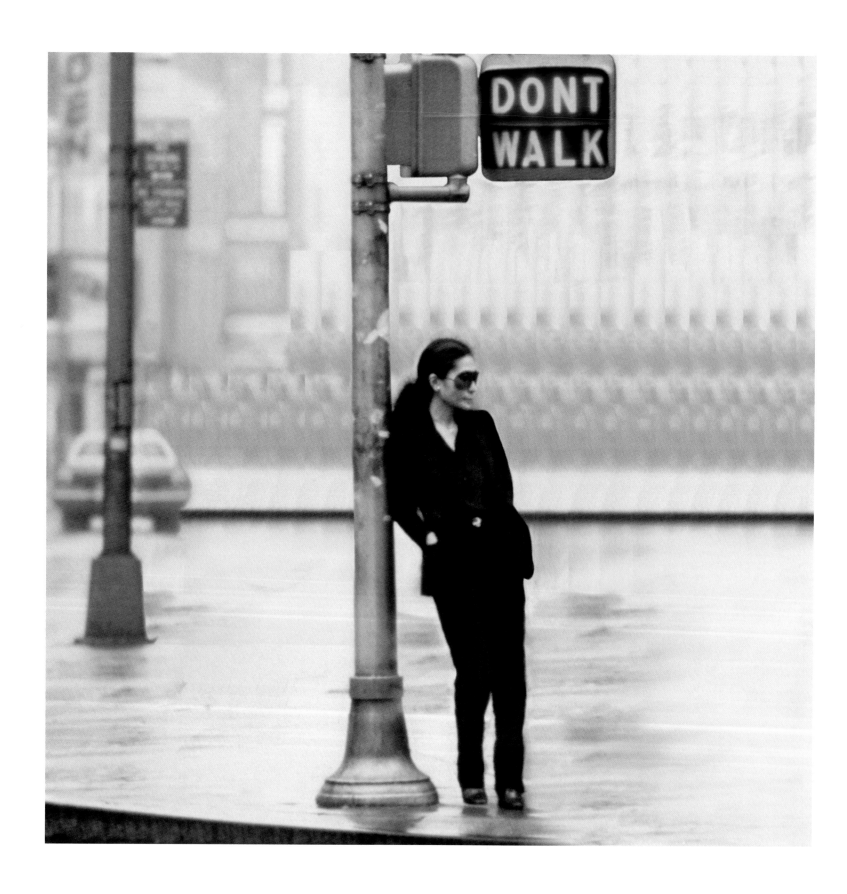

WALKING ON THIN ICE, 1981
Videostill
Music video
Color, sound, 5:57 min.

Against the Wind, against the Wall

Yoko Ono's Music

Jörg Heiser

A black-and-white photo: a woman in a black dress lies on a concert piano. The cover is missing; she is lying on her back on the strings—hardly a comfortable position—with her head hanging over the edge, one arm bent upward at the elbow. Spotlights illuminate the stage. Visible in the background are three men wearing suits, their backs turned to one another. They appear to be immersed in silent activities that don't seem directed toward the auditorium, or directly related to what the woman is doing. Her mouth is half-open. Is she singing? Or is she screaming?

This photograph (ill. left) documents a 1962 performance in Tokyo of John Cage's *Music Walk*. Cage is one of the three men. The woman is Yoko Ono. The original 1958 score called for one or more pianists to perform with different sound sources—the piano itself, their own voices, or portable radios—according to the instructions, on transparent plastic cards, and at intervals of their own choosing. A recording of Cage's *Aria and Solo for Piano with Fontana Mix* from the Tokyo concert recently published for the first time[1] bears witness to Cage's ability to elicit aesthetic form from concerted randomness: an animated soundscape interspersed with radio and piano tones that intensifies from time to time in cacophonous outbursts in which Yoko Ono contributes her richly modulated voice. As the photo shows, Ono realized Cage's concept of the *prepared piano*—piano strings manipulated, plucked, or damped in order to produce new sound events—with her own body, while interpreting her vocal contribution on the basis of her own musical concepts.

The aforementioned photograph, taken in 1962, seems to vividly capture a turning point that had actually already occurred one year earlier with Ono's first public performances at Village Gate nightclub and Carnegie Recital Hall in New York—the point at which she managed to shift, within the realm of musical performance, from the interpretation of existing work to the realization of her "own" artistically controlled events. It also makes apparent that the sound event gradually shifted toward a conceptual, performative event, especially within the context of Fluxus—a movement in which she played an instrumental role. Cage had laid the groundwork. The first published version of the score for his famous piece entitled *4'33"* (1952), released in 1960, calls for three phases of *tacet* (he/she/it is silent)—although it also notes that David Tudor signaled the beginning and end of these intervals during the 1952 premiere performance by opening and closing the keyboard lid, and also emphasized that the work could be performed with one or more instruments and last "any length of time." Cage, employing chance operations, limited the range of options for a performance only to a certain extent. And yet, somewhere in the spectrum between Cage's work of the 1950s and the origins of Fluxus around 1960/1961—in which Yoko Ono played a leading role—resides the nucleus of both performance and conceptual art of the 1960s and 1970s: in the idea of integrating found material and chance into a deliberately intended structure composed of signs and symbols. The step from musical score to visual performance art was but a small one and required nothing more than a small dose of Marcel Duchamp, and that came when Duchamp's concept of the readymade and his idea of a work of art to be completed by the viewer was applied not only to objects, but also to sounds or everyday actions,

Yoko Ono performing in John Cage's *Music Walk* with John Cage, David Tudor, and Toshirō Mayuzumi, Sōgetsu Art Center, Tokyo, October 9, 1962

—1 The Japanese label EM Records released a series of three CDs under the title *John Cage Shock* in the summer of 2012, featuring the Tokyo recordings for the first time. The release does not include a recording of *Music Walk*, but one piece for which Ono is listed as a vocalist: *Aria and Solo for Piano with Fontana Mix*.

as in the work of the Cage student George Brecht. The idea of the event score assumed concrete form in Brecht's art around 1961; it was in July of that same year that Yoko Ono showed 15 *Instruction Paintings* at AG Gallery in New York, including *Waterdrop Painting* (which involved a bottle with liquids hung above a cloth placed on the floor, so the ink would slowly drip on it). Just as Ono's works marked the transition from painting as a completed object to a process unfolding during exhibition, Brecht's earliest event scores marked the transition from an instruction declared as musical to one that implies an event "in all possible dimensions" (Brecht). A title like *Drip Music (Drip Event)* (1959–62)[2]—letting water drip into a vessel—can be read both as a musical score and an *Instruction* for a work of visual art.

Another black-and-white photo from 1962 (ills. pp. 36, 37), also taken in Tokyo, shows Yoko Ono at the piano. Yet she doesn't touch the keys. Instead, she strikes a match and lets it burn out. This was a performance of an instruction dated 1955:

LIGHTING PIECE

Light a match and watch till it goes out.

1955 autumn

At first, the driving impulse was probably not so much the aim of inventing a new genre (performance—not theater, not concert, not object art) as it was the idea of undermining the prevailing convention of concert performance and pursuing it *ad absurdum* with minimalistic humor. It is also pointless to speculate as to who took the first step from the score and its musical interpretation to the conceptual instruction and its performative realization. Yet Brecht and Ono are certainly among the most important pioneers in this context, along with La Monte Young—the same La Monte Young who in 1960 dedicated a composition to Robert Morris consisting of the instruction to draw a straight line and follow it, and who organized a series of performances of new, experimental music in collaboration with Ono in her loft between December 1960 and June 1961. Cage and Duchamp remained primary coordinates—as progenitors embraced as well as departed from—within this sphere of resonance for the idea of the written or spoken instruction for events—along with East-Asian influences, such as the meditative clarity of Zen and the linguistic minimalism of *haiku*.

The *Scores* or *Instructions* from this period have three determinants: language as sound, language as an instruction for an action, and as objects, either as remnants of a performance or as "autonomous" art objects.[3] With this ambiguity and permeability of the writing-based works, which is also capable of association with the ideal of the unity of life and art, Yoko Ono would continue to operate again and again throughout her long career as an artist and musician.

Yoko Ono met Cage in the mid-1950s. Her first husband, the composer Toshi Ichiyanagi, attended—as did Brecht—some of Cage's courses in experimental composition at the New School for Social Research. In the early 1960s, Ono started to clearly mark out her own artistic and musical path. While pursuing the transformation of the musical score into an instruction for conceptual, dematerialized, imagined, or reified art, Ono's main emphasis was perhaps on *not* implicitly treating that very transformation as a departure from materialized music.

——2 The dating of 1959 refers to a notebook entry by Brecht, and to an earlier incarnation of the piece, in John Cage's class, under the title *Burette Music*, while 1962 marks the completion of the understanding of the musical score as essentially a written suggestion for a possible performative event. Cf. George Brecht, *Events. A Heterospective*, Julia Robinson and Alfred M. Fischer (eds.), exh. cat. Museum Ludwig, Cologne (Cologne, 2005), 30–32.
——3 Liz Kotz, "Post-Cagean Aesthetics and the Event Score," in: *OCTOBER*, no. 95 (winter 2001): pp. 55–89, 60.

VOICE PIECE FOR SOPRANO
 to Simone Morris

Scream.
 1. against the wind
 2. against the wall
 3. against the sky

1961 autumn

Yoko Ono recording FLY, July 13, 1971

Perhaps nothing illustrates this point better than *Voice Piece for Soprano* written in 1961 (ill. left, and p. 45, left). It is the epitome of calm, cool instruction and loud, hot realization with which Yoko Ono turned against the entirely cool, typical male aura of serious dedication to science—despite its humorous aspect—that was characteristic of the ways in which instruction pieces by composers from Cage to Brecht were realized. Ono did so by isolating the stereotype of bourgeois female hysteria and transplanting it to Cage's pieces: the "hysterical arching" over the piano, the scream-singing. After first performing it in New York in 1961, Ono may ultimately have realized *Voice Piece for Soprano* in Tokyo a year later, this time as part of Cage's pieces—not only *prepared piano*, but also *prepared Cage*?

Conversely, Yoko Ono's use of the human voice—her own—is itself also prepared in a certain sense. The conventional facets of sound produced by the instrument are expanded and transformed with the aid of "foreign objects." Ono's first important solo concert—in which George Brecht, Philip Corner, Jackson Mac Low, Yvonne Rainer, and La Monte Young also participated—took place at Carnegie Recital Hall in New York in 1961. She employed her own voice along with tape recordings of groans and words spoken backward. Jill Johnston, writing in *The Village Voice*, described Ono's vocal spectrum in the following words: "amplified sighs, breathing, gasping, retching, screaming—many tones of pain and pleasure mixed with a jibberish of foreign-sounding language that was no language at all."[4]

Yoko Ono took the idea of the voice as an instrument both seriously and literally. She had received classical training in singing. Looking even farther back, Ono cites a childhood experience in various interviews. At the age of four, she recalls, she once overheard servants imitating the screams of a woman in labor at her parents' home. "I remember it even now, exactly how it sounded. Around 1961, I had a miscarriage ... or an abortion. And that reminded me of those stories. So I thought, I'm going to try to recreate that sound of a woman giving birth."[5] The anecdote offers evidence of Ono's idea, maintained over the course of many years, of taking the voice back to an amorphous, prelingual stage that perforates social barriers and hierarchies—man/woman, master/servant, public/private, West/East—with acoustically strenuous frequencies.

Whether with the resources of the voice or of performance, Yoko Ono carried this idea with her into her relationship with John Lennon as a producing and loving couple under the glaring light of public exposure in the mass media, from their first encounter at the Indica Gallery in London in 1966 to the day the shots were fired at Lennon outside the Dakota Building in New York in 1980.

The Beatles had finished a US concert tour in the summer of 1966. The screams of their fans in the stadiums were louder than the loudspeakers, and the band resolved that this would be their last tour. On June 25, 1967, they played "All You Need Is Love" for some 350 million television viewers in the first global satellite broadcast. Yoko Ono and John Lennon had met in the meantime, in November of 1966. Of course there were also avid followers of the ideal hippie-happening couple Lennon/Ono, but over the course of the ensuing years and until the group broke up officially in 1970, the widespread cognitive dissonance that emerged in response to the presence of a Japanese-American avant-garde artist at the side of a British pop star swelled immensely, loaded with sexist and racist prejudices—among pubescent Beatles fans, and some less open-minded circles of the art world. As Ono recalled in 1996, even before meeting Lennon the public attention she received after the release of her film *Film No. 4* in 1966 – close-ups of people's bottoms for five and a half minutes—was held against her: "All my avant garde friends dropped me because I got a tremendous amount of attention and reviews, [...] this nice avant garde artist couple had a dinner party, and the wife told me, 'My husband feels like you sold out and we're not inviting you for dinner ...'"[6]

——4 Jill Johnston, "Life and Art," in: *The Village Voice*, Dec. 7, 1961, 10. Quoted from Alexandra Munroe and Jon Hendricks (eds.), *Yes Yoko Ono* (New York, 2000), 239.
——5 Quoted from Joy Press, "A Life In Flux," in: *The Wire*, no. 146, April 1996; http://www.thewire.co.uk/articles/186/ (retrieved September 3, 2012).
——6 Joy Press, "A Life In Flux," in: *The Wire*, no. 146 (April 1996); online http://www.thewire.co.uk/articles/186/, n.p.

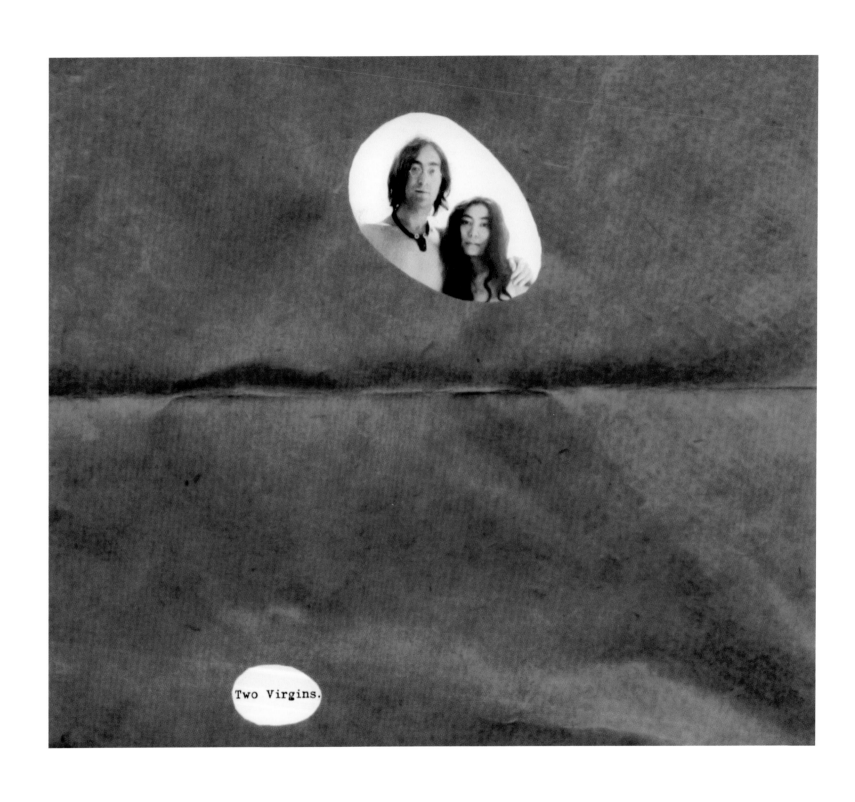

Yoko Ono / John Lennon
Unfinished Music No. 1: Two Virgins, 1968
Album cover

And then there was this music. Yoko Ono's entry into the world of pop was anything but purchased with pleasing sounds. Her first session with John Lennon on May 20, 1968 involved fourteen hours of recording during the night, interspersed, according to legend, with sex and consciousness-expanding drugs. The result was later released under the title *Unfinished Music No.1: Two Virgins* (ill. p. 168), condensed to fourteen minutes on each side of an LP. Ono's voice is heard in extended modulations ranging from lyrical moments to crass, scat-style cascades contrasted by Lennon's injections of music-hall piano and echo loops on the guitar.

Lennon/Ono turned intimacy into a public statement from the outset, massively intensified by the infamous album cover showing the naked couple arm in arm. They also transformed experimental avant-garde improvisation into a pop product.

Several months before the release of the *Two Virgins* LP, Ono had appeared with the Ornette Coleman Ensemble at the Royal Albert Hall in London. A photograph (ill. left) shows Ono during one of the rehearsals, leaning against the wall, her eyes closed and her open mouth turned upward, while the other musicians—Coleman on trumpet, Charlie Haden and David Izenzon each on bass, and Ed Blackwell on drums—formed a circle with her, in the middle of which stood a lone saxophone without a player. A cut from the session was released as a seven-minute piece under the title *AOS* on the *Yoko Ono/Plastic Ono Band* LP (1970) (ill. p. 172), and one can hear that Ono's voice actually takes the place of the free-jazz saxophone, shifting between interludes of breathing and gasping and vibrant sing-song until about midway through the piece, when she switches to a whispered "not yet" and pleasingly rhythmic humming. The sound of the saxophone appears to give way abruptly to something akin to pillow talk à la Serge Gainsbourg before being replaced suddenly by shrill screams that sound threatening and warning, blood-curdlingly abrupt, rather than orgiastic, only to dissolve into a sirenlike meandering line of song.

The record was released in 1970. Shortly after the Beatles broke up that same year, the artist attracted the full brunt of public hostility. One of the few exceptions was the overall positive record review written by rock critic Lester Bangs in *Rolling Stone*. Following a few snide remarks about Lennon/Ono's earlier recordings—he contended, among other things, that their experiments with electronic music and silence were nothing more than poor Cage imitations—he praised the new record, especially Lennon's guitar-playing and his breathtaking shifts from "eloquent distortions" to "an expertly abstracted guitar line straight out of Chuck Berry." Yoko Ono, he noted, was now capable of making more controlled use of her "vocal spasms" than in earlier recordings, and he emphasized in particular the electronically modified sequences in the piece entitled *Paper Shoes*, in which "Yoko's voice, cut up by machine and melted into itself, flashes in weird echoes around the trestles."[7]

Although Lester Bangs's "Cage takeoff" remark is off the mark—perhaps because he was not aware of how long Yoko Ono herself had been a friend of Cage, and had been active independently as a musician in New York avant-garde circles—it is reasonable to say, in a positive sense, that Ono and John Lennon brought musical techniques first developed in the avant-garde context (and some of which they had developed themselves), such as tape manipulation and sound experiments, to pop music.[8] In itself, Ono's approach is at least as in-between genres as Lennon's. She combines her classically trained voice with free-jazz-style, free, pre- or post-lingual vocal modulation, which enables her to alternate between artistic vocal intonation and richly faceted guttural vocalization. The singing style of Japanese *kabuki* theater, which deliberately incorporates the forced and the harsh, noise and cacophony into vocal expression (as when demons are personified with the aid of inarticulate sounds—snorting, snarling, and so on)—serves as the missing link between these two very different approaches.[9] In her best moments, Ono succeeds in tapping all of these

Ornette Coleman concert with Yoko Ono,
Royal Albert Hall, London, 1968
Program cover

——7 Lester Bangs, *Rolling Stone*, March 4, 1971; http://www.rolling-stone.com/music/albumreviews/yoko-ono-and-plastic-ono-band-19710304 (retrieved October 15, 2012).

——8 Incidentally, this also occurred under the banner of the Beatles in the sound collage entitled *Revolution 9* on the *White Album* of 1968, for which recording began ten days after the *Two Virgins* session.

——9 Cf. Adeline Hirschfeld-Medalia, "The Voice in Wayang and Kabuki," in: *Asian Theatre Journal*, vol. 1, no. 2 (autumn 1984): 217–22.

YOKO ONO PLASTIC ONO BAND
BETWEEN MY HEAD AND THE SKY,
2009
Album cover

sources simultaneously and achieving seamless transitions between them. In the nearly twenty-three-minute title track on the double LP *Fly* (1971) (ill. p. 173)—which is also the sound track for the film of the same name that traces the passage of a fly over a woman's body[10]—Ono's voice seems at first to imitate the nervous buzzing of a fly, which is transformed progressively and demoniacally into sounds somewhat reminiscent of sighing, dogs barking, cats meowing, parrots screeching, babies crying, and mosquitoes buzzing.

The scream against the wind, the wall, and the sky that Yoko Ono had articulated as a minimalistic option for action had long since become an infinitely variable, amorphous vocal storm. And it unsettled contemporaneous rock fans no less than it would offer lasting inspiration to later punk generations: the scream as a cry of protest against the bonds of mainstream rock, which was dominated by the ideals of male pathos and manual "skill," and male fantasies in which women appeared either as groupies or mothers, whores, or saints.

The Lennon/Ono single *Woman Is the Nigger of the World* was released in 1972. Yoko Ono had first used the slogan in an interview in 1969, and the song denounced the worldwide oppression of women. While the BBC placed the song on the index in England because of the word "nigger," the Black Congressman Ron Dellums defended the use of the word: "If you define 'nigger' as someone whose lifestyle is defined by others, whose opportunities are defined by others, whose role in society is defined by others, the good news is that you don't have to be black to be a nigger in this society. Most of the people in America are niggers."[11] Ono's solo records from this period convey the spirit of the protest song, which unites blunt, pointed messages with clearly defined pop structures—in diametrical opposition to her earlier atonal, amorphous recordings. Ono now sang melodious, classically structured songs,

—— 10 Ono had made film sound tracks already in 1964: for Takahiko Iimura's black-and-white film *Ai* (Love) (1962)—extreme, yet sensuous close-ups of a couple making love)—she recorded, two years later, the sound of the wind outside her Tokyo apartment, interspersed with occasional noises from the street; and for Yoji Kuri's grotesque black-and-white animation *AOS* (1964), the latter titled after Ono's eponymous composition first conceived in 1960, she contributed her unique vocal approach.
—— 11 Quoted from http://www.popmatters.com/pm/feature/133778-revolutionary-man-john-lennon-as-political-artist/P0 (retrieved September 5, 2012).

and the double LP *Approximately Infinite Universe* (ill. left) is perhaps her best work in this respect. Classic rock-band instrumentation (guitar, bass, and drums) plus piano and saxophone opened up a spectrum of sounds reminiscent of vaudeville and jazz and also included high-energy soul rock, with borrowings from such musicians as Sly Stone and Edwin Starr—all in all the kind of glam rock that at the time was also produced by British acts such as David Bowie and Roxy Music.

At first, however, the inspiration provided by Yoko Ono's music for the indie and punk subcultures in the 1980s and later years did not appear to come from its closeness to glam rock or to other musical influences, but instead seemed to follow a reverse pattern. Whatever triggered such strong aversions among "rock squares" could only be pure punk. In 1996, several musicians, including Ween and Thurston Moore from Sonic Youth, took part in a remix of Ono's *Rising* LP (ill. p. 176), which she had recorded with IMA, the band led by her son, Sean Ono Lennon. Just as a pioneering achievement receives public recognition through elevation to museum status in art, the same thing happens in rock music through collaboration with younger generations of musicians. The cool New Wave disco style of the hit single "Walking on Thin Ice" (ill. p. 164), released in 1981 after the murder of John Lennon—the last recording made by Yoko Ono and John Lennon together—provided the basis for new remixes by the pop dandies of the Pet Shop Boys and House producer Felix Da Housecat in 2003. Recordings featuring Ono singing were made available to sixteen musical acts for the composition of new titles for the album entitled *Yes, I'm a Witch* (2007). These included Antony Hegarty (an icon of transgender pride in the heart of pop whose inimitable voice has been compared to that of Nina Simone), Kathleen Hanna (the eloquent and powerful vocalist and pioneer of the Riot Grrrl movement), and Hank Shocklee (the legendary producer of the trailblazing political hip-hop act Public Enemy). The symbolic merger of different emancipatory struggles in the broad field between pop and avant-garde was possible only because Ono herself had long since fought her battles for emancipation in that very field.

The predictably subversive tendency to regard Yoko Ono as good precisely because she had caused resentment among the narrow-minded has long since given way to a kind of reciprocal exchange of respect. Not in the sense of "time heals all wounds," but rather of "time opens the eyes (and ears)." Accordingly, the parade of collaborative projects with high-profile musicians has continued. In 2009, an album was released under the band name Yoko Ono / Plastic Ono Band for the first time since the 1973 album *Feeling the Space.* The new album is entitled *Between My Head and the Sky* (ill. p. 170), and the band line-up features Ono's son, Sean, along with the two renowned musicians Cornelius and Yuka Honda. At the age of seventy-six, Ono performed as the singer in a band that took pleasure in experimentation and wound its way through a multiplicity of styles. She also recorded a mini-album with six tracks in collaboration with Thurston Moore and Kim Gordon of the avant-garde rock band Sonic Youth, which had broken up shortly before. The album was released under the title *YOKOKIMTHURSTON* on Chimera Music (the label run by Sean Lennon and Charlotte Muhl) in September 2012. In this constellation, whirring guitar feedback blends with Ono's free-floating, amorphous vocalizing. Or, as Ono says succinctly in the final piece on the *Between My Head and the Sky* album, "It's me, I'm alive."

YOKO ONO
APPROXIMATELY INFINITE UNIVERSE, 1973
Album cover

YOKO ONO / JOHN LENNON
WEDDING ALBUM, 1969, album cover

YOKO ONO / JOHN LENNON / PLASTIC ONO BAND
LIVE PEACE IN TORONTO, 1969, album cover

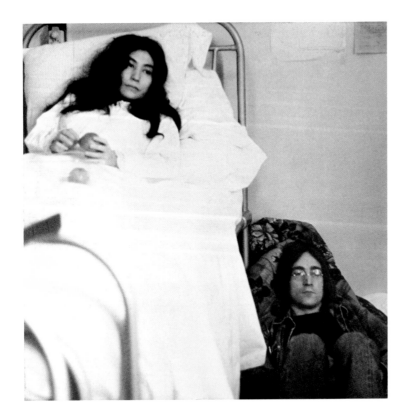

YOKO ONO / JOHN LENNON
UNFINISHED MUSIC NO. 2: LIFE WITH THE LIONS, 1969, album cover

YOKO ONO / PLASTIC ONO BAND
PLASTIC ONO BAND, 1970, album cover

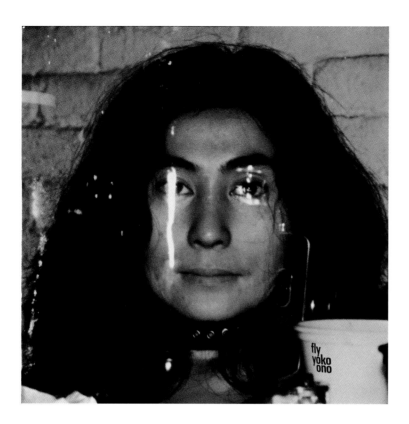

YOKO ONO
FLY, 1971, album cover

John Lennon & Yoko Ono / PLASTIC ONO BAND
Some Time in New York City, 1972, album cover

YOKO ONO / PLASTIC ONO BAND
FEELING THE SPACE, 1973, album cover

YOKO ONO
A STORY, 1974/1997, album cover

John Lennon / Yoko Ono
Double Fantasy, 1980, album cover

YOKO ONO
IT'S ALRIGHT (I SEE RAINBOWS), 1982, album cover

YOKO ONO
SEASON OF GLASS, 1981, album cover

John Lennon / Yoko Ono
Milk and Honey, 1984, album cover

John Lennon / Yoko Ono
Heart Play –unfinished dialogue– 1983, album cover

YOKO ONO
STARPEACE, 1985, album cover

YOKO ONO
WALKING ON THIN ICE (compilation), 1992, album cover

175

YOKO ONO / IMA
RISING, 1995, album cover

YOKO ONO
RISING MIXES, 1996, album cover

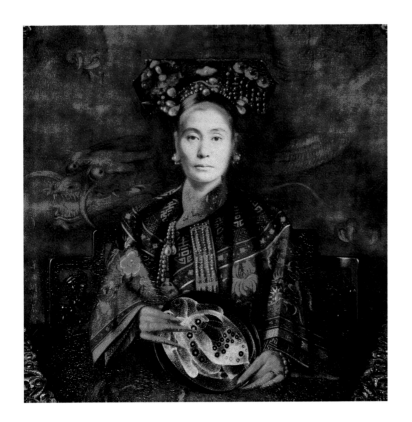

YOKO ONO
BLUEPRINT FOR A SUNRISE, 2001, album cover

YOKO ONO
YES, I'M A WITCH (remix album), 2007, album cover

YOKO ONO
OPEN YOUR BOX, 2007, album cover

YOKO ONO / KIM GORDON / THURSTON MOORE
YOKOKIMTHURSTON, 2012, album cover

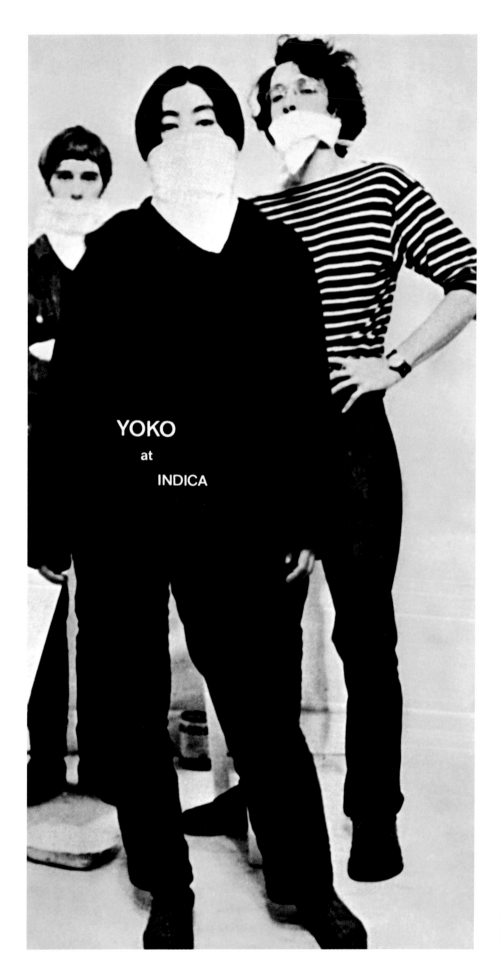

YOKO
at
INDICA

YOKO at INDICA, 1966
Exhibition catalog
Indica Gallery, London,
November 9–22, 1966

Texts by Yoko Ono

Biography/Statement, 1966

Biography

born: bird year
early childhood: collected skys
adolescence: collected sea-weeds
late adolescence: gave birth to a grapefruit
 collected snails, clouds, garbage
 cans, etc. Have graduated many
 schools specializing in these
 subjects

at present: traveling as a private lecturer of the
above subjects and others

recipient of Hal Kaplow Award

Statement

People went on cutting the parts they do not like of
me finally there was only the stone remained of me
that was in me but they were still not satisfied and
wanted to know what it's like in the stone.

 y.o.

P.S. If the butterflies in your stomach die, send
yellow death announcements to your friends.

Published in *The Stone* (New York, Judson Gallery, 1966)

To the Wesleyan People

YOKO ONO
1 WEST 100TH ST.
NEW YORK, 10025

JANUARY 23, 1966

To the Wesleyan People (who attended the meeting.)
-a footnote to my lecture of January 13th, 1966

When a violinist plays, which is incidental: the arm movement or the bow sound?

Try arm movement only.

If my music seems to require physical silence, that is because it requires concentration to yourself – and this requires inner silence which may lead to outer silence as well.

I think of my music, more as practice (gyo) than music.

The only sound that exists to me is the sound of the mind. My works are only to induce music of the mind in people.

It is not possible to control a mind-time with a stopwatch or a metronome. In the mind-world, things spread out and go beyond time.

There is a wind that never dies.

My paintings, which are all instruction paintings (and meant for others to do), came after collage & assemblage (1915) and happening (1905) came into the art world. Considering the nature of my painting, any of the above three words or a new word can be used instead of the word, painting. But I like the old word painting because it immediately connects with "wall painting" painting, and it is nice and funny.

Among my instruction paintings, my interest is mainly in "painting to construct in your head". In your head, for instance, it is possible for a straight line to exist-not as a segment of a curve but as a straight line. Also, a line can be straight, curved and something else at the same time. A dot can exist as a

1,2,3,4,5,6, dimensional object all at the same time or at various times in different combinations as you wish to perceive. The movement of the molecule can be continuum and discontinuum at the same time. It can be with colour and/or without. There is no visual object that does not exist in comparison to or simultaneously with other objects, but these characteristics can be eliminated if you wish. A sunset can go on for days. You can eat up all the clouds in the sky. You can assemble a painting with a person in the North Pole over a phone, like playing chess. This painting method derives from as far back as the time of the Second World War when we had no food to eat, and my brother and I exchanged menus in the air.

There may be a dream that two dream together, but there is no chair that two see together.

I think it is possible to see a chair as it is. But when you burn the chair, you suddenly realize that the chair in your head did not burn or disappear.

The world of construction seems to be the most tangible, and therefore final. This made me nervous. I started to wonder if it were really so.

Isn't a construction a beginning of a thing like a seed? Isn't it a segment of a larger totality, like an elephant's tail? Isn't it something just about to emerge-not quite structured... like an unfinished church with a sky ceiling? Therefore, the following works:

A venus made of plastic, except that her head is to be imagined.

A paper ball and a marble book, except that the final version is the fusion of these two objects which come into existence only in your head.

A marble sphere (actually existing) which, in your head, gradually becomes a sharp cone by the time it is extended to the far end of the room.

A garden covered with a thick marble instead of snow-but like snow, which is to be appreciated only when you uncover the marble coating.

One thousand needles: imagine threading them with a straight thread.

I would like to see the sky machine on every corner of the street instead of the coke machine. We need more skies than coke.

Dance was once the way people communicated with God and godliness in people. Since when did dance become a pasted-face exhibitionism of dancers on the spotlighted stage? Can you not communicate if it is totally dark?

If people make it a habit to draw a somersault on every other street as they commute to their office, take off their pants before they fight, shake hands with strangers whenever they feel like, give flowers or part of their clothing on streets, subways, elevator, toilet, etc., and if politicians go through a tea house door (lowered, so people must bend very low to get through) before they discuss anything and spend a day watching the fountain water dance at the nearest park, the world business may slow down a little but we may have peace.
To me this is dance.

All my works in the other fields have an "Event bent" so to speak. People ask me why I call some works Event and others not. They also ask me why I do not call my Events, Happenings.

Event, to me, is not an assimilation of all the other arts as Happening seems to be, but an extrication from the various sensory perceptions. It is not "a get togetherness" as most happenings are, but a dealing with oneself. Also, it has no script as happenings do, though it has something that starts it moving – the closest word for it may be a "wish" or "hope".

At a small dinner party last week, we suddenly discovered that our poet friend whom we admire very much was colour blind. Barbara Moore said, "That explains about his work. Usually people's eyes are blocked by colour and they can't see the thing."

After unblocking one's mind, by dispensing with visual, auditory, and kinetic perceptions, what will come of us? Would there be anything? I wonder. And my Events are mostly spent in wonderment.

In Kyoto, at the Nanzenji Temples the High Monk was kind to let me use one of the temples and the gardens for my Event. It is a temple with great history, and it was an unheard of honour for the Monk to give permission for such a use, especially, to a woman. The Event took place from evening till dawn. About fifty people came with the knowledge that it will last till dawn. The instruction was to watch the sky and to "touch". Some of them were just fast asleep until dawn. Some sat in the garden, some on the wide corridor, which is like a verandah. It was a beautiful full moon night, and the moon was so bright, that the mountains and the trees, which usually looked black under the moonlight, began to show their green. People talked about moonburn, moonbath, and about touching the sky. Two people, I noticed, were whispering all about their life story to each other. Once in a while, a restless person would come to me and ask if I was alright. I thought that was very amusing, because it was a very warm and peaceful July night, and there was no reason why I should not be alright. Probably he was starting to feel something happening to him, something that he did not yet know how to come with, the only way out for him was to come to me and ask if I was alright. I was a little nervous about people making cigarette holes on the national treasure floors and tatami, from being high on the moonlight, since most of the people were young modern Japanese, and some French and Americans. But nothing like that happened. When the morning breeze started to come in, people quietly woke up their friends and we took a bath, three at a time in a bath especially prepared for us at that hour of day. The temple bath is made of huge stone, and it is very warm. After the bath, we had miso soup and onigiri (rice sandwich). Without my saying anything about it, people silently swept the room and mopped the corridor before leaving. I did not know most of them, as they were mostly Kyoto people, and they left without giving their names. I wonder who they were.

At another time, also in Kyoto, before the Nanzenji Event, I had a concert at Yamaichi Hall. It was called "The Strip-tease Show" (it was stripping of the mind). When I met the High Monk the next day, he seemed a bit dissatisfied.

"I went to see your concert," he said.
"Thank you, did you like it?"
"Well, why did you have those three chairs on the stage and call it strip-tease by three?"
"If it I a chair or stone or woman, it is the same thing, my Monk."
"Where is he music?"
"The music is in the mind, my Monk."
"But that is the same with what we are doing, aren't you an avant-garde composer?"
"That is a label which was put by others for convenience."
"For instance, does Toshirō Mayuzumi create music of your kind?"
"I can only speak for myself."
"Do you have many followers?"
"No, but I know of two men who know what I am doing. I am very thankful for that."
Though he is a High Monk he is extremely young, he may be younger than myself. I wonder what the Monk is doing now.

Another Event that was memorable for me was "Fly", at Naiqua Gallery in Tokyo. People were asked to come prepared to fly in their own way. I did not attend.

People talk about happening. They say that art is headed towards that direction, that happening is assimilating the arts. I don't believe in collectivism of art nor in having only one direction in anything. I think it is nice to return to having many different arts, including happening, just as having many flowers. In fact, we could have more arts "smell", "weight", "taste", "cry", "anger" (competition of anger, that sort of thing), etc. People might say, that we never experience things separately , they are always in fusion, and that is why "the happening", which is a fusion of all sensory perceptions. Yes, I agree, but if that is so, it is all the more reason and challenge to create a sensory experi-

ence isolated from other sensory experiences, which is something rare in daily life. Art is not merely a duplication of life. To assimilate art in life, is different from art duplicating life.

But returning to having various divisions of art, does not mean, for instance, that one must use only sounds as means to create music. One may give instructions to watch the fire for 10 days in order to create music in the mind, or drink water once a month to create a vision in ones mind.

*

The mind is omnipresent, events in life never happen alone and the history is forever increasing its volume. The natural state of life and mind is complexity. At this point, what art can offer (if it can at all – to me it seems) is an absence of complexity, a vacuum through which you are led to a state of complete relaxation of mind. After that you may return to the complexity of life again, it may not be the same, or it may be, or you may never return, but that is your problem.

Mental richness should be worried just a physical richness. Didn't Christ say that it was like a camel trying to pass through a needle hole, for John Cage to go to heaven? I think it is nice to abandon what you have as much as possible, as many mental possession as the physical ones, as they clutter your mind. It is nice to maintain poverty of environment, sound, thinking and belief. It is nice to keep oneself small like a grain of rice instead of expanding and make yourself dispensable, like paper. See little, hear little, and think little.

The body is the Bodhi Tree
The mind like a bright mirror standing
Take care to wipe it all the time
And allow no dust to cling. – Shen-hsiu

There never was a Bodhi Tree
Nor bright mirror standing
Fundamentally, not one things exists
So where is the dust to cling? – Hui-neng

y.o.

On Film No. 4 (in taking the bottoms of 355 saints of our time)

I wonder why men can get serious at all. They have this delicate long thing hanging outride their bodies, which goes up and down by its own will. First of all having it outside your body is terribly dangerous, If I were a man I would have a fantastic castration complex to the point that I wouldn't be able to do a thing. Second, the inconsistency of it, like carrying a chance time alarm or something. If I were a man I would always be laughing at myself, Humour is probably something the male of the species discovered through their own anatomy. But men are so serious. Why ? Why violence ? Why hatred ? Why war ? If people want to make war, they should make a colour war, and paint each others cities up during the night in pinks and greens. Men have an unusual talent for making a bore out of everything they touch. Art, painting, sculpture, like who wants a cast-iron woman, for instance.

The film world is becoming terribly aristocratic, too. It's professionalism all the way down the line. In any other field, painting, music, etc., people are starting to become iconoclastic. But in the film world – that's where nobody touches it except the director. The director carries the old mystery of the artist. He is creating a universe, a mood, he is unique, etc., etc. This film proves that anybody can be a director. A filmmaker in San Francisco wrote to me and asked if he could make the San Francisco version of No, 4. That's OK with me. Somebody else wrote from New York, she wants to make a slow-motion version with her own behind. That's OK, too. I'm hoping that after seeing this film people will start to make their own home movies like crazy.

In 50 years or so, which is like 10 centuries from now people will look at the film of the 60's. They will probably comment on Ingmar Bergman as meaningfully meaningful film-maker, Jean-Luc Godard as the meaningfully meaningless. Antonioni as meaninglessly meaningful, etc., etc. Then they would come to the No. 4 film and see a sudden swarm of exposed bottoms, that these bottoms, in fact belonged to people who represented the London scene. And I hope that they would see that the 60's was not only the age of achievements, but of laughter. This film, in fact, is like an aimless petition signed by people with their anuses. Next time we wish to make an appeal, we should send this film as the signature list.

My ultimate goal in film-making is to make a film which includes a smiling face snap of every single human being in the world. Of course, I cannot go around the whole world and take the shots myself. I need cooperation from something like the post offices of the world. If everybody would drop a snapshot of himself and his family to the post office of his town, or allow himself to be photographed by the nearest photographic studio, this would be soon accomplished. Of course, this film would need constant adding of footage. Probably nobody would like to see the whole film at once, so you can keep it in a library or something, and when you wanted to see some particular town's people's smiling faces you could go and check that section of film. We can also arrange it with a television network so that whenever you want to see faces of a particular location in the world, all you have to do is to press a button and there it is. This way, if Johnson wants to see what sort of people he killed in Vietnam that day, he only has to turn the channel. Before this you were just part of a figure in the newspapers, but after this you become a smiling face, And when you are born, you will know that if you want to, you will have in your life time to communicate with the whole world. That is more than most of us could ask for. Very soon, the age may come where we will not need photographs to communicate – like ESP; etc. it will happen soon, but that will be *After the Film Age*.

Yoko Ono, London '67

Self-published as part of 16-page film program in London, 1967

Water Talk [1967]

water talk

you are water
I'm water
we're all water in different containers
that's why it's so easy to meet
someday we'll evaporate together

but even after the water's gone
we'll probably point out to the containers
and say, "that's me there, that one."
we're container minders

Written for *Yoko Ono at Lisson: Half-A-Wind Show*,
exh. cat. (London: Lisson Gallery, 1967)

Air Talk [1967]

air talk

It's sad that the air is the only
thing we share.
No matter how close we get to each other,
there is always air between us.

It's also nice that we share the air.
No matter how far apart we are,
the air links us.

From "Some notes on the Lisson Gallery Show," published
in *Yoko Ono at Lisson: Half-A-Wind Show*, exh. cat.
(London: Lisson Gallery, 1967). Reprinted in *Grapefruit*
(New York: Simon and Schuster, Touchstone Book, 1971)

On Rape [April 1969]

ON RAPE

Violence is a sad wind that, if channelled carefully, could bring seeds, chairs and all things pleasant to us.

We are all would-be Presidents of the World, and kids kicking the sky that doesn't listen .

What would you do if you had only one penis and a one-way tube ticket when you want to fuck the whole nation in one come?

I know a professor of philosophy whose hobby is to quietly crush biscuit boxes in a supermarket.

Maybe you can send signed, plastic lighters to people in place of your penis. But then some people might take your lighter as a piece of sculpture and keep it up in their living-room shelf.

So we go on eating and feeding frustration every day, lick lollipops and stay being peeping-toms dreaming of becoming Jack-the-Ripper.

This film was shot by our cameraman, Nick, while we were in a hospital. Nick is a gentle-man, who prefers eating clouds and floating pies to shooting "Rape." Nevertheless it was shot.

And as John says: "A is for parrot, which we can plainly see."

Yoko Ono
April '69, London

Self-published in London, 1969: reprinted In *Grapefruit*
(New York: Simon and Schuster, Touchstone Book, 1971)

The Feminization of Society [1971]

THE FEMINIZATION OF SOCIETY

The aim of the feminist movement should not just end with getting more jobs in the existing society, though we should definitely work on that as well. We have to keep on going until the whole of the female race is freed.

How are we going to go about this? This society is the very society that killed female freedom: the society that was built on female slavery. If we try to achieve our freedom within the framework of the existing social set-up, men, who run the society, will continue to make a token gesture of giving us a place in their world. Some of us will succeed in moving into elitist jobs, kicking our sisters on the way up. Others will resort to producing babies, or being conned into thinking that joining male perversions and madness is what equality is about: "join the army," "join the sexist trip," etc.

The major change in the contemporary woman's revolution is the issue of lesbianism. Lesbianism, to many, is a means of expressing rebellion toward the existing society through sexual freedom. It helps women realize that they don't necessarily have to rely on men for relationships. They have an alternative to spending 90% of their lives waiting for, finding and living for men . But if the alternative to that is finding a woman to replace the man in her life, and then build her life around another female or females, it isn't very liberating. Some sisters have learned to love women more deeply through lesbianism, but others have simply gone after their sisters in the same manner that the male chauvinists have.

The ultimate goal of female liberation is not just to escape from male oppression. How about liberating ourselves from our various mind trips such as ignorance, greed, masochism, fear of God, and social conventions? It's hard to so easily dismiss the importance of paternal influence in this society, at this time. Since we face the reality that, in this global village, there is very little choice but to coexist with men, we might as well find a way to do it and do it well.

We definitely need more positive participation by men in the care of our children. But how are we going to do this? We have to demand it. James Baldwin has said of this problem, "I can't give a performance all day in the office and come back and give a performance at home." He's right. How can we expect men to share the responsibility of childcare in the present social conditions where his job in the office is, to him, a mere "performance" and where he cannot relate to the role of childcare except as yet another "performance"? Contemporary men must go through major changes in their thinking before they volunteer to look after children, and before they even start to want to care.

Childcare is the most important issue for the future of our generation. It is no longer a pleasure for the majority of men and women in our society, because the whole society is geared towards living up to a Hollywood-cum-Madison Avenue image of men and women, and a way of life that has nothing to do with childcare. We are in a serious identity crisis. This society is driven by neurotic speed and force accelerated by greed, and frustration of not being able to live up to the image of men and women we have created for ourselves; the image has nothing to do with the reality of people. How could we be an eternal James Bond or Twiggy (false eyelashes, the never-had-a-baby-or-a-full-meal look) and raise three kids on the side? In such an image-driven culture, a piece of reality, such as a child, becomes a direct threat to our false existence.

What is the Relationship between the World and the Artist? [May 1971]

WHAT IS THE RELATIONSHIP BETWEEN THE WORLD AND THE ARTIST?

Many people believe that in this age, art is dead. They despise the artists who show in galleries and are caught up in the traditional art world. Artists themselves are beginning to lose their confidence. They don't know whether they are doing something that still has value in this day and age where the social problems are so vital and critical. I wondered myself about this. Why am I still an artist? And why am I not joining the violent revolutionaries? Then I realized that destruction is not my game. Violent revolutionaries are trying to destroy the establishment. That is good. But how? By killing? Killing is such an artless thing. All you need is a coke bottle in your hand and you can kill. But people who kill that way most often become the next establishment after they've killed the old. Because they are using the same method that the old establishment used to destroy. Violent revolutionaries' thinking is very close to establishment-type thinking and ways of solving problems.

I like to fight the establishment by using methods that are so far removed from establishment-type thinking that the establishment doesn't know how to fight back. For instance, they cannot stamp out John and Yoko events *Two Virgins*, *Bed Peace*, *Acorn Peace* and *War Is Over* poster event.

Artists are not here to destroy or to create. Creating is just as simple and artless a thing to do as destroying. Everyone on

Earth has creativity. Even a housewife can create a baby. Children are just as creative as the people whom society considers artists. Creative artists are just good enough to be considered children. Artists must not create more objects, the world is full of everything it needs. I'm bored with artists who make big lumps of sculpture and occupy a big space with them and think they have done something creative and allow people nothing but to applaud the lump. That is sheer narcissism. Why don't they at least let people touch them? Money and space are wasted on such projects when there are people starving and people who don't have enough space to sleep or breathe.

The job of an artist is not to destroy but to change the value of things. And by doing that, artists can change the world into a Utopia where there is total freedom for everybody. That can be achieved only when there is total communication in the world, Total communication equals peace. That is our aim. That is what artists can do for the world!

In order to change the value of things, you've got to know about life and the situation of the world. You have to be more than a child.

That is the difference between a child's work and an artist's work. That is the difference between an artist's work and a murderer's work. We are artists. Artist is just a frame of mind. Anybody can be an artist. It doesn't involve having a talent. It involves only having a certain frame of mind, an attitude, determination, and imagination that springs naturally out of the necessity of the situation.

Examples of today's living artists:
There was a temple in Japan called the Golden Temple. A man loved it very much as it was, and he couldn't stand the thought of anything happening to it. He felt the only way he could stop anything from happening to it was to burn it down, and he did. Now, the image of the temple was able to stay forever in his mind as a perfect form.

There was a man who made a counterfeit one thousand yen. It circulated with no trouble at all. The man travelled to another city and circulated another counterfeit one thousand yen . If he had made lots of counterfeit money he could have been discovered right away. But he wasn't interested in making lots of money. He wanted to have fun and play a subtle game. The police went wild and announced that if anybody found a counterfeit one thousand yen they would get two thousand yen as a reward if they came to the police station. This man changed the value of money by his actions.

In this very same sense, we have artists today whose works move beyond the gallery space and help change the world: Abbie Hoffman, Jerry Rubin, Paul Krassner, for instance, and many others. They radiate something that is sensitive and artistic in a very renaissance sense, when the majority of so-called artists these days are hardcore businessmen. Message is the medium. There are only two classes left in our society. The class who communicates and the class who doesn't. Tomorrow I hope there will be just one. Total communication equals peace.

Men can destroy / Women can create / Artists revalue.

Y.O. Cannes Film Festival, May, 1971

Published in *This is Not Here*, exh. cat. (Syracuse, Everson Museum of Art, 1971); reprinted in *Museum of Modern [F]art* (New York, 1971)

Yoko Ono with her parents, San Francisco, 1935

1933–1940

Yoko Ono is born in Tokyo on February 18, 1933. Her mother, Isoko Yasuda, comes from a family with a long tradition in banking. Her father is Yeisuke Ono, whose ancestors include samurai, nobles, and priests. Although trained as a concert pianist, Yeisuke Ono decides on a career as a banker, which is successful. Dependent on his professional commitments and on political circumstances, Yoko moves with her family, living with her mother and her two younger siblings at various times in San Francisco, New York, and Tokyo. She grows up speaking both English and Japanese and receives classical musical instruction, primarily in piano and voice, at an early age. Yoko enrolls at the elite Gakushūin School in 1937.

1941–1951

Yoko Ono returns to Japan in 1941 and spends several years there. Initially unaffected by the ravages of war, she survives the devastating bombardment of Tokyo unharmed in her family's bomb shelter in March of 1945. She then is evacuated to the countryside with her siblings. After her former school is reopened, Yoko returns there and graduates in 1951.

1951–1954

Yoko Ono is admitted to Gakushūin University as its first female student of philosophy. There, she is introduced to Existentialism and Marxism and other forms of philosophy, and becomes acquainted with the pacifist ideas propagated in postwar Japanese intellectual circles. Although she leaves the university after two semesters and follows her family to New York, her philosophical inclinations and her fundamental belief in pacifism continue to influence her life and work. In New York, she enrolls at Sarah Lawrence College, majoring in contemporary poetry and composition.

1955–1960

Yoko Ono distances herself progressively from her family structures and withdraws from college. She meets the avant-garde composer Toshi Ichiyanagi and lives with him in Manhattan. Through Ichiyanagi and Stefan Wolpe, a composer then teaching at Black Mountain College,

Ono develops closer ties with John Cage, whom she first meets at a lecture on Zen at Columbia University. The circle associated with Cage also includes Morton Feldman, Richard Maxfield, David Tudor, and Merce Cunningham. In 1959, Ono makes the first of many appearances in front of small audiences at various locations in the US under the auspices of the Japan Society. On these occasions, Ono demonstrates traditional Japanese art forms, reads her own poetry, and also folds and unfolds origami. It is also during this period that she begins to make a name for herself as an independent artist. With her composition entitled LIGHTING PIECE (1955), Ono is one of the very first artists to create *Event Scores*.

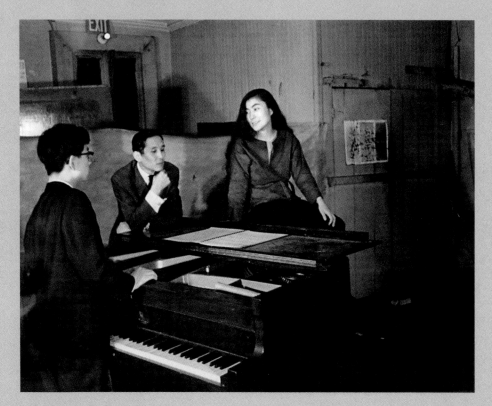

Toshi Ichiyanagi, Toshirō Mayuzumi, and Yoko Ono, 112 Chambers Street, New York, c. March 1961

1960/61

Yoko Ono rents a simple loft on Chambers Street in New York. There, in collaboration with the composer La Monte Young, she organizes events and concerts by Toshi Ichiyanagi, Terry Jennings, La Monte Young, Jackson Mac Low, Richard Maxfield, Henry Flynt, Simone Forti, and Robert Morris. Their guests include Marcel Duchamp, Peggy Guggenheim, and George Maciunas. Also presented within that context, Ono's INSTRUCTION PAINTINGS attract some public attention. They are shown again soon thereafter at her first solo exhibition entitled

Paintings & Drawings by Yoko Ono at Maciunas's AG Gallery in New York. This show is one of the earliest exhibitions of conceptual painting. A number of these works, including PAINTING TO BE STEPPED ON, WATERDROP PAINTING, and SMOKE PAINTING, have survived only in photographs taken by Maciunas. Ono's early compositions are shown at several solo performances in New York in 1961, including performances at the Village Gate and a solo concert at Carnegie Recital Hall. A number of artists perform in Ono's works during these concerts, among them George Brecht, Jonas Mekas, Yvonne Rainer, La Monte Young, and Trisha Brown.

Peggy Guggenheim, John Cage, and Yoko Ono, Kyoto, 1962

1962

Yoko Ono returns to Japan and remains in Tokyo until 1964. On May 24, 1962, she stages her first solo concert and exhibiton at the Sōgetsu Art Center. At this event, many of the most prominent avant-garde artists of the time perform in her pieces. Her exhibition WORKS OF YOKO ONO features a number of her INSTRUCTIONS FOR PAINTINGS, which Ichiyanagi writes out in Japanese at Ono's request. This is the first exhibition of conceptual works of this kind. Later, Ono appears at the same venue in a performance of John Cage's *Music Walk* within the framework of the "Sōgetso Contemporary Series" and performs other pieces with Cage and David Tudor.

Yoko Ono performing **CHAIR PIECE**, Sōgetsu Art Center, Tokyo, May 24, 1962

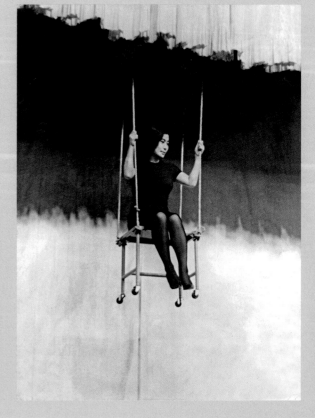

Yoko Ono and others performing **AUDIENCE PIECE**, Sōgetsu Art Center, Tokyo, May 24, 1962

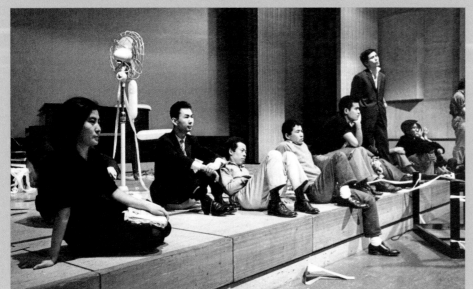

1963/64

Following a period of personal crisis, Yoko Ono meets Anthony Cox during a stay in a sanatorium. Their daughter, Kyoko Cox, is born on August 3, 1963. During this period, Nam June Paik arrives in Tokyo from Europe and together they perform with the artist group Hi Red Center. In May of 1964, Ono first performs MORNING PIECE, in which she offers past and future mornings for sale. In September 1965, a repeat performance of this event, dedicated to George Maciunas, will be staged in New York. On July 4, 1964, Ono publishes *Grapefruit*, containing a collection of many of her written *Instructions*, which still serve as points of departure for her works today. At the "Contemporary American Avant-Garde Music Concert: Insound and Instructure" in Kyoto, Ono performs CUT PIECE and BAG PIECE for the first time. These are among the best-known performances of the artist, and both have been performed often by Ono and others over the years. Ono and Cox move to New York from Tokyo in the late autumn of 1964. There, Ono initiates a number of postcard events, including DRAW CIRCLE EVENT. For this action, participants are asked to draw a circle on the postcard and send it to the artist at the Empire State Building.

Ticket, *Contemporary American Avant-Garde Music Concert: Insound and Instructure*, Yamaichi Hall, Kyoto, July 20, 1964

Program, *Contemporary American Avant-Garde Music Concert: Insound and Instructure*, Yamaichi Hall, Kyoto, July 20, 1964

1965

The concert entitled *New Works of Yoko Ono* is presented at Carnegie Recital Hall in New York. Among other pieces, she presents CUT PIECE, STRIPTEASE FOR THREE, a performance featuring only three chairs standing motionless on the stage, and CLOCK PIECE, in which the audience has to imagine strokes of the clock. Ono takes part in a number of Fluxus events. She performs BAG PIECE and BEAT PIECE in *Perpetual Fluxfest Presents Yoko Ono*. In the performance of *Beat Piece*, Ono, Anthony Cox, Nam June Paik, Shigeko Kubota, and others lie on top of each other and listen to each other's hearts beating. A second major concert entitled *Fluxorchestra at Carnegie Recital Hall* features her SKY PIECE TO JESUS CHRIST, a composition in which the musicians

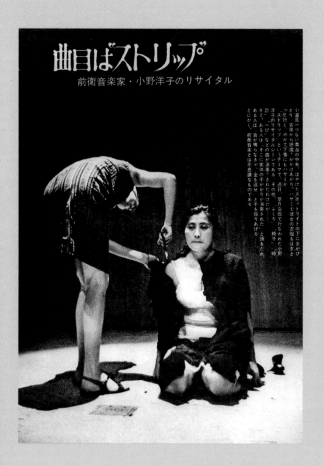

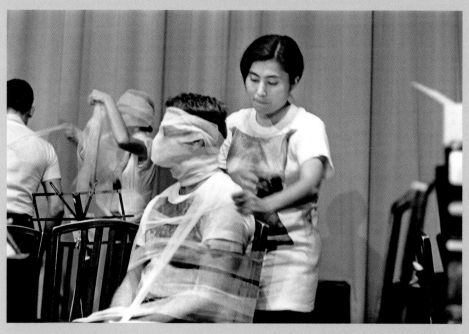

Magazine article with image of Yoko Ono performing **CUT PIECE**, Yamaichi Concert Hall, Kyoto, 1964

Yoko Ono and the Fluxus Symphony Orchestra performing **SKY PIECE to Jesus Christ**, Carnegie Recital Hall, New York, September 25, 1965 Photograph by Peter Moore

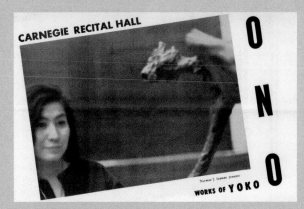

Poster, **WORKS OF YOKO ONO**, Carnegie Recital Hall, New York, November 24, 1961

are wrapped in gauze bandages until they can no longer move or play their instruments. Ono produces a number of objects for sale, including SELFPORTRAIT, a small mirror signed on the reverse, and the tape entitled SOUNDTAPE OF THE SNOW FALLING AT DAWN. These multiples are included in her work BUY NOW! SELFPORTRAIT BY YOKO ONO.

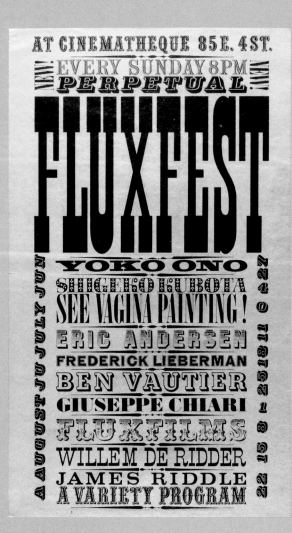

```
BUY NOW!
SELFPORTRAIT
BY YOKO ONO
$1 ONLY
$5 WITH FRAME

BUY NOW!
SOUNDTAPE AND,
OR FILM OF
THE SNOW
FALLING AT DAWN
25¢ PER INCH
TYPES:
A: SNOW OF INDIA
B: SNOW OF KYO
C: SNOE OF AOS

FOR THOSE WHO
WISH TO SPEND
MORE    WE HAVE
GRAPEFRUIT
$7
FOR TOILET
READING

SEND YOUR ORDER
AND MONEY TO
YOKO ONO
C/O FLUXUS
P.O.BOX 180
NEW YORK 10013

YOKO ONO
87 CHRISTOPHER
STREET
NEW YORK, N.Y.
```

BUY NOW! SELFPORTRAIT
by Yoko Ono, 1965
Offset on paper, 21.1 × 7 cm

Poster, *Perpetual Fluxfest Presents Yoko Ono*, Cinematheque (at East End Theater), New York, June 27, 1965

1966/67

Yoko Ono realizes BLUE ROOM EVENT for the first time in her own appartment. For this event, she writes *Instructions* on small cards or directly on the walls. Later versions of the piece are realized in numerous museums around the world. After participating with several performances in the Destruction in Art Symposium (DIAS) in London, she decides to stay in London. During the symposium, she meets John Dunbar and soon presents her solo exhibition entitled *Yoko at Indica* at his Indica Gallery. It is there that she meets John Lennon, who visits the gallery before the show opens and is particularly fascinated with APPLE, PAINTING TO HAMMER A NAIL IN, and CEILING PAINTING. In 1966–67, Ono makes the long version of FILM NO. 4 (BOTTOMS), (a shorter version of the film was realized the year before in New York), which is initially censored in Great Britain and cannot be shown in public. The artist demonstrates in protest of the ban, and the film finally premieres on August 8, 1967. Her LION WRAPPING EVENT, in which Ono wraps a large sculpture of a lion in cloth, takes place that same month at Trafalgar Square. In October, the Lisson Gallery opens her solo exhibition entitled *Half-A-Wind Show*, which features the first presentations of HALF-A-ROOM and AIR BOTTLES, the latter a product of one of her earliest collaborations with Lennon.

Poster, **YOKO ONO: MUSIC OF THE MIND**, Saville Theatre, London, December 8, 1967

WHAT'S WRONG WITH THIS ←PICTURE

Twenty - five - year - old Japanese actress Yoko Ono led a protest today against the banning of her film about the human posterior.
With several of the film's cast (unpaid) she picketed the censor's office in Soho Square and laid flowers on the door-step.
Her husband, 30-year-old director Anthony Cox, was there, too — armed with a 3ft blown-up segment of the film

showing the nether portions of some anonymous anatomy.
The marchers, all eight of them, paraded defiantly along the pavement, watched with tolerant amusement by a hand-ful of police.
Said Miss Ono: "This is not a great leg pull on my part. It was a serious film, and I hope the censor will change his mind and allow us to show it publicly. I have challenged him to appear on TV and dis-cuss it."

The film is called "Number Four" and is a 90-minute study of naked bottoms.
Censor Mr. John Trevelyan refused to issue a certificate and asked her to remove it "as soon as possible from the premises."

Newspaper article on Yoko Ono demonstrating for **FILM NO. 4 (BOTTOMS)**, London 1967

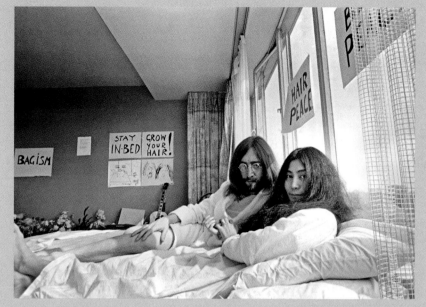

Yoko Ono and John Lennon performing **BED-IN FOR PEACE**, Hilton Hotel, Amsterdam, March 25–31, 1969

1968

Yoko Ono works with John Lennon as a musician and artist more and more frequently. In addition to concert appearances, they realize a joint performance—ACORN EVENT, during which they plant two acorns at Coventry Cathedral. They also perform earlier works by Ono, including BAG PIECE. The first two of joint film produc-tions, TWO VIRGINS and FILM NO. 5 (SMILE), premiere in Chicago in November, and their first album, UNFINISHED MUSIC NO. 1: TWO VIRGINS, is released that same year. The cover shows the couple naked and holding hands. The publication of a photo of the cover in *Rolling Stone* triggers a major scandal.

From a publication for Yoko Ono and John Lennon's perform-ance **ACORN EVENT**, Coventry Cathedral, Coventry, England, June 15, 1968

Yoko Ono and John Lennon performing **ACORN EVENT**, Coventry Cathedral, Coventry, England, June 15, 1968

1969

Yoko Ono and John Lennon are married in Gibraltar on March 20. Their film RAPE, co-produced for Austrian television, is presented for the first time that month. The couple appears in an increasing number of actions in support of world peace. In place of a honeymoon, they perform BED-IN FOR PEACE at the Hilton Hotel in Amsterdam. During the presentation of the second ver-sion of the performance at the Queen Elizabeth Hotel in Montreal, they record the song GIVE PEACE A CHANCE, which they release under the name of the newly formed Plastic Ono Band. Large billboards and/or posters are set up in twelve cities around the world; they display the

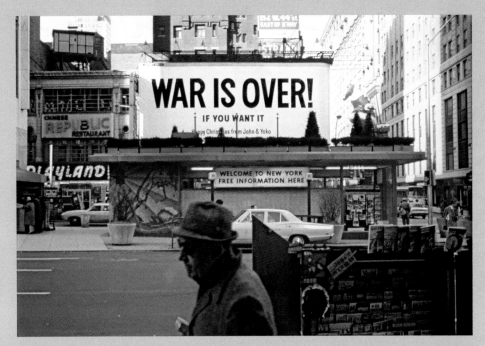

1970/71

Yoko Ono makes her films FREEDOM and FLY. Produced in collaboration with John Lennon, her films APOTHEOSIS, ERECTION, and IMAGINE, premiere and are shown at a number of film festivals, for example in New York and in Cannes. During Lennon's appearance in the television show *Top of the Pops*, he plays the song *Instant Karma*, while Ono holds the corresponding *Instructions* up to the camera, her eyes covered by a blindfold. Lennon also appears as a guest artist at the major Yoko Ono retrospective entitled *This Is Not Here* at the Everson Museum in Syracuse, New York. The exhibition is conceived by Yoko Ono. George Maciunas helps to organize and coordinate some of the production and the exhibition catalog, and he creates a complicated *Catalog Box* based on Ono's concept. The exhibition also features the first presentation of WATER EVENT, with contributions by more than 100 people, including John Cage, Ornette Coleman, Joseph Cornell, Richard Hamilton, Allan Kaprow, Gordon Matta-Clark, Jonas Mekas, Shigeko Kubota, Andy Warhol, and Bob Dylan. Premiere presentations also include AMAZE, as well as several DISPENSERS, from which visitors receive capsules filled with air, acorns, or other things by inserting coins. For her "imaginary event" MUSEUM OF MODERN (F)ART, Ono holds an imaginary exhibition at MoMA. The exhibition is advertised, and a catalog is published. An accompanying film features interviews with pedestrians about the exhibition.

words WAR IS OVER! (IF YOU WANT IT). In the ACORNS FOR PEACE action, they send acorns to ninety-six heads of state and international political figures. On December 16, they make PEACE-PHONECALLS to various radio stations. Ono becomes more closely involved with pop music through Lennon. In addition to several singles, they also release three LPs: UNFINISHED MUSIC NO. 2: LIFE WITH THE LIONS, WEDDING ALBUM, and PLASTIC ONO BAND, LIVE PEACE IN TORONTO.

Yoko Ono and John Lennon, **WAR IS OVER!**, 1969. Billboard installed in Times Square, New York

Yoko Ono and John Lennon with
WHITE CHESS SET, Everson
Museum, Syracuse, New York, 1971

PLASTIC ONO BAND, GIVE PEACE A CHANCE / Remember Love, 1969, single cover

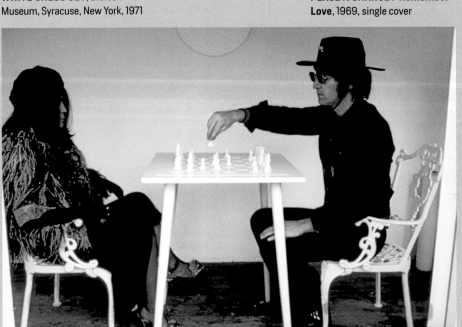

Dinner in George Maciunas's backyard, 80 Wooster St., 1971
Left to right: Aldolfas Mekas, Andy Warhol, Fred Hughes, Yoko Ono, John Lennon, Jonas Mekas, Barbara Moore
Photograph by Peter Moore

1972–1975

Deportation proceedings are initiated against Yoko Ono and John Lennon in the United States. Finally, Lennon is given a green card in 1976. The couple receives the *Positive Image of Women Award* presented by the National Organization of Women for their songs WOMAN IS THE NIGGER OF THE WORLD and SISTERS, O SISTERS. Ono's first straight pop album, the double LP APPROXIMATELY INFINITE UNIVERSE, is released. She exhibits at documenta 5 in 1972. Her presentation in the section *Individual Mythologies, Self-Representation, Process* includes the film FLY and several other works, such as PAINTING TO HAMMER A NAIL IN, PAINTING TO BE STEPPED ON, FORGET IT, and WHITE CHESS SET. Although Ono receives custody of her daughter, Kyoko, in 1973, Anthony Cox disappears with the child, and Ono is not reunited with Kyoko until many years later. She and Lennon move into an apartment in the Dakota Building in New York, The couple separates for slightly over a year in October. Their son, Sean Tarō Ono Lennon, is born on October 9, 1975.

1976–1980

Yoko Ono, John Lennon, and their son take two extended trips to Japan. The couple withdraws progressively from public exposure and issues an explanation in an open letter entitled A LOVE LETTER FROM JOHN AND YOKO TO PEOPLE WHO ASK US WHAT WHEN AND WHY. John Lennon is shot and killed outside the Dakota Building on December 8, 1980. On December 14, Ono calls for ten minutes of silence around the world in memory of John.

Cover of *Rolling Stone*, January 22, 1981

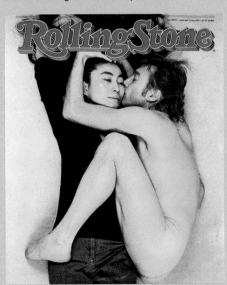

1981–1985

Yoko Ono devotes herself increasingly to music. The video for WALKING ON THIN ICE is released along with several singles and the SEASON OF GLASS album. Besides a number of singles, the LP IT'S ALRIGHT – I SEE RAINBOWS and the video entitled GOODBYE SADNESS are released the following year. These two works are expressions of her effort to come to terms with her grief. Ono is awarded a Grammy for "Album of the Year" for DOUBLE FANTASY, the last LP she recorded with Lennon. Ono undertakes a world tour in support of the album STARPEACE, which is released in 1985. *Strawberry Fields*, the memorial to Lennon designed by Ono, is dedicated in New York's Central Park.

Poster, **STARPEACE WORLD TOUR**, 1986

Strawberry Fields, Central Park, New York

1986–1989

Yoko Ono gradually focuses her interest on exhibitions once again. Her solo exhibition *Yoko Ono: Objects, Films* is presented at the Whitney Museum of American Art in New York in 1989. The show includes the premiere presentation of her new bronze sculptures, most of which are a dialogue with works from the 1960s. Soon thereafter, the exhibition entitled *Yoko Ono: The Bronze Age*, a greatly expanded exhibition, is presented in several cities in the US and Europe. One of the curators is the artist and Fluxus expert Jon Hendricks, who will be involved in many of Ono's projects from then on.

Poster, **YOKO ONO: BRONZE AGE**, Cranbrook Academy of Art Museum, Bloomfield Hills, Michigan, 1989

Poster from the event **A CELEBRATION OF BEING HUMAN**, Langenhagen, 1994

1990–1995

The exhibition entitled *Yoko Ono: In Facing* is held at the Riverside Studios in 1990. Ono is represented at the Venice Biennale, at which Fluxus is a focal theme, with WISH PIECE, HALF-A-ROOM, and SKY PIECE TO JESUS CHRIST. Other solo exhibitions presented that year include *Yoko Ono: EnTrance* at the Randers Kunstmuseum in Denmark, *Yoko Ono: Insound/ Instructure* at the Henie Onstad Arts Centre in Norway, and *Yoko Ono: To See the Skies* at the Fondazione Mudima in Milan. Some of the aforementioned exhibition titles relate to earlier

works or exhibitions. A cinema retrospective first presented at the American Federation of Arts in New York embarks on a world tour. The ONOBOX CD collection is released in 1992 and includes new recordings as well as reissues of nearly all of her previous music. In addition to several gallery shows, *Yoko Ono: Endangered Species 2319–2322* is presented at the Mary Boone Gallery in New York. This exhibition also tours in many countries. Ono develops concepts for a number of public events, including the massive public installation YOKO ONO: A CELEBRATION OF BEING HUMAN in Langenhagen, in which practically all of the public advertising space in the city is covered with posters featuring photographs of naked bottoms. The spectacular projection event entitled YOKO ONO: LIGHTING PIECE is presented in an urban setting in the city of Florence.

Exhibition poster, **HAVE YOU SEEN THE HORIZON LATELY?**, Museum of Modern Art, Oxford, 1998

Yoko Ono **ONOBOX**, 1992

1996–1999

Her RISING album of 1995 is released as a remix. Yoko Ono tours the US and Europe with Sean Lennon's IMA band. All of Ono's LPs are released on CDs in 1997. Ono is also amenable to using the new digital technology for her art. She is one of the first artists to participate in Internet-based exhibitions. *Yoko Ono: One Woman Show* is a straight online exhibition presented on the website of the Los Angeles Museum of Contemporary Art. She also

takes part in the Internet 1996 World Exposition, in which, among other things, artists exhibit works in online pavilions. Ono's contribution is ACORNS: 100 DAYS WITH YOKO ONO, in which she publishes a new instruction on the Internet every day for 100 days. She continues to participate in physical solo and group exhibitions, including *Yoko Ono: Conceptual Photography* at the Fotografisk Center in Copenhagen, *Yoko Ono: En Trance – Ex It* in Alicante and Valencia, Spain, and the retrospective *Yoko Ono: Have You Seen the Horizon Lately?*, with venues in Great Britain, Germany, Finland, and Israel.

2000–2004

YES Yoko Ono, the most extensive retrospective devoted to the artist to date, is shown at the Japan Society in New York in 2000 and subsequently presented at numerous venues in North America, Korea, and Japan. Yoko Ono's songs, most notably WALKING ON THIN ICE, inspire other musicians and DJs, such as Pet Shop Boys, to release new recordings and remixes of her work. Ono now collaborates more and more often with other musicians or makes guest appearances at their concerts. In 2003, Ono performs CUT PIECE once again, at the age of seventy, in Paris. She participates in the Liverpool Biennial

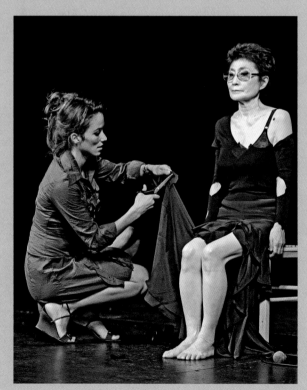

the following year, presenting banners, posters, postcards, and flyers showing a breast or a woman's pubic region, which are distributed throughout the city. The title of this work is MY MUMMY WAS BEAUTIFUL.

2005–2009

YES, I'M A WITCH, a remix album, is released in 2007. Yoko Ono invites a number of popular musicians to interpret her songs, among them The Flaming Lips, Cat Power, Porcupine Tree, and Peaches. Her IMAGINE PEACE TOWER is inaugurated in Reykjavík in 2007 on the occasion of John Lennon's birthday. The tower beams a seemingly endless column of light into the sky for several weeks every year. The project is an homage to Lennon and a memorial to the cause of peace. In 2008, the retrospective *Yoko Ono: Between the Sky and My Head* is presented at the Kunsthalle Bielefeld and the Baltic Art Centre and features many conceptual works in physical form, some of them for the first time. Ono is awarded the

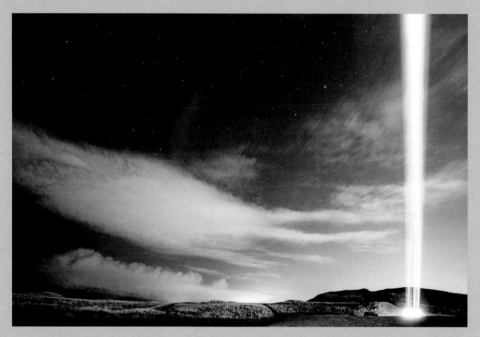

IMAGINE PEACE TOWER,
Reykjavík, 2012

Yoko Ono performing
CUT PIECE,
Théâtre du Ranelagh,
Paris, 2003

Golden Lion for Lifetime Achievement at the 53rd Venice Biennale in 2009. BETWEEN MY HEAD AND THE SKY is released. It is the first album since 1973 made by the Plastic Ono Band, which now includes Sean Lennon.

Yoko Ono receiving the Golden Lion for her career from Venice Mayor Massimo Cacciari, 53rd Biennale International Art Exhibition in Venice, Italy, June 6, 2009

197

appearances, Ono maintains a strong Internet presence, communicating daily on such online platforms as Facebook, Twitter, and Instagram, and on her own website at http://imaginepeace.com/.HALF-A-WIND SHOW, a retrospective in honor of her 80th birthday, will be presented at the Schirn Kunsthalle Frankfurt in 2013 and tour to three major museums: the Louisiana Museum in Humlebæk, Denmark, the Kunsthalle Krems in Austria, and the Guggenheim Bilbao in Spain.

Yoko Ono on stage with
Sean Lennon and Iggy Pop
**YOKO ONO: WE ARE
PLASTIC ONO BAND**,
Orpheum Theater,
Los Angeles, October 1, 2010

imaginepeace.com,
Website, December 12, 2012
world wide web

2010–2013

For the first time in many years, Yoko Ono gathers former members of the Plastic Ono Band for a concert. Eric Clapton, Bette Middler, and Paul Simon are among the performers. Lady Gaga also appears with Ono. The remix album ONOMIX is released under the pseudonym ONO; a second release is YOKOKIMTHURSTON, an album recorded in collaboration with Thurston Moore and Kim Gordon. Ono receives multiple honors for her life's work in 2011 and 2012, including the Hiroshima Art Prize, the Oskar Kokoschka Prize, and the Lifetime Achievement Award at the Dublin Biennial. Her exhibition *To the Light* is presented at the Serpentine Gallery in London. In addition to her involvement in numerous exhibition projects all over the world, Ono continues to work actively in support of world peace and environmental protection. She awards one of the 2012 LennonOno Grants for Peace, which she established in 2002, to the Russian band Pussy Riot. Aside from numerous art projects and

Compiled by Lisa Beißwanger

Selected Bibliography

Books by Yoko Ono

Grapefruit.
Artist's book.
Tokyo: Wunternaum Press, 1964.

Yoko at Indica.
London: Indica Gallery, 1966.
Exhibition catalog.

Yoko Ono at Lisson: Half-A-Wind Show.
London: Lisson Gallery, 1967.
Exhibition catalog.

Grapefruit: A Book of Instructions and Drawings by Yoko Ono.
Artist's book.
New York: Simon & Schuster, 1970.

Everson Catalog Box for *This Is Not Here*,
Everson Museum, Syracuse, 1971.
Contains the four-page catalog
This Is Not Here; Grapefruit (1971);
multiple works by Ono and John Lennon.

Museum Of Modern (F)art.
Artist's book.
New York: self-published, 1971.

Yoko Ono: Instruction Paintings.
New York/Tokyo: Weatherhill, 1995.

Yoko Ono: Spare Room.
Artist's book.
Published in the framework of
"Yoko Ono – Women's Room"
at the Musee d'Art Moderne de la Ville
de Paris, 2003.

Yoko Ono: The Other Rooms.
Artist's Book.
Milan: Charta, 2009.

Yoko Ono: An Invisible Flower.
Artist's book.
San Francisco: Chronicle Books, 2012.

Exhibition Catalogs, Solo Exhibitions

Yoko Ono: Objects, Films.
New York: Whitney Museum of American Art,
1989. Exhibition catalog.

Yoko Ono: The Bronze Age.
Edited by Jon Hendricks.
Bloomfield Hills, MI: Cranbrook Academy
of Art Museum, 1989. Exhibition catalog.

Yoko Ono: En Trance.
Edited by Jon Hendricks and
Birgit Hessellund.
Randers (Denmark): Randers Kunstmuseum,
1990. Exhibition catalog.

Yoko Ono: To See the Skies.
Edited by Jon Hendricks.
Milan: Fondazione Mudima, 1990.
Exhibition catalog.

Yoko Ono: Insound/Instructure.
Edited by Jon Hendricks and Ina Blom.
Høovikodden (Norway): Henie Onstad
Arts Centre, 1990. Exhibition catalog.

Yoko Ono: In Facing.
London: Riverside Studios, 1990.
Exhibition catalog.

Homage to Nora.
Ina Blom.
Høovikodden (Norway): Henie Onstad
Arts Centre, 1991. Exhibition catalog.

Yoko Ono: Color, Fly, Sky.
Edited by Jon Hendricks and Marianne Beck.
Roskilde (Denmark): Museet for
Samtidskunst, 1992. Exhibition catalog.

Yoko Ono: Endangered Species 2319–2322.
Edited by Jon Hendricks and Jörg Starke.
Berlin: Stiftung Starke, 1992.
Exhibition catalog.

Family Album.
Edited by Jon Hendricks and Jörg Starke.
Berlin: Stiftung Starke, 1993.
Exhibition catalog.

Yoko Ono: A Piece of Sky.
Rome: Galleria Stefania Miscetti, 1993.
Exhibition catalog.

Yoko Ono: Sphere 9.
Edited by Jon Hendricks, Pablo J. Rico,
and Pilar Baos.
Mallorca: Fundació Pilar i Joan Miró
a Mallorca, 1995. Exhibition catalog.

Yoko Ono: Lighting Piece.
Ida Panicelli.
Rome: Studio Stefania Miscetti, 1995.
Exhibition catalog.

*Yoko Ono: The Yoko Ono Film Festival
Smile Event.*
Edited by Stefania Miscetti, Simona Rossi,
and Massimo Burgio.
Rome: Studio Stefania Miscetti, 1996.
Exhibition catalog.

Yoko Ono: En Trance – Ex It.
Edited by Jon Hendricks and Pablo J. Rico.
Valencia (Spain): Consortium of Museums
of the Community of Valencia, 1997.
Exhibition catalog.

Yoko Ono. Have You Seen the Horizon Lately?
Chrissie Iles.
Oxford: Museum of Modern Art, 1997.
Exhibition catalog.

Yoko Ono: Conceptual Photography.
Edited by Jon Hendricks and Lars Schwander.
Copenhagen (Denmark): Fotografisk Center,
1997. Exhibition catalog.

Yoko Ono: Open Window.
Edited by Shlomit Shaked.
Umm El-Fachem (Israel): Umm El-Fachem
Art Gallery, 1999. Exhibition catalog.

Yoko Ono: Impressions.
Edited by Gunnar Kvaran.
Bergen (Norway): Bergen Art Museum, 1999.
Exhibition catalog.

Yes: Yoko Ono.
Edited by Alexandra Munroe and Jon Hendricks.
New York: Japan Society, 2000.
Exhibition catalog.

Yoko Ono: Ebro.
Edited by Jon Hendricks and Pablo Rico.
Zaragoza: Sástago Palace, 2000.
Exhibition catalog.

Yoko Ono: Herstory
Berlin: Fine Art, Rafael Vostell, 2001.
Exhibition catalog.

Yoko Ono: Horizontal Memories.
Edited by Grete Arbu.
Oslo: Astrup Fearnley Museum of Modern Art,
2005. Exhibition catalog.

Yoko Ono: Odyssey of a Cockroach.
New York: Deitch Projects, 2005.
Exhibition catalog.

Yoko Ono: Between the Sky and my Head.
Edited by Thomas Kellein.
Bielefeld: Kunsthalle Bielefeld, 2009.
Exhibition catalog.

Yoko Ono: Gemälde / Paintings 1960–1964.
Edited by Wulf Herzogenrath and
Frank Laukötter.
Bremen: Kunsthalle Bremen, 2007. Exhibition
catalog for *Yoko Ono: Window for Germany.*

Imagine Peace Tower.
Edited by Haukur Haraldsson.
Reykjavík: Iceland Post, 2008.
Catalog to commemorate the inauguration
of Yoko Ono's *Imagine Peace Tower*,
Viðey island, Reykjavík.

Yoko Ono: Touch Me.
Edited by Filomena Moscatelli.
New York: Galerie Lelong, 2008.
Exhibition catalog.

Yoko Ono: Sognare.
Edited by Jon Hendricks and Luigi Bonotto.
Treviso: Museo de Santa Caterina, 2008.
Exhibition catalog.

Yoko Ono: Fly.
Guangzhou (China): Guangdong Museum
of Art, 2008. Exhibition catalog.

Yoko Ono: The Road of Hope.
Hiroshima: Hiroshima City Museum of
Contemporary Art, 2011. Exhibition catalog.

Yoko Ono: To the Light.
Edited by Kathryn Rattee, Melissa Larner,
and Rebecca Lewin.
London: Serpentine Gallery, 2012.
Exhibition catalog.

Books on Yoko Ono

Haskell, Barbara Haskell and John Hanhardt.
Yoko Ono: Arias and Objects. Salt Lake City,
1991.

Instructions for Paintings. Edited by
Jon Hendricks. Budapest: Galeria 56, 1993.

Obrist, Hans Ulrich. *Yoko Ono.
The Conversation Series 17*. Cologne, 2010.

For a comprehensive bibliography on
Yoko Ono, see: *Yes: Yoko Ono*. Edited by
Alexandra Munroe and Jon Hendricks.
New York: Japan Society, 2000.
Exhibition catalog, pp. 337–45.

Selected Bibliography

Books by Yoko Ono

Grapefruit.
Artist's book.
Tokyo: Wunternaum Press, 1964.

Yoko at Indica.
London: Indica Gallery, 1966.
Exhibition catalog.

Yoko Ono at Lisson: Half-A-Wind Show.
London: Lisson Gallery, 1967.
Exhibition catalog.

Grapefruit: A Book of Instructions and Drawings by Yoko Ono.
Artist's book.
New York: Simon & Schuster, 1970.

Everson Catalog Box for *This Is Not Here*, Everson Museum, Syracuse, 1971.
Contains the four-page catalog *This Is Not Here; Grapefruit* (1971); multiple works by Ono and John Lennon.

Museum Of Modern (F)art.
Artist's book.
New York: self-published, 1971.

Yoko Ono: Instruction Paintings.
New York/Tokyo: Weatherhill, 1995.

Yoko Ono: Spare Room.
Artist's book.
Published in the framework of "Yoko Ono – Women's Room" at the Musee d'Art Moderne de la Ville de Paris, 2003.

Yoko Ono: The Other Rooms.
Artist's Book.
Milan: Charta, 2009.

Yoko Ono: An Invisible Flower.
Artist's book.
San Francisco: Chronicle Books, 2012.

Exhibition Catalogs, Solo Exhibitions

Yoko Ono: Objects, Films.
New York: Whitney Museum of American Art, 1989. Exhibition catalog.

Yoko Ono: The Bronze Age.
Edited by Jon Hendricks.
Bloomfield Hills, MI: Cranbrook Academy of Art Museum, 1989. Exhibition catalog.

Yoko Ono: En Trance.
Edited by Jon Hendricks and Birgit Hessellund.
Randers (Denmark): Randers Kunstmuseum, 1990. Exhibition catalog.

Yoko Ono: To See the Skies.
Edited by Jon Hendricks.
Milan: Fondazione Mudima, 1990.
Exhibition catalog.

Yoko Ono: Insound/Instructure.
Edited by Jon Hendricks and Ina Blom.
Høovikodden (Norway): Henie Onstad Arts Centre, 1990. Exhibition catalog.

Yoko Ono: In Facing.
London: Riverside Studios, 1990.
Exhibition catalog.

Homage to Nora.
Ina Blom.
Høovikodden (Norway): Henie Onstad Arts Centre, 1991. Exhibition catalog.

Yoko Ono: Color, Fly, Sky.
Edited by Jon Hendricks and Marianne Beck.
Roskilde (Denmark): Museet for Samtidkunst, 1992. Exhibition catalog.

Yoko Ono: Endangered Species 2319–2322.
Edited by Jon Hendricks and Jörg Starke.
Berlin: Stiftung Starke, 1992.
Exhibition catalog.

Family Album.
Edited by Jon Hendricks and Jörg Starke.
Berlin: Stiftung Starke, 1993.
Exhibition catalog.

Yoko Ono: A Piece of Sky.
Rome: Galleria Stefania Miscetti, 1993.
Exhibition catalog.

Yoko Ono: Sphere 9.
Edited by Jon Hendricks, Pablo J. Rico, and Pilar Baos.
Mallorca: Fundació Pilar i Joan Miró a Mallorca, 1995. Exhibition catalog.

Yoko Ono: Lighting Piece.
Ida Panicelli.
Rome: Studio Stefania Miscetti, 1995.
Exhibition catalog.

Yoko Ono: The Yoko Ono Film Festival Smile Event.
Edited by Stefania Miscetti, Simona Rossi, and Massimo Burgio.
Rome: Studio Stefania Miscetti, 1996.
Exhibition catalog.

Yoko Ono: En Trance – Ex It.
Edited by Jon Hendricks and Pablo J. Rico.
Valencia (Spain): Consortium of Museums of the Community of Valencia, 1997.
Exhibition catalog.

Yoko Ono. Have You Seen the Horizon Lately?
Chrissie Iles.
Oxford: Museum of Modern Art, 1997.
Exhibition catalog.

Yoko Ono: Conceptual Photography.
Edited by Jon Hendricks and Lars Schwander.
Copenhagen (Denmark): Fotografisk Center, 1997. Exhibition catalog.

Yoko Ono: Open Window.
Edited by Shlomit Shaked.
Umm El-Fachem (Israel): Umm El-Fachem Art Gallery, 1999. Exhibition catalog.

Yoko Ono: Impressions.
Edited by Gunnar Kvaran.
Bergen (Norway): Bergen Art Museum, 1999.
Exhibition catalog.

Yes: Yoko Ono.
Edited by Alexandra Munroe and Jon Hendricks.
New York: Japan Society, 2000.
Exhibition catalog.

Yoko Ono: Ebro.
Edited by Jon Hendricks and Pablo Rico.
Zaragoza: Sástago Palace, 2000.
Exhibition catalog.

Yoko Ono: Herstory
Berlin: Fine Art, Rafael Vostell, 2001.
Exhibition catalog.

Yoko Ono: Horizontal Memories.
Edited by Grete Arbu.
Oslo: Astrup Fearnley Museum of Modern Art, 2005. Exhibition catalog.

Yoko Ono: Odyssey of a Cockroach.
New York: Deitch Projects, 2005.
Exhibition catalog.

Yoko Ono: Between the Sky and my Head.
Edited by Thomas Kellein.
Bielefeld: Kunsthalle Bielefeld, 2009.
Exhibition catalog.

Yoko Ono: Gemälde / Paintings 1960–1964.
Edited by Wulf Herzogenrath and Frank Laukötter.

Bremen: Kunsthalle Bremen, 2007. Exhibition catalog for *Yoko Ono: Window for Germany.*

Imagine Peace Tower.
Edited by Haukur Haraldsson.
Reykjavík: Iceland Post, 2008.
Catalog to commemorate the inauguration of Yoko Ono's *Imagine Peace Tower*, Viðey island, Reykjavík.

Yoko Ono: Touch Me.
Edited by Filomena Moscatelli.
New York: Galerie Lelong, 2008.
Exhibition catalog.

Yoko Ono: Sognare.
Edited by Jon Hendricks and Luigi Bonotto.
Treviso: Museo de Santa Caterina, 2008.
Exhibition catalog.

Yoko Ono: Fly.
Guangzhou (China): Guangdong Museum of Art, 2008. Exhibition catalog.

Yoko Ono: The Road of Hope.
Hiroshima: Hiroshima City Museum of Contemporary Art, 2011. Exhibition catalog.

Yoko Ono: To the Light.
Edited by Kathryn Rattee, Melissa Larner, and Rebecca Lewin.
London: Serpentine Gallery, 2012.
Exhibition catalog.

Books on Yoko Ono

Haskell, Barbara Haskell and John Hanhardt.
Yoko Ono: Arias and Objects. Salt Lake City, 1991.

Instructions for Paintings. Edited by Jon Hendricks. Budapest: Galeria 56, 1993.

Obrist, Hans Ulrich. *Yoko Ono. The Conversation Series 17*. Cologne, 2010.

For a comprehensive bibliography on Yoko Ono, see: *Yes: Yoko Ono*. Edited by Alexandra Munroe and Jon Hendricks. New York: Japan Society, 2000. Exhibition catalog, pp. 337–45.

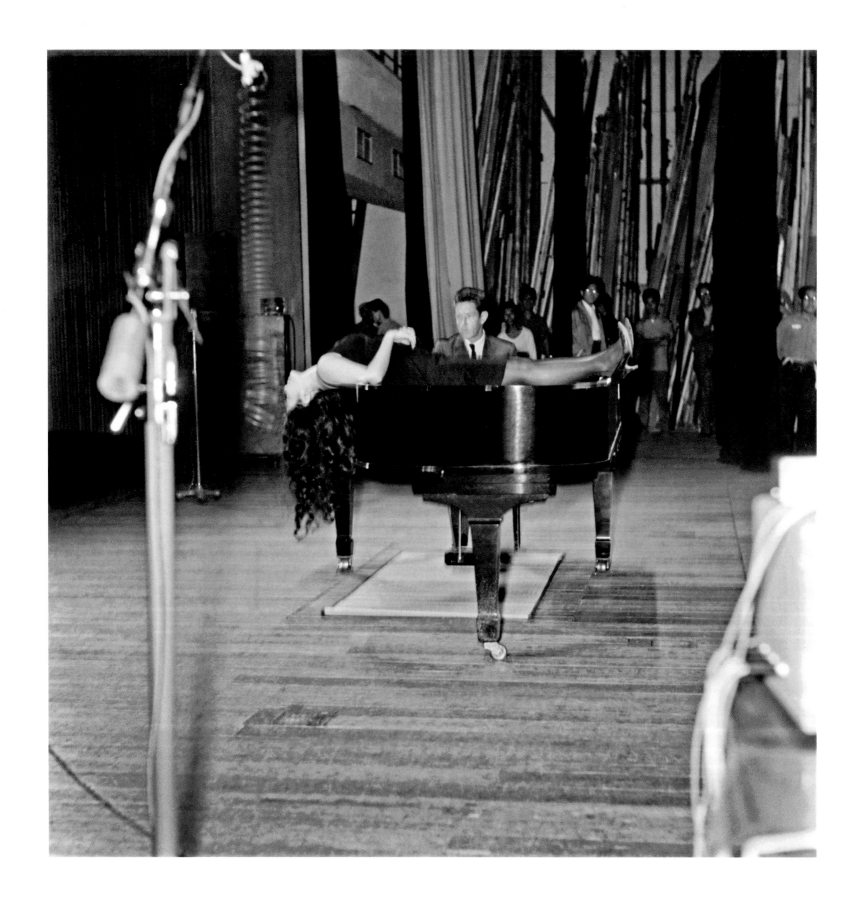

Yoko Ono performing in
John Cage's *Music Walk* with John Cage
Sōgetsu Art Center, Tokyo, October 9, 1962

The Authors

Ingrid Pfeiffer

Curator at the Schirn Kunsthalle since early 2001; served previously as a research assistant at the Museum Wiesbaden (1997–2000). Dissertation on the German Constructivist Erich Buchholz. Numerous publications on architecture, photography, and art of the 19th to the 21st century (e.g. Johannes Itten, Sonia Delaunay, Eva Hesse). Exhibitions at the Schirn Kunsthalle: *Shopping – 100 Years of Consumerism* (2002), *Henri Matisse – The Cut-Outs* (2002/03), *Julian Schnabel* (2004), *Yves Klein Retrospective* (2004/05), *James Ensor Retrospective* (2005/06), *A. R. Penck Retrospective* (2007), *Women Impressionists* (2008), *E. W. Nay* (2009), *László Moholy-Nagy Retrospective* (2009/10), *Barbara Kruger – Circus* (2010/11), *Surreal Objects* (2011).

Jon Hendricks

An artist and the Fluxus Consulting Curator of the Gilbert and Lila Silverman Fluxus Collection Gift at The Museum of Modern Art in New York. He has been the curator of Yoko Ono exhibitions since 1989. He has edited and coedited a number of books, including *Fluxus Codex* (1988); *What's Fluxus? What's Not! Why.* (2003); *Fluxus Scores and Instructions: The Transformative Years* (2008); *Strip-tease intégral de Ben* (2010); and with Alexandra Munroe, *Yes: Yoko Ono* (2000). Has curated a number of Yoko Ono exhibitions and exhibitions of Fluxus, as well as a major retrospective of Ben Vautier. He is a member, with Jean Toche, of GAAG (Guerilla Art Action Group), which they founded in 1969. From 1966 to 1968, Hendricks was the director of the Judson Gallery at Judson Memorial Church in New York. In 1967 and 1968, he curated numerous Destruction Art events and cocurated the *DIAS USA 68* at the Judson Gallery.

Alexandra Munroe

Alexandra Munroe is Senior Curator of Asian Art at the Solomon R. Guggenheim Museum. Her recent exhibitions are the major retrospective *Cai Guo-Qiang: I Want to Believe* (2008) and *The Third Mind: American Artists Contemplate Asia, 1860–1989* (2009). Further exhibitions and publications were *Yayoi Kusama: A Retrospective* (1989); *Japanese Art After 1945: Scream Against the Sky* (1994); with Jon Hendricks, *Yes: Yoko Ono* (2000); *The Art of Mu Xin* (2002). Munroe served as Vice President of Arts & Culture at the Japan Society, New York, and Director of the Japan Society Gallery from 1998 to 2005. She is a trustee of the United States–Japan Foundation; the Institute of Fine Arts, New York University; the Alliance for the Arts; Longhouse Reserve; and is a member of the Council on Foreign Relations.

Kerstin Skrobanek

Studied art history, classical culture, and applied theater in Frankfurt, Giessen, Marburg, and Thessaloniki. Earned a doctoral degree with a dissertation on the Cologne object artist Mary Bauermeister. Curator at the Wilhelm Hack Museum in Ludwigshafen am Rhein since 2009. In addition to exhibitions on recent contemporary art, she has also published numerous articles, most notably on the experimental art of the 1960s and 1970s and the phenomenon of "Intermedia." Directed the research project *Kunst für Alle! Die Sammlung Heinz Beck und die Editionspraxis seit den 1960er Jahren*, which will culminate in the publication of a collection catalog and an exhibition in Ludwigshafen in 2013.

Kathleen Bühler

Curator and director of the Contemporary Art Department at the Kunstmuseum Bern since 2008. Served previously (from 2005) as curator at the Bündner Kunstmuseum in Chur and as curator of the video art section of the Flick Collection from 2000 to 2002. Freelance author for the *Neue Zürcher Zeitung* (culture section). Studied art history, film, and philosophy and earned a doctoral degree from the University of Zurich (dissertation on the experimental films of Carolee Schneemann). Involved in numerous exhibitions, including *Tracey Emin – 20 Years* (2009), *Yves Netzhammer. A Refuge of Drawbacks* (2010/11), *The Mystery of the Body: Berlinde de Bruyckere in Dialogue with Lucas Cranach and Pier Paolo Pasolini* (2011), and *Zarina Bhimji* (2012).

Jörg Heiser

Coeditor in chief of the international art journal *frieze*, editor of *frieze d/e,* and contributing author to the *Süddeutsche Zeitung*. Has written numerous articles on music for *Spex, taz,* and other periodicals since the early 1990s. His dissertation on the contextual shift between art and pop music, in which Yoko Ono plays an instrumental role, is nearing completion. Guest professor at the Kunstuniversität Linz and adjunct instructor at the Hochschule der Bildenden Künste Hamburg. His book *Plötzlich diese Übersicht. Was gute zeitgenössische Kunst ausmacht* was published in 2007. Served as curator for *Romantic Conceptualism* (Kunsthalle Nürnberg and Bawag Foundation, Vienna, 2007), among other exhibitions.

Lisa Beißwanger

Studied art history, economic sciences, and ethnology in Freiburg im Breisgau and Madrid. Master's thesis on Daniel Richter's figurative painting within the context of the history of painting (2010). Served as an academic assistant for the 8th Internationale Foto-Triennale, Villa Merkel, Galerien der Stadt Esslingen am Neckar. Began a curatorial internship at the Schirn Kunsthalle in autumn 2010, followed by her appointment to the research staff. Involved in several exhibition projects, including *Surreal Objects* (2011), *Edward Kienholz* (2011), *Edvard Munch* (2012), and *Privacy* (2012).

TÁ AN COGADH THART!

MÁS MIAN LEAT É

Nollaig Shona Daoibh ó John ⌐ Yoko

DER KRIEG IST AUS!

WENN DU ES WILLST

John und Yoko Lennon Wuenschen Ihnen Froehliche Weihnachten

MILITO ESTAS FOR!

SE VI DEZIRAS TION

Feliĉan Kristnaskon de John k Yoko

戦争は終りだ

あなたが望めば

ハッピー・クリスマス　ジョンとヨーコより

WAR IS OVER!

IF YOU WANT IT

Happy Christmas from John & Yoko

LA GUERRE EST FINIE!

SI VOUS LE VOULEZ

John & Yoko vous souhaitent un Joyeux Noël

KRIG ER FORBI!

HVIS DU ØNSKER DET

Glædelig jul fra John & Yoko

GERRA AMAITUTA DAGO!

ZU NAHI BADUZU

Zorionak John & Yoko Partez

STRÍÐIÐ ER Á ENDA!

EF ÞIÐ VILJIÐ

Gleðileg Jól frá John & Yoko

imaginepeace.com

List of Exhibited Works

LIGHTING PIECE, 1955
Performed by Yoko Ono, Sōgetsu Art Center,
Tokyo, May 24, 1962
2 photographs by Yoshioka Yasuhiro
Concept collection of the artist
pp. 36, 37

TOUCH POEM NO. 5, c. 1960
Human hair, paper, ink
17.1 × 12.7 cm
Private collection
p. 93

ADD COLOR PAINTING, 1960/1966
Paint, newspaper, tin foil on canvas
40 × 40 cm
Private collection
p. 97

**PART PAINTING / PAINTING UNTIL
IT BECOMES MARBLE**, 1961
Ink on paper
Folded: 6.25 × 5 cm,
unfolded c. 6.25 × 120 cm
Private collection
pp. 12–13

**PAINTINGS & DRAWINGS
BY YOKO ONO**, 1961
AG Gallery, New York, July 16–30, 1961
Poster
Offset on paper
20.3 × 26 cm
Private Collection
p. 14

A PLUS B PAINTING, 1961
Canvas version
Lost
Photograph by George Maciunas
Original print in the collection of
The Museum of Modern Art, New York
Exhibition print from a digital image
in the artist's collection
p. 17

PAINTING FOR THE WIND, 1961
Canvas version
Lost
Photograph by George Maciunas
Original print in the collection of
The Museum of Modern Art, New York
Exhibition print from a digital image
in the artist's collection
p. 17

PAINTING IN THREE STANZAS, 1961
Canvas version
Lost
Photograph by George Maciunas
Original print in the collection of
The Museum of Modern Art, New York
Exhibition print from a digital image
in the artist's collection
p. 21

PAINTING IN THREE STANZAS, 1961
Instructions
Ink on the back of an AG Gallery program
announcement card, installed next to the
painting at the AG Gallery, New York, July 1961
8.5 × 27 cm
Private collection
p. 21

PAINTING TO BE STEPPED ON, 1961
Canvas version
Lost
Photograph by George Maciunas
Original print in the collection of
The Museum of Modern Art, New York
Exhibition print from a digital image
in the artist's collection
p. 18

**PAINTING TO LET THE EVENING LIGHT
GO THROUGH**, 1961
Canvas version
Lost
Photograph by George Maciunas
Original prints in the collection of
The Museum of Modern Art, New York
Exhibition prints from a digital images
in the artist's collection
p. 20

PAINTING TO SEE IN THE DARK
(2 versions), 1961
Canvas version
Lost
Photographs by George Maciunas
Original prints in the collection of
The Museum of Modern Art, New York
Exhibition prints from a digital image
in the artist's collection
p. 16

SHADOW PAINTING, 1961
Canvas version
Lost
Photograph by George Maciunas
Original print in the collection of
The Museum of Modern Art, New York
Exhibition print from a digital image
in the artist's collection
p. 19

SMOKE PAINTING, 1961
Canvas version
Lost
Photograph by George Maciunas
Original print in the collection of
The Museum of Modern Art, New York
Exhibition print from a digital image
in the artist's collection
p. 19

TIME PAINTING, 1961
Canvas version
Lost
Photograph by George Maciunas
Original print in the collection of
The Museum of Modern Art, New York
Exhibition print from a digital image
in the artist's collection
p. 20

WATERDROP PAINTING (2 versions), 1961
Canvas version
Lost
Photographs by George Maciunas
Original prints in the collection of
The Museum of Modern Art, New York
Exhibition prints from a digital images
in the artist's collection
p. 18

VOICE PIECE FOR SOPRANO, 1961
Performed by Yoko Ono
Photograph, photographer unknown
Concept collection of the artist
p. 45

22 *Instructions for Paintings*, 1961 and 1962
A PLUS B PAINTING, 1961
A PLUS BE PAINTING, 1961
PAINTING FOR A BROKEN SEWING MACHINE,
1961
PAINTING FOR THE BURIEL, 1961
PAINTING FOR THE WIND, 1961
PAINTING IN THREE STANZAS, 1961
PAINTING TO BE CONSTRUCTED IN YOUR
HEAD, 1961
PAINTING TO ENLARGE AND SEE, 1961
PAINTING TO HAMMER A NAIL, 1961
PAINTING TO LET THE EVENING LIGHT GO
THROUGH, 1961
PAINTING TO SEE THE ROOM, 1961
PAINTING TO SEE THE SKIES, 1961
PAINTING TO SHAKE HANDS, 1961
PAINTING UNTIL IT BECOMES MARBLE, 1961
SMOKE PAINTING, 1961
WATERDROP PAINTING, 1961
UNTITLED (PAINTING TO SEE THE SKIES), 1961
PAINTING TO BE CONSTRUCTED IN YOUR
HEAD, 1962
PAINTING TO BE CONSTRUCTED IN YOUR
HEAD, 1962
PAINTING TO BE CONSTRUCTED IN YOUR
HEAD, 1962
PAINTING TO BE CONSTRUCTED IN YOUR
HEAD, 1962
PORTRAIT OF MARY, 1962
Written in Japanese by Toshi Ichiyanagi
Ink on paper
25 × 38 cm each
The Gilbert and Lila Silverman Collection, Detroit
pp. 60–65

COUGH PIECE, 1961/1964
Sound recording transferred to digital
30:18 min.
Sound recording and concept collection
of the artist
No image

**PAINTING TO LET THE EVENING LIGHT
GO THROUGH**, 1961/1966
Plexiglas
Engraved: PAINTING TO LET THE EVENING LIGHT
GO THROUGH
YOKO ONO 1961
84 × 70 cm
Private collection
p. 20

SKY MACHINE, 1961/1966
Stainless-steel dispenser, handwritten paper
cards, metal pedestal
Inscribed: WORD MACHINE PIECE #1
'SKY MACHINE' BY YOKO ONO 1961,
REALIZED BY ANTHONY COX 1966
Dispenser: 130 × 41 × 41 cm
The Museum of Modern Art, New York.
The Gilbert and Lila Silverman Fluxus Collection
Gift
p. 113

SKY MACHINE, 1961/1966
Cards with pencil inscriptions
Inscribed: SKY
2.5 × 4.4 cm each
The Museum of Modern Art, New York.
The Gilbert and Lila Silverman Fluxus
Collection Gift
p. 112

PAINTING TO HAMMER A NAIL, 1961/1966
Painted wood panel, nails, painted hammer,
chain
Panel: 34.9 × 26.6 × 11.4 cm,
hammer and chain: 92 cm long
Private collection
p. 68

PAINTING TO HAMMER A NAIL IN,
1961/1967
Stainless steel, glass
Engraved: Hammer a nail in for John. '67
London Yoko Ono
Panel: 30.5 × 20.5 × 10.2 cm,
hammer and chain: 125 cm long
Collection Walker Art Center, Minneapolis
T.B. Walker Acquisition Fund, 2002
p. 69

PAINTING TO BE STEPPED ON, 1961/2013
Canvas, sumi ink
c. 90 × 90 cm
Exhibition copy
Concept collection of the artist
p. 18, image of an earlier version of the piece

BALANCE PIECE, 1997/2010
Two chairs, table, toaster, tea kettle, frying pan
& lid, colander, ladle, serving fork, serving
spoon, spatula, whisk, water pitcher, two salt
shakers, mixing bowl, two cups, two saucers,
tongs
Base area c. 300 × 400 cm
Private collection
p. 139

BALANCE PIECE, 1958/1997
Instruction
Ink on paper
17 × 11 cm
Private collection
p. 138

BALANCE PIECE, 1997
Instruction drawing
Ink on paper
24 × 25 cm
Private collection
p. 138

WORKS OF YOKO ONO, 1962
Program / catalog announcement
Offset and letterpress on paper
Sōgetsu Art Center, Tokyo, May 24, 1962
47.6 × 11.4 cm
Private collection
p. 92

WATER PIECE (PAINTING TO BE WATERED), 1962/2012
Sponge, eyedropper, water in glass vial on Plexiglas pedestal
Engraved: WATER PIECE YOKO ONO 1962 WATER EVERY DAY
60 × 60 × 60 cm
Exhibition copy
Concept collection of the artist
p. 75, image of an earlier version of the piece

SHADOW PIECE, 1963
Performed by Yoko Ono and Barbara Steveni, Destruction in Art Symposium (DIAS), Notting Hill Gate, London, September, 1966
Photograph by Tom Picton
Concept collection of the artist
pp. 44

SOUNDTAPE OF THE SNOW FALLING AT DAWN, 1963/1965
Soundtape, metal container, offset on paper
Closed container: 5 × 2 cm
Collection of Jon and Joanne Hendricks
p. 103

Announcement for **GRAPEFRUIT**, 1964
Envelope, four offset sheets
Envelope: 8.3 × 20.3 cm,
sheet ("no 86"): 23 × 6 cm,
sheet ("no. 81"): 23 × 6 cm,
sheet "the price of the book...": 7.1 × 23 cm
The Museum of Modern Art, New York.
The Gilbert and Lila Silverman Fluxus Collection Gift
p. 52

GRAPEFRUIT, 1964
Artist's book
Published by Wunternaum Press, Tokyo, July 4, 1964
14 × 14 × 3.2 cm
The Museum of Modern Art, New York.
The Gilbert and Lila Silverman Fluxus Collection Gift
p. 52

Piece for Nam June Paik no.1, 1964
Ink on paper
28 × 21.7 cm
The Museum of Modern Art, New York.
The Gilbert and Lila Silverman Fluxus Collection Gift
p. 66

MORNING PIECE, 1964
Shards of glass, typewriting on paper, glue, wooden box, cloth strapping
Box: 16 × 34.75 × 34.75 cm
Private collection
p. 51

MORNING PIECE (Notice), 1964
English version
Ink on paper
29.5 × 21 cm
Private collection
p. 48

MORNING PIECE (Notice), 1964
Japanese version
Ink on paper
29.5 × 21 cm
Private collection
No image

MORNING PIECE (Mornings for Sale), 1964
Ink on paper
36 × 25 cm each
Private collection
p. 51

MORNING PIECE (Types of Mornings), 1964
Ink on paper
36 × 25 cm each
Private collection
p. 51

MORNING PIECE (Morning Dates), 1964
Ink on paper
36 × 25 cm each
Private collection
p. 51

**MORNING PIECE (1964)
to George Maciunas**, 1965
Flyer
Offset print on paper
21.6 × 27.9 cm
Private collection
p. 55

BAG PIECE, 1964
Performed by Yoko Ono and Anthony Cox, Sōgetsu Art Center, Tokyo, August 11, 1964
5 photographs by Yoshioka Yasuhiro
Concept collection of the artist
pp. 40–43

CUT PIECE, 1964
Performed by Yoko Ono, Sōgetsu Art Center, Tokyo, August 11, 1964
Photograph, photographer unknown;
Carnegie Recital Hall, New York, March 21, 1965
Photographs by Minoru Niizuma
Concept collection of the artist
pp. 31, 38, 39, 191

DRAW CIRCLE EVENT, 1964
Various examples completed by people
Offset on paper, ink, pigment, etc., mailed
8.9 × 21.6 cm each
Private collection
p. 102

POINTEDNESS, 1964/1966
Crystal sphere on Plexiglas pedestal
Engraved: POINTEDNESS YOKO ONO 1964 THIS SPHERE WILL BE A SHARP POINT WHEN IT GETS TO THE FAR CORNERS OF THE ROOM IN YOUR MIND
Pedestal: 143 × 26.6 × 25.4 cm,
sphere: 6.6 cm
Private collection
p. 78

BUY NOW! SELFPORTRAIT BY YOKO ONO, 1965
Flyer
Offset on paper
21.1 × 7 cm
Private collection
p. 192

ETERNAL TIME, 1965
Altered clock in Plexiglas box, Plexiglas pedestal with stethoscope
Engraved: ETERNAL TIME
Pedestal: 101.5 × 20 × 20 cm
Private collection
p. 77

ONO'S SALES LIST, 1965
Offset with handwritten additions
35.6 × 21.7 cm
The Museum of Modern Art, New York.
The Gilbert and Lila Fluxus Collection Gift
p. 67

PIECES DEDICATED TO GEORGE MACIUNAS, THE PHANTOM ARCHITECT, 1965
Ink on paper
15 × 23 cm
Private collection
pp. 120–121

SKY PIECE TO JESUS CHRIST, 1965
Performance piece for orchestra
Performed by Yoko Ono, La Monte Young, Tony Cox, and the Fluxus Symphony Orchestra, Carnegie Recital Hall, New York, September 25, 1965
2 photographs by Peter Moore
Concept collection of the artist
pp. 56, 191

DIAS PRESENTS TWO EVENINGS WITH YOKO ONO, 1966
Poster
Africa Center, London, September 28 and 29, 1966
Silkscreen on paper
53 × 40 cm
Private collection
p. 86

YOKO at INDICA, 1966
Exhibition catalog
Indica Gallery, London, November 9–22, 1966
Offset on paper, glue, stapled
28 × 14.5 cm
Private collection
p. 178

APPLE, 1966
Apple on Plexiglas pedestal with brass plaque
Engraved: APPLE
Pedestal: 114 × 17 × 18 cm
Private collection
p. 73, image of a different version of the piece

CEILING PAINTING, YES PAINTING, 1966
Text on paper, glass, metal frame, metal chain, magnifying glass, painted ladder
Ladder: 183 × 49 × 21 cm,
framed text: 2 × 64.8 × 56.4 cm
Private collection
pp. 70–71

FORGET IT, 1966
Stainless-steel needle on Plexiglas pedestal
Engraved: FORGET IT YOKO ONO 1966
Needle: 8.2 cm,
Pedestal: 126.5 × 30.5 × 30.5 cm
Private collection
p. 72

WRAPPING PIECE FOR LONDON (WRAPPED CHAIR), 1966
Wooden chair, gauze, white paint
83.2 × 40.6 × 39.4 cm
Private collection
p. 82

FILM NO.1 (Match Piece), *Fluxfilm No.14*, 1955/1966
16 mm film transferred to digital
b/w, silent, 5 min.
Private collection
p. 153

EYE BLINK, *Fluxfilm No. 9*, 1966
16 mm film transferred to digital
b/w, silent
2:40 min.
Private collection
pp. 154–155

FILM NO. 4 (BOTTOMS), *Fluxfilm No. 16*, 1966
16 mm film transferred to digital
b/w, silent, 5:30 min.
Private collection
pp. 148, 150, 151, 156

9 Concert Pieces for John Cage, 1966
Title Page; To John; Beat Piece; Breath Piece; Clock Piece; Cut Piece; Disappearing Piece; Fly Piece; Hide Piece; Promise Piece; Question Piece; Sweep Piece; Touch Piece; Whisper Piece; Wind Piece
15 loose leaves
Ink on paper
26 × 20 cm each
Courtesy Northwestern University Library
pp. 104–107

CORNER PAINTING, c. 1966–71
Canvas over wood with gilded frame
Each side: 41.9 × 24.9 cm
Private collection
pp. 84–85

YOU AND ME, 1966/c. 1990/2013
Canvas, pigment, two condoms, water
91.4 × 91.4 cm
Private collection
No image

MEND PIECE, 1966/1968
Broken cup, tube of glue, ink on paper, ink on collaged box
Installation dimensions variable
Collection of Jon and Joanne Hendricks
p. 27

WHITE CHESS SET, 1966/2013
Table, two chairs, chess set, all wood painted white
Exhibition copy
Concept collection of the artist
p. 100, image of an earlier version of the piece

CHAIR PAINTING, c. 1966/1971
Wooden chair, canvas over wood with gilded frame
Collection of Barbara Goldfarb
p. 83

SKY TV, 1966/2013
TV monitor, closed-circuit video camera
Dimensions variable
Exhibition copy
Concept collection of the artist
pp. 126–127, image of an earlier version of the piece

BLUE ROOM EVENT, 1966/2013
Installation with handwritten texts by Yoko Ono
Installation dimensions variable
Concept collection of the artist
pp. 98–99, image of an earlier version of the piece

MIND OBJECT II, c. 1966/1967
Bottle on Plexiglas pedestal
Engraved: MIND OBJECT II NOT TO BE APPRECIATED UNTIL ITS BROKEN
Pedestal: 139 × 26.5 × 26.5 cm,
bottle: 25 cm
Concept collection of the artist
p. 79

FILM NO. 4 (Bottoms), 1967
Poster for film screening
Offset on paper
30 × 20.5 cm
Private collection
p. 157

LION WRAPPING EVENT, 1967
Performed by Yoko Ono and others,
Trafalgar Square, London, August 3, 1967
2 photographs by Nigel Hartnup;
other photographer unknown
Concept collection of the artist
pp. 46–47

A BOX OF SMILE, 1967
Sterling silver, mirror
Engraved: A BOX OF SMILE Y.O. '67
Closed: 6.8 × 6.4 × 6.4 cm
Private collection
p. 116

GLASS KEYS TO OPEN THE SKIES, 1967
Glass keys in Plexiglas box with brass hinges
Box: 20.25 × 27 × 4.5 cm, keys: c. 14 cm each
Private collection
p. 131

HALF-A-ROOM, 1967
Half-a-Suitcase; Half-a-Radio; Half-a-Picture;
Half-a-Heater; Half-a-Chair; Half-a-Chair;
Half-a-Bookshelf; Half-a-Garbage Can;
Half-a-Sauce Pan; Half-a-Tea Pot; Half-a-Hat;
Half-a-Tea-Kettle; Half-a-Measuring Cup;
Half-a-Sack; Half-a-Basket of Flowers;
Half-a-High Heeled Shoe; Half-a-Man's Shoe;
Half-a-Strainer; Half-a-Plastic Cup;
Half-a-Scrub Brush; Half-a-Utensil;
Half-a-Compact; Half-a-Plastic Soap Holder;
Half-a-Glasses Case; Half-a-Globe Holder;
Half-a-Glass Jar; Half-a-Drinking Glass;
Half-a-Drinking Glass; Half-a-Dresser
Cut in half, painted white
Installation dimensions variable
Private collection
pp. 108–109

THREE SPOONS, 1967
Silver spoons on Plexiglas pedestal with silver
plaque
Engraved: THREE SPOONS Y O 67
Pedestal: 139.7 × 28.5 × 28.5 cm,
spoons: 15.2 cm
The Gilbert and Lila Silverman Collection, Detroit
p. 115

FILM NO. 5 (Smile), 1968
Performed by John Lennon
16 mm film transferred to digital
Color, sound, 51 min.
Private collection
p. 161

RAPE, 1969
Performed by Eva Majlata
Directed in collaboration with John Lennon
16 mm film transferred to digital
Color, sound, 77 min.
Private collection
pp. 152, 158

WAR IS OVER!, 1969–
In collaboration with John Lennon
Different media
Dimensions variable
Concept collection of the artist
pp. 194, 202

FLY, 1970
Performed by Virginia Lust
16 mm film transferred to digital
Color, sound, 25 min.
Private collection
p. 159

FREEDOM, 1970
16 mm film transferred to digital
Color, sound, 1 min.
Sound track by John Lennon
Private collection
p. 163

APOTHEOSIS, 1970
Directed in collaboration with John Lennon
16 mm film transferred to digital
Color, sound, 18 min.
Private collection
p. 160

ERECTION, 1971
Directed in collaboration with John Lennon
16 mm film transferred to digital
Color, sound, 55 min.
Private collection
p. 162

EVERSON MUSEUM CATALOG BOX, 1971
Design by Yoko Ono with George Maciunas
Mixed media
Closed: 16 × 15 × 18 cm
Private collection
p. 117

THIS IS NOT HERE, 1971
Publication in newspaper format
Edited by John Lennon with Peter Bendry,
designed by John Lennon
Everson Museum of Art, Syracuse,
New York, October 9–27, 1971
Offset on paper
55 × 42 cm
Private collection
p. 118

THIS IS NOT HERE, 1971
Poster
Everson Museum of Art, Syracuse,
New York, October 9–27, 1971
Offset on paper
46 × 61 cm
Private collection
p. 119

Museum Of Modern (F)art, 1971
Advertisement
Published in *Village Voice*, December 2, 1971
17 × 17.5 cm
Private collection
p. 34

Museum Of Modern (F)art, 1971
Exhibition catalog
Offset on paper
30 × 30 cm
Private collection
No image

Museum Of Modern (F)art, 1971
16 mm film transferred to digital
Color, sound, 7:03 min.
Private collection
No image

DISAPPEARING PIECE, 1971
Metal box on Plexiglas base
Engraved: CAUTION÷ THE OBJECT IN
THIS BOX EVAPORATES WHEN EXPOSED
TO LIGHT YOKO ONO 1971
17.8 × 10.20 × 5 cm
Private collection
p. 76

WATER EVENT, 1971
Invitation
Everson Museum, Syracuse, New York,
October 9–27, 1971
Offset on paper
16 × 12 cm
Private collection
p. 128

WATER EVENT, 1971/2013
Joint work of Yoko Ono and a number of
invited people who provided containers;
Yoko Ono provided the water
Dimensions variable
Confirmed participants at the time of going to
print: John Dunbar, Olafur Eliasson, Hans-Peter
Feldmann, William Forsythe, Robert Gober,
Charlotte Gyllenhammar, Judith Hopf, Arata
Isozaki, Jean-Jacques Lebel, Sean Lennon,
Christian Marclay, Paul McCarthy, Mariko Mori,
Ernesto Neto, Cornelia Parker, Kiki Smith,
Lawrence Weiner, Adrian Williams
Concept collection of the artist
pp. 128–129, image of an earlier version of the
piece

AIR DISPENSERS, 1971/2013
Metal, plastic
Engraved: AIR CAPSULES BY YOKO ONO
50 CENTS
c. 43 × 20 × 20 cm
Exhibition copies
Concept collection of the artist
pp. 110–111, image of earlier versions of the piece

DANGER BOX, 1971/2012
Plexiglas pedestal, silver plaque
Inscriptions: DANGER BOX Y.O.
WARNING: THE MANAGEMENT WILL NOT
GUARANTEE THAT A HAND WHEN PUT
IN THIS HOLE WILL COME OUT IN THE SAME
CONDITION AS PRIOR TO ENTRY
30.5 × 30.5 × 61 cm
Exhibition copy
Private collection
p. 130, image of an earlier version of the piece

TELEPHONE IN MAZE, 1971/2011/2013
Plexiglas, metal, wood, telephone
Base area 380 × 380 cm
Private collection
p. 144, image of an earlier and different version
of the piece

WALKING ON THIN ICE, 1981
Music video
Directed by Yoko Ono
Color, sound, 5:57 min.
p. 164

HELL IN PARADISE, 1985
Directed by Yoko Ono
Color, sound, 3:30 min.
No image

FOUR SPOONS, 1988
Patinated bronze
Engraved: FOUR SPOONS Y.O. 88
2.9 × 19.7 × 19.7 cm
Private collection
p. 114

UNTITLED, 1988
Patinated bronze
4 × 11.5 × 14.5 cm
Private collection
p. 114

FRANKLIN SUMMER, 1995–
Drawings from a larger, ongoing series
started in 1995
Ink on paper
17.3 × 11.3 cm each
Private collection
pp. 132–133

DREAM, 1996/2013
Billboards in the City of Frankfurt
am Main
Dimensions variable
Concept collection of the artist
p. 35, image of a different version of the piece

MORNING BEAMS / RIVERBED, 1996/2013
Nylon ropes, stones
Installation dimensions variable
Concept collection of the artist
p. 145, image of an earlier version of the piece

WISH TREE, 1996/2013
Olive tree, paper, string, pens
Installation dimensions variable
Concept collection of the artist
p. 147, image of an earlier version of the piece

VERTICAL MEMORY, 1997
21 framed prints with texts
Iris prints, Plexiglas, texts
Frames: 32 × 49.5 × 4 cm,
texts: 9 × 28.5 cm
Private collection
pp. 134–137

CRICKET MEMORIES, 1998
13 antique Chinese cricket cages
Wood, engraved metal, text, table, chair,
bound book
Installation dimensions variable
Private collection
pp. 140–141

EN TRANCE, 1998/2013
Glass, metal, beaded curtain
Installation dimensions variable
Exhibition copy
Concept collection of the artist
p. 146, image of an earlier version of the piece

WE ARE ALL WATER, 2006
Glass bottles, water, ink on paper
Dimensions variable
Private collection
pp. 80–81

TOUCH ME, 2008/09
Wood, marble, ceramic, cloth
Table: 61 × 244 × 76 cm,
Pedestal with ceramic bowl: 76 × 30 × 30 cm
Body part boxes:
Mouth (1 box): 4.4 × 8.6 × 20 cm,
Breasts (2 boxes): 10.7 × 14 × 20 cm,
Belly (1 box): 13.7 × 15.2 × 20 cm,
Pubis (1 box): 14 × 19 × 20 cm,
Knees (2 boxes): 23 × 14 × 20 cm,
Feet (2 boxes): 20.3 × 8.3 × 20 cm
Private collection
pp. 142–143

MOVING MOUNTAINS, 2013
Cloth bags
Various sizes
Exhibition copy
Concept collection of the artist
No image

This catalog has been published in conjunction with the exhibition

Yoko Ono. Half-A-Wind Show – A Retrospective

Schirn Kunsthalle Frankfurt, Germany, February 15 – May 12, 2013
Louisiana Museum of Modern Art, Humlebæk, Denmark, June 1 – September 15, 2013
Kunsthalle Krems, Austria, October 20, 2013 – February 23, 2014
Guggenheim Museum Bilbao, Spain, March 18 – September 7, 2014

Catalog

Editors
Ingrid Pfeiffer, Max Hollein
in cooperation with Jon Hendricks

Coeditor
Ingrid Pfeiffer, Jon Hendricks

Catalog Manager
Katharina Siegmann

Project Management Prestel
Gabriele Ebbecke

Assistance
Eva Dotterweich

English Copyediting
Danko Szabó, Munich

Translation from the German
John Southard, Cologne

Grafic Design and Typesetting
Harold Vits, Mannheim

Production Prestel
Wolfram Friedrich, Andrea Cobré

Typeface
Heron, Cyrus Highsmith for Font Bureau

Reproduction
Reproline Media, Munich-Unterfoehring

Printing and Binding
Passavia Druckservice GmbH, Passau

Printed in Germany

Front Cover
Yoko Ono, photo: Greg Kadel / Trunk
Archive

Exhibition – Schirn Kunsthalle Frankfurt

Director
Max Hollein

Curator
Ingrid Pfeiffer

Curatorial Assistance
Lisa Beißwanger

Head of Exhibitions
Esther Schlicht

Exhibition Tour
Inka Drögemüller

Registrars
Karin Grüning, Jessica Keilholz,
Elke Walter

Technical Service
Ronald Kammer, Christian Teltz

Installation Crew Supervision
Andreas Gundermann

Conservators
Stefanie Gundermann,
Stephanie Wagner

Exhibition Architecture
Karsten Weber

Typographic Concept
Heike Stumpf

Press
Axel Braun, Carolyn Meyding,

Simone Krämer, Christoph Engel

Internet Editing
Fabian Famulok

Marketing
Inka Drögemüller, Luise Bachmann,
Laura Salice

Graphic Design
Heike Stumpf

Education
Chantal Eschenfelder, Simone
Boscheinen, Laura Heeg,
Irmi Rauber, Antje Lindner

Sponsoring
Julia Lange, Elisabeth Häring

Administration
Klaus Burgold, Katja Weber, Tanja Stahl

Executive Assistant to the Director
Katharina Kanold

Team Assistant
Daniela Schmidt

Courier
Ralf Stoßmeister

Supervision Cleaning
Rosaria La Tona

Reception
Josef Härig, Vilizara Antalavicheva

Coordinators

Yoko Ono, Studio One, New York

Jon Hendricks, Susie Lim, Karla Merrifield, Connor Monahan, Colby Bird, Eva Bracke,
Ellen Goldin, Andrew Kachel, Jonas Herbsman

Prestel Verlag, Munich
A member of Verlagsgruppe
Random House GmbH

Prestel Verlag
Neumarkter Strasse 28
81673 Munich
Tel. +49 (0)89 4136-0
Fax +49 (0)89 4136-2335

www.prestel.de

Prestel Publishing Ltd.
4 Bloomsbury Place
London WC1A 2QA
Tel. +44 (0)20 7323-5004
Fax +44 (0)20 7636-8004

Prestel Publishing
900 Broadway, Suite 603
New York, NY 10003
Tel. +1 (212) 995-2720
Fax +1 (212) 995-2733

www.prestel.com

Library of Congress Control Number is available;
British Library Cataloging-in-Publication Data: a
catalog record for this book is available from the
British Library; Deutsche Nationalbibliothek holds
a record of this publication in the Deutsche
Nationalbibliografie; detailed bibliographical data
can be found under: http://www.dnb.de

Prestel books are available worldwide. Please con-
tact your nearest bookseller or one of the above
addresses for information concerning your local
distributor.

ISBN 978-3-7913-5283-1 (English trade edition)
ISBN 978-3-7913-5282-4 (German trade edition)
ISBN 978-3-7913-6460-5 (English museum edition)
ISBN 978-3-7913-6459-9 (German museum edition)

FSC-certified paper LuxoSatin
was delivered by
Papyrus GmbH & Co. KG.